MILITARY MACCLESFIELD

MILITARY MACCLESFIELD

AND BRITAIN'S BATTLES
1066–1656

Dorothy Bentley Smith

AMBERLEY

To Eileen, Jamie and Freddie,
three special friends with Irish connections.

First published 2019

Amberley Publishing
The Hill, Stroud
Gloucestershire, GL5 4EP

www.amberley-books.com

Copyright © Dorothy Bentley Smith, 2019

The right of Dorothy Bentley Smith to be identified as the Author of this work has been asserted in accordance with the Copyrights, Designs and Patents Act 1988.

ISBN 978 1 4456 9467 2 (paperback)
ISBN 978 1 4456 9468 9 (ebook)

All rights reserved. No part of this book may be reprinted or reproduced or utilised in any form or by any electronic, mechanical or other means, now known or hereafter invented, including photocopying and recording, or in any information storage or retrieval system, without the permission in writing from the Publishers.

British Library Cataloguing in Publication Data.
A catalogue record for this book is available from the British Library.

Typesetting by Aura Technology and Software Services, India. Printed in the UK.

CONTENTS

Author's Note 7

1. The Middle Ages

In the Beginning	9
The Normans	10
Macclesfield Forest	12
Crusade	15
Family Affairs	19
Wars in France	23
Scottish Interlude	26
The Battle of Crécy	27
The Siege of Calais	33
The Prince of Wales	37
Poitiers	42
Richard II	55
Agincourt	65
The Macclesfield Parkland	75
The Wars of the Roses	82
Recommencement of War	90
Richard III	100
The Battle of Bosworth	103

2. Tudor Times

Henry VII	106
The Battle of Stoke Field	109
Brittany	112
French Matters	113
Finale	117
Henry VIII	120
The Battle of the Spurs	124
Flodden Field	125
Defence of the Realm	132
The Field of the Cloth of Gold	135
Wars with France and Scotland	138
The Pillage of Edinburgh	142
Modernisation of the English Army	144
Return to France	145
Action in Scotland	148
Edward VI	149
Queen Mary I	151
Queen Elizabeth I	155
Troubles in Ireland	159
The Last of the Tudor Years	166

3. The Stuarts

James I	174
Charles I	179
The Civil War	189
The Battle of Edge Hill	193
Divided Loyalties	194
Charles II	210
Cromwell	213
Bibliography	219
Acknowledgements	221
Index	222

AUTHOR'S NOTE

The year 2018 proved to be noteworthy in the intensity with which many individuals and associations were busily researching the events of World War 1, and nowhere more so than in Macclesfield, Cheshire. In researching the history of the town over many years I had become aware of its military importance during past centuries. The time seemed appropriate, therefore, to prepare a military history that would complement the anticipated publications in respect of World War 1.

My original intention was to write two remarkable stories from the nineteenth century, related in a series of letters sent to family and occasionally friends by two military personnel. Their letters are remarkable because of the volume of intimate detail that they contain; however, they are only part of the one relating to Macclesfield's military commitments from the years following the arrival of the Normans in 1066.

It was therefore essential to lay the foundations for Macclesfield's significant role as a military township and subsequent borough when bringing to light its achievements over several centuries. Also necessary was the understanding of Britain's military involvements, both as background material, and in suggesting possible engagements where local information is limited. It quickly became apparent that more than one volume was necessary in order to present a more inclusive story. Conveniently the first relates to the period 1066–1656, i.e. from

the reign of William I and his commissioning of the Domesday survey, to the height of Cromwell's military achievement as Lord Protector of the Commonwealth. This was the period during which England, and finally Britain, had no permanent standing army.

Whilst war and battles encompass death, gloom and destruction, there are also lighter, fascinating interludes, so it is important to balance the story and bring to life the characters of those involved, and also their comrades and friends. Many stories in this volume are centuries old, but still make interesting reading.

Today in the parish church of St Michael and All Angels hangs a series of flags in the chancel proclaiming the town's proud military inheritance. There they will hang until they turn to dust, as it is an acknowledged sacramental tradition that military colours must never be destroyed, but be allowed to fade away.

One can only hope that this book will encourage an appreciation of those long-forgotten Macclesfield men who served their country because of what they genuinely thought were the right reasons, and tried desperately to act by those reasons, and also to recognise and respect exactly what the town of Macclesfield, in proportion to its size, has sacrificed in the way of talented young men's lives for its nation and its sovereigns.

I

THE MIDDLE AGES

In the Beginning
Up to the time of writing Macclesfield has not be able to claim a Roman military presence, unlike its county town of Chester (Deva), or its northern neighbour, the Lancastrian city of Manchester (Manucium), both conspicuously located on the Roman map of Britain.

The east Cheshire area, with its meres, bogs and swamps, and an enormous forest stretching on its eastern side from Mottram in Longdendale in the north to almost Bosley in the south, from the Derbyshire border in the east to Gawsworth and the smaller hamlets on the west, had little to offer the Anglo-Saxons that were to follow. Fertile patches were eventually occupied for farming activities, and gradually a small trading post was established, resulting from the carriage of salt from Middlewich, a major Roman source for the precious commodity.

The first part of the route across the Cheshire Plain was presumably accomplished with the salt loaded in carts, until it reached what the Anglo-Saxons had called 'the maclesfeld', literally translated to 'the field of the trader'. However, it was not the centre of the town as known today; it was in the adjoining parish of Sutton on its southern side, in the area of the town's football ground. There the salt would be reloaded into the packs carried by sturdy mules or ponies for transportation over the steep hills into Derbyshire and Yorkshire. The two most important established packhorse routes can be traced through names such as Saltersford and Salter's Flat, etc., along these

ancient tracks, which began in the traders' field and then divided as they crossed the Kerridge Hills.

The Anglo-Saxon mydelfield ('the middle field'), mentioned in a deed of 1400, covered the centre of Macclesfield today. The bottfeld or bothefeld, reminiscent of Bothefeld, now part of Hanover in northern Germany, referred to a sandy, marshy area in a forest, and is mentioned in a very early deed for an area to the east of Beech Lane extending down to the River Bollin, which lay on the north-eastern side of the ancient hamlet. The maclesfeld was the southernmost field, as stated, which is now the parish of Sutton.

There were five enclosures for animals known as 'heys', mostly near the River Jordan (now the Bollin). One was named Horsehey, indicating that horses were kept there; two were simply known as Lower and Higher Heys adjoining the eastern side of today's Park Green around the area of Pickford Street; a fourth was Whalley Heys (now a car park); and the fifth, 'the Welshman's Hey', is yet to be identified, but was possibly in Hurdsfield, east of Fence Avenue, where there was an area known as Fence – an enclosure for animals.

The Normans

Claiming the throne as William I after Harold's defeat at Hastings, Duke William of Normandy and his host of 1066 were originally of Viking stock. William hoped for a peaceful takeover, but was forced to demonstrate his power against an uprising in Yorkshire, where large areas of the shire were laid waste. He immediately crossed the Pennines into Cheshire to build castles in Chester and Shrewsbury.

At this time Macclesfield was one of the manors held by Earl Edwin of Mercia, but William granted the whole county to Gherbod, who shortly returned to Flanders, allowing the grant to be transferred to William's nephew, Hugh. In 1071, most of what was until recently modern Flintshire and Denbighshire came under Cheshire jurisdiction, and Hugh, as Earl of Chester, was granted extensive power in return for military service against the Welsh.

Cheshire was in the unique position of having only two royal tenants – the bishop and Earl Hugh. Although not above the law, it allowed the earl some independence to give away land or retain it on his own terms, with very little contrivance. He also chose to preside

The Middle Ages

Scene depicting Norman cavalry on the Bayeaux Tapestry during their English conquest of 1066. The tapestry was commissioned by William I's half-brother, Bishop Odo.

Above left and right: Small sections of a reversed scene from the famous battle featured on the Bayeaux Tapestry embroidered by Lady Wardle of Leek, whose husband was closely associated with William Morris. These figures portray the English foot soldiers, including a young archer, under attack. The whole section is on display in the Macclesfield Silk Museum.

in the county court, as sheriffs of other counties did, thus giving the sheriffs of Cheshire a somewhat demoted position.

In 1085, William I commissioned the Domesday survey, which was completed within a year. It reveals Cheshire as divided into seven areas called 'hundreds', the poorest of which was Macclesfield. At this time, the county was barren and sparsely populated. Records reveal poor climatic conditions, with many wet spells in the late eleventh and early twelfth centuries. The result was ruined harvests, plague and famine, with cattle disease and many animals drowned. The rivers Dee and Weaver were liable to flooding in their lower reaches, so the county was not the same lush green territory as today.

The survey records only one mill in the whole of the Macclesfield hundred – the one for the manor 'to supply the Hall'. The manor, held by Robert Fitzhugh, had only 12 acres of sown land. Another tenant had 7 acres, indicating that the remainder of the area was either forest or waste, apart from a little sown land in the adjoining Butley manor. The incentive therefore was with the earl to build up the county's resources, and he already had a lucrative income from the salt trade, with tolls levied at 4 pence for each cartload drawn by four or more oxen; 2 pence for those drawn by two oxen, or by a horse; and a farthing (a quarter of a penny) for a man carrying a load.

On Earl Hugh's death, in 1101, the earldom passed to his son, then nephew, Ranulph I and continued within the family.

Until the arrival of the Normans in 1066 the area's potential had not been fully realised, for they were the great forest administrators. The importance of Macclesfield Forest to the development of Macclesfield town, in fact, to the very existence of the township, cannot be overemphasised, and during the twelfth century the Anglo-Saxon open three-field system of farming, together with the forest, was developed further by the earls of Chester.

Macclesfield Forest

The forest close to the original hamlet would have been cleared over a period of time for fuel and building purposes, but a thick covering still remained, amongst which were many oaks.

Forest management was based on French hunting laws, which gave priority to preservation and conservation of the environment.

The Middle Ages

These had been adopted by the Normans and were disciplines that they had brought with them at the time of the Conquest.

A French hunting book, later translated by Edward, nephew of the Black Prince, clearly indicates which animals remained in the English forests more than 300 years after the advent of the Normans. Edward omits only four: reindeer, chamois (including the ibex), bear and, surprisingly, rabbits. Favourite for the chase was the hare, which, together with foxes and others, was considered vermin and hunted all-year round. Next came the hart, buck and roe deer, but only in the appropriate season, with breeding carefully respected and selected mature animals killed.

Wild boar, like deer, were also hunted for food and sport made out of it. Wolves were hunted, not only for the danger to livestock but also to human beings – one is reminded of the man-eating tigers of India.

The medieval wolf was an extremely large, strong animal that could easily kill a cow or mare, and its jaws had such power that it was known to have carried off a goat, sheep or even young hogs. Young wolves reared near battlefields or gallows, the latter having corpses hanging too near the ground, unfortunately acquired a taste for tender human flesh. Occasionally it happened that a shepherd would be dragged away and killed, his flock untouched!

Normally in England hunting was done with 'running hounds' (the best kind considered as 'of a hue brown tan') and greyhounds; trapping was used more on the Continent. Hounds were highly revered and had to be kept in good condition by hunting two or three times each week.

This adherence to forest law was essential, and circumstantial evidence suggests that the earls of Chester saw it as an important part of their duties to ensure that the forests of Cheshire, especially those of Wirral and Macclesfield, were soon brought under strict control.

Macclesfield Forest was divided into areas and a forest bailiff given the task of ensuring the law was obeyed. As the system developed each area fell under the jurisdiction of an appointed forester, known as a 'riding-huntsman', with responsibility to the chief forester. Because of their adherence to the forest law, many would later send sons to Oxford University, a seat of learning from the eleventh century, from

Military Macclesfield

where some became lawyers well versed in general law in London. Several of the ancestral homes around Macclesfield were originally established as hunting lodges by these foresters. The chief forester was a member of the Davenport family, who held the power of life and death when hearing a case brought to his attention in the forest court. The death penalty was by hanging in the Gallowfields, situated on the track leading out of the hamlet towards Chester.

The foresters soon developed their skills further and were organised into a cohesive force, the result of an order issued with instructions to practice their archery every day in the forest. At the same time as they were learning to obey orders, horse breeding and stocking were being developed. Animals for purchase and sale were brought to the hamlet as market facilities increased, and, as further development took place, other goods became part of the commerce, for carts and packhorses never travelled light – their owners could ill afford a wasted journey.

Above left: A falconer. Macclesfield foresters were entitled to hunt quail and partridge in the forest using their birds of prey and spaniels.

Above right: Alphonso I (1139–85), first king of Portugal, dressed in the battledress akin to early crusaders. He is depicted grasping his shield in his left hand and holding up his sword with his right hand.

14

Officials from Chester, although on the extreme western side of the county, were determined to maintain complete control of affairs on the eastern side. They were being provided with venison from the forest and Cheshire cheese from the expanding farming community. Cheshire was also becoming convenient for military purposes; horses for the army were kept in an area designated the Macclesfield manor and parkland, and produce from the farming communities was sufficient to feed an army awaiting departure from the port of Chester, to suppress any uprisings in Ireland, Scotland or, eventually, Wales.

As the pope endeavoured to gain help from Christendom in order to restrain Muslim aggression in the Holy Land and retake Jerusalem for the Christians, the knights of England would soon be encouraged by the Archbishop of Canterbury to answer the call.

Crusade

An account, though somewhat legendary, persists that men from Macclesfield were associated with Sherwood Forest during the twelfth century, raising the strong possibility that archers from both areas were involved in the Third Crusade.

On 2 October 1187 the city of Jerusalem was surrendered to the indefatigable Muslim leader Saladin. The new pope, Gregory VIII, quickly appealed to European leaders for help, and the Third Crusade (1189–92) was soon underway.

Richard I, king from 1189, having settled affairs in England, joined the French King Philip II, and, together with both their armies, they arrived in Sicily during July 1190. The previous year a dispute had arisen that resulted in Richard's capture of Minorca, causing tension between the two kings; however, putting aside their differences, they sailed for Acre in March 1191. Whilst Philip's fleet sailed directly for Acre, Richard's was blown off course by a storm, forcing him to alter course via Crete, Rhodes and then Cyprus. Presumably while taking fresh provisions on board, he learnt that the Greek ruler, Isaac Comnenus, had imprisoned some English crusaders, and he immediately captured the island.

Cyprus was vital to the English and other crusaders for fresh supplies on their journeys to and from the Holy Land, and for those

returning injured. Having secured the island Richard set sail again, with a slightly reduced army, and arrived to join the Siege of Acre on 8 June 1191. His fleet soon sank a Saracen supply vessel and, with the city's inhabitants starving and diseased, Saladin was forced into capitulation on 12 July 1191.

Having recovered the fortress Richard set about strengthening the fortifications, but the leaders in his army were anxious to retake the Holy City, a strategy that the Templars and Hospitallers rejected. Presumably because of the necessity of bringing the remainder of his force to Acre from Cyprus, Richard gave the island to the Hospitallers. He next learnt that Saracens in the surrounding hills were ambushing travellers, and, whilst hunting them down, saw Jerusalem in the distance, which he vowed to recover.

By September 1192 Richard was seriously ill, yet managed to agree a truce with Saladin. Due to the latter's considerable respect for the English king, they agreed that Jaffa would become Christian and Ascalon would remain with whoever held it. The peace terms included free passage of people and goods in the coastal region and Jerusalem, without payment of tolls. Although Richard agreed, he insisted on a three-year term only as he was anxious to return to England and raise another army in order to retake the Holy City. He quickly sailed away, but having departed from his troops in Corfu, he and his four comrades were captured and held as prisoners; the subsequent details, including his death in 1199, are well recorded in the chronicles.

The Fourth Crusade (1202–04) was very much a French and German affair, during which they pillaged and ruined the Christian city of Constantinople. Subsequently, the re-established Kingdom of Jerusalem, ruled by its Frankish king and barons, experienced civil war, but the coastal strip still remained part of the Frankish kingdom. There were no effectual leaders, and it was left to those who took part in the Fifth Crusade to rescue what they could from the constant advance of the Muslims.

In 1218, Ranulf de Blunderville (1172–1232), 6th Earl of Chester, left with a large contingent to support the Fifth Crusade. Gathering archers and bowmen from the Cheshire forests, Ranulf would have particularly included the archers from Macclesfield. In later centuries

their successors would prove crucial to the victories at Crécy, Poitiers and Agincourt. Ranulf had given his commitment by oath some three years earlier, having heard the Archbishop of Canterbury preach for support from the Chester High Cross.

By tradition, Ranulf created a Macclesfield guild in about 1220, and there is little doubt that he holds the key to the mystery as to why St Barnabas of Cyprus became the guild's patron saint. He was a strong administrator and much involved in the Barons' Wars with King John, who had succeeded to the throne in 1199, but did support him. As an elder statesman with great power as Earl of Chester, he granted land near Leek in Staffordshire on 22 April 1214 to the Cistercian abbey at Poulton on the River Dee, 5 miles south of Chester. This became Dieulacres Abbey, only 16 miles to the south of the small hamlet of Macclesfield, which had sprung up in the mydelfeld on the higher ground above the trading field.

The hamlet's main thoroughfare was given the name Chestergate, and evidently Ranulf owned a property on the small street, for he allowed the rent to the monks of Leek Abbey as part of the income for their chapel of St Mary. It suggests that he was familiar with the area, and would have been very much aware of the skills of the forest's bowmen.

In supporting John of Brienne, King of Jerusalem, Ranulf achieved considerable success in Egypt, especially the taking of Damietta, a great city on the banks of the River Nile. This made him a popular hero, and on returning home his adventures inspired many ballads. He left Egypt late in September 1220, disappointed at the failure of political negotiations with the pope in respect of Jerusalem. There is little doubt that the surviving contingent would have visited Cyprus on the return journey for stores and recuperation, especially allowing time for the injured to recover sufficiently in order to cope with the arduous travelling ahead.

On their return to England, as a gesture of goodwill to the Macclesfield men, Ranulf appears to have granted a charter, with the guild likely to have been established late in 1220 or early 1221. Being a Christian establishment, the guild would have had a saint and, as the patron saint of Cyprus, Barnabas seems to have been an obvious choice.

Left and below: Kolossi Castle, Cyprus, a crusader stronghold. Originally built in the thirteenth century and reconstructed in the fifteenth.

Payment for the charter would have allowed privileges in Chester. Members looked after their widows and orphans, and trained apprentices, usually for seven years, in the 'Art and Mystery' of their trade and in absolute secrecy; the knowledge gained to learn their skills was vital to the success of their particular trade, and they were proud of it.

The trade of the Macclesfield guild is unknown – no records remain. The logical answer, however, would be that relating to supplying the necessary equipment for the bowmen and archers of the forest, such as fletchers who made the arrows. Young apprentices would have been trained in making the arrows, longbows and other associated accoutrements until the position of journeyman was achieved. This demanded utmost loyalty and suggests that the guild would have been one for the foresters. Whether or not those in the wool and leather trades were included is contentious, but they were vital to the 'production line'.

Guild members and their grand master would walk in procession each year, carrying an effigy of their saint to Prestbury Church on the designated feast day, and celebrate from the previous evening with feasting and a fair.

Family Affairs

King John, after the turmoil with his barons, consented to Magna Carta in 1215, but died the following year and was succeeded by his son, Henry III, who perhaps did not learn from his father's mistakes.

During 1230, an interesting episode took place when the then earl, Ranulph III, and Henry visited Brittany, where Simon de Montfort, who was Ranulph's cousin, rightly claimed the earldom of Chester in lieu of his father and elder brother who had been killed in battle. Ranulph agreed the claim and Henry supported, so Simon became English by adoption, and agreed a pension of 400 marks per annum in lieu of rent for the Cheshire estates.

Meanwhile, Cheshire was developing, and many troops left the port of Chester for Ireland, or on occasion, Carlisle, when there was trouble with the Scots.

Ranulph died in 1232, and the king settled the earl's estates outside Cheshire amongst the co-heirs; however, he could not reinstate de

Montfort to the earldom without too much upset, so continued to pay Simon the pension of 400 marks each year.

Ranulph's nephew, John the Scot, 8th Earl of Huntingdon, assumed the earldom. Early in 1237 John fell ill, and, on 13 May, Henry III sent the Bishop of Coventry and Lichfield, together with Henry de Audley, to keep peace in the county. It was no secret that John was dying of poisoning (the culprit was alleged to be his wife). He died on 6 June 1237 without heirs, and Henry seized the county revenues, Chester Castle and the new castle at Beeston, but was legally unable to complete the land acquisitions.

Unsurprisingly, as an appeasement, Simon de Montfort secretly married the king's widowed sister on 7 January 1238. The king gave away the bride and Montfort became godfather to Prince Edward.

The stained-glass window depicting Queen Eleanor of Castile in the east-facing window of the Savage Chapel of St Michael's Church. It was adapted from the Burne-Jones image of St Catharine in Christ Church, Oxford, but with the addition of the Castile coat of arms.

In 1253, Henry had problems negotiating the marriage of his son Edward to Eleanor, the only daughter of Ferdinand III of Castile, having approached and been rejected by other Continental rulers with eligible daughters. The problem was finding enough revenue for the young prince to include in his marriage settlement. However, on 14 February 1254 Henry created his son Earl of Chester, and as a present gave him the whole county together with his own lands in North Wales.

Henry's problems had obviously been solved, for on 1 November 1254 Edward married Eleanor (by tradition, at the Cistercian convent of las Huegas, near Burgos in Castile), and she, as part of the settlement, held the revenues of the manor and forest of Macclesfield. At the time she appears to have been only fifteen years of age. She took part in the crusade of 1270–72, during which her daughter, Joanna, was born in Acre. She also saved Edward's life by sucking poison from his wound after an assassination attempt. This account was recorded by an Italian chronicler from a country through which they passed on their return to England; other accounts ignore Eleanor and credit male companions. From the subsequent devotion of Edward to Eleanor, the former version has more of a ring of truth to it.

In 1272, whilst in Acre, Henry died and Edward I succeeded. In subsequent years, the court continually moved around the English countryside. The controller of Eleanor's household, Richard de Bures, had at one time been bailiff of Macclesfield manor and forest. Despite the constant travelling, Eleanor kept in touch with her family and also corresponded with her forest bailiff, Thomas of Macclesfield. Thomas was a faithful and excellent administrator of the forest, and under him the Macclesfield foresters kept law and order, for it was a large area to control.

The township, created a borough in 1261 by Prince Edward when he was heir to the throne, was under the control of 120 aldermen and burgesses. This strong body of men, having consolidated their procedures, petitioned Queen Eleanor for a chapel. This she was able to grant, with permission from the pope, by providing a small plot of manor and forest land on the boundary of the borough in the market square. The foundation, on 1 November 1278, provided the name for the subsequently built chapel of All Saints (now the parish church of St Michael's).

Military Macclesfield

At this period there is a record of eight hereditary foresters holding lands in the forest, one of whom is recorded in 1288 as Roger Stanley. His lands were at Stanley in Disley, a possible indicator of the derivation of the family name; however, a further list of around the same period lists nine not eight foresters, and shows the first name of Stanley as 'Grim' – no doubt an appropriate soubriquet.

Unfortunately Eleanor died in November 1290, and after the death of Edward I in 1307, his son Edward II allowed his wife Isabella the title of Lady of the Manor and Forest of Macclesfield, as Eleanor before her. However, Edward had no time for campaigns, and after he had granted Gaveston his earldom of Cornwall, and all Isabella's jewels given as a wedding present by her father, Gaveston seized the opportunity to completely dominate royal affairs. (The dukedom of Cornwall was created by Edward III and became subsumed into the inheritance of several subsequent Princes of Wales.) Isabella, having become besotted with her paramour Mortimer, soon had little time for administrative matters, allowing many misdemeanours to take place as the forest became badly neglected.

This much-mutilated stone figure, now set in the south wall of the Savage Chapel of St Michael's, seems to represent a bowyer – an artisan skilled in making bows. His costume is of the days of Edward I, comprising a long super tunic with a hood, which terminates in a liripipe – a long tail that hung down the back or was wound around the head.

It was vital to keep control, not only because of the game, wood and other necessities it could provide, but because the archers were becoming some of the finest and best practised in England. Macclesfield had gained such independence during the twenty-year reign of Edward II that, immediately following his murder in 1327, steps were taken to bring it once more under the jurisdiction of Chester.

Wars in France

In 1337, the Hundred Years' War with France began. The previous year Philip VI, the French king and successor to his father, intent on helping the Scots against his cousin Edward III, son of Edward II, gathered a huge fleet in his Channel ports. As a consequence, Edward was voted a large war tax by a worried Parliament in order to combat the threat.

Philip suddenly claimed Gascony for the French Crown, but legally it belonged to Edward through his mother Isabella of France. Edward was determined to regain his possessions as he had a legitimate claim to the French throne, but after diplomatic relations broke down and ports in south-east England were harassed by French naval shipping, he took action.

Edward finally laid official claim to the kingdom of France in 1340, and included the fleurs-de-lys on his insignia. What followed was the great sea Battle of Sluys, just off the Flemish coast, the details of which were assiduously recorded by two chroniclers from Hainhault in Flanders, which was ruled by Edward III's brother-in-law, Count William II.

Early on the morning of Saturday 24 July 1340, Philip's fleet, comprised of both French and Spanish ships, divided into three flotillas. Edward waited until the afternoon, when the sun was at his rear and the wind blew in his favour, then he manoeuvred his fleet into three units, with the most powerful in the van. Having filled his vessels with archers on all sides, they were arranged so that 'between every two shiploads of archers there was one of men at arms'. Additionally, he had a 'flanking squadron made up entirely of archers', which, being detached from the rest, could give support to those subjected to the most intensive attack. There is little doubt

that amongst these archers were bowmen from Macclesfield Forest, and, as the attack began, there was a hail of bolts from crossbows and arrows from longbows, which killed hundreds of enemy soldiers.

The longbow was an extremely effective weapon, and one known to the Anglo-Saxon invaders of England. Typically made usually from yew tree wood, at 6 feet in length and 6 inches in circumference it was drawn back to the ear, allowing it the potential to reach a distance of some 150 to 200 yards with steel-tipped barbed arrows. However, in a forest environment the short bow, drawn to the chest, and the crossbow would initially have been the most convenient and efficient weapons for hunting purposes.

It was Edward I who had recognised the battle potential of the longbow, said to have been the result of his campaigns in Wales, and initially he predominantly recruited archers from South Wales for his army. The longbow was presumably introduced to the archers of Macclesfield Forest about this time, hence the order to undertake

Caerphilly Castle, South Wales, the second largest castle in Britain after Windsor, built by Gilbert de Clare in the thirteenth century to protect South Wales from Welsh domination. From this area of Glamorgan Edward I recruited his longbowmen who fought alongside their Macclesfield counterparts.

daily practice in the forest clearings, although it could have arrived earlier with the Anglo-Saxons. With constant practice an experienced archer could fire ten shots per minute with his longbow, and by 1346 the archers of Macclesfield were proving their superiority by earning 6 pence each day in contrast to the 3 pence paid to the Welsh archers.

With the Battle of Sluys won by Edward III, an exhausted army returned to England and a year-long truce with Philip was negotiated. Edward's concern was trade and, having secured a continuation of Derbyshire wool exports to the Continent via Flanders, he declared that 'no person whether native or foreigner shall purchase wool at a lower price than 9 and a half marks per sack, that being the price established in the county of Derby'. He was also instrumental in having the Woolsack filled with Derbyshire wool and placed in the Great Chamber, where the Lord Chancellor and judges sat upon it. Today it is the seat of the Lord Chancellor in what is now the House of Lords. This was Edward III's way of indicating that both wool and the woollen industry were 'the sovereign treasure of the Kingdom'.

Despite what was an important victory for Edward, he returned heavily in debt, having spent far more on his war efforts than the considerable sum voted by Parliament. By 1340 the flow of coinage had almost ceased, so in order to satisfy the enormous taxation demands 'the government resorted to a tax in kind' – corn and wool were collected and 'sold off for cash'. With an almost empty treasury, Edward was forced to borrow from Italian merchant houses, which operated an effective banking system.

Until this time various methods of recruitment for the army had been tried by previous English monarchs, based on an obligatory system judged by the value of land owned, and also by oath when knighted on the battlefield. As a permanent solution, all had failed. Unless there was a good chance of a share of booty, invariably desertions would take place or men would accept money as mercenaries to whoever was willing to pay the highest rate. Edward III began to realise that threats of land forfeiture were causing serious resistance and the only satisfactory solution was to pay all ranks, not only his personal bodyguards and small permanent standing army of knights.

Scottish Interlude

After Sluys there was renewed fighting with the Scots. Problems with Scotland had been festering since Roman times, but during King John's reign (1199–1216), despite a claim that Northumberland, Westmorland and Cumberland were really part of Scotland, subsequent relations between the two countries were quite amicable, even during the thirteenth century. All might have been well had a double tragedy not occurred in 1290.

King Alexander III of Scotland (1249–86) had two sons and a daughter, all of whom predeceased him, leaving his young Norwegian granddaughter, Margaret, as his heiress. Edward I had hoped for a betrothal between her and his son Edward, but on the night of 19 March 1286 the horse of the Scottish king plunged over a cliff in Fife, and both were killed. Four years later, following Edward's success with her guardians in concluding a marriage agreement, Margaret, aged only seven, died whilst sailing to Scotland, which triggered a Scottish succession problem.

The death of Edward I's beloved wife, Eleanor of Castile, also in 1290, caused him such grief that he appears to have become obsessed with action in an effort to nullify his losses. Acting within the law he claimed suzerainty over Scotland and declared John Baliol's right to the Scottish throne. It was a good choice as the best claim, but the supporters of the other greatest competing candidate out of the thirteen hopefuls, Robert the Bruce, Lord of Arrandale, were outraged. He was descended from one of the original knights who had crossed the Channel with William the Conqueror, before the family settled in the Lowlands of Scotland.

Edward won his case, but after Baliol's acceptance he treated him as another English magnate, declaring that he had to attend Parliament and serve in the English army – it was a recipe for Scottish rebellion. During the remaining years of his life, despite a further marriage and two more children, Edward's obsession with Scottish subjugation continued apace. He sent twelve more armies north of the border, deposed Baliol, captured Berwick-on-Tweed, was instrumental in the brutal death of the popular leader William Wallace at Smithfield, and seized the ancient Scottish coronation seat of Scone, depositing it in

Westminster Abbey. Although to date no positive evidence is known of Macclesfield knights or archers taking part in the Scottish campaigns, it is feasible to assume that some of them must have done so.

A defiant Robert the Bruce was crowned King of Scotland at Scone in 1306, and after raids into England he effected a humiliating defeat on Edward II at Bannockburn in 1314. He finally succeeded in obtaining recognition of Scotland as an independent realm and himself as king in 1328, the year after Edward II's death.

Bruce, however, died on 7 June 1329, creating years of internal rivalries until James Stewart (1394–1437), a descendent of his daughter, secured the Scottish throne as James I in 1424 – the first of the House of Stuart.

After Sluys, whilst the English strengthened their alliance with Flanders, the French supported Scotland, a situation that would plague Edward III's reign. It began in 1342 when fighting was renewed with Scotland, but he was a much tougher opponent than his father and managed to quell resistance with an English victory.

The Battle of Crécy

In the year 1343 the pope sent two cardinals to broker a truce between Edward III and Philip VI, who would not agree on their choice of candidate for the dukedom of Brittany. A truce was agreed for three years, but due to French encroachments in Aquitaine and local fighting in Brittany, Edward chose to act and broke the truce in 1345.

Edward's cousin, the Earl of Derby, on duty in France, had initially been successful in counteracting French aggressions, but a powerful French army under the Duke of Normandy laid siege to the castle of Aiguillon. By midsummer 1346, Edward, who had planned a relief expedition only to Gascony, suddenly became aware of the accelerating situation and Derby's need for reinforcements.

Leaving sufficient forces in England, the king sailed from Southampton on 5 July with 400 men-at-arms and 10,000 archers. Amongst the archers was Piers, known by his English name Peter, son of Robert Legh (1308–70), a riding forester of Macclesfield Forest and bailiff of the hundred. Peter was evidently part of a Macclesfield contingent.

At first no one was aware of their destination, but having decided on Normandy on the advice of Sir Godfrey of Harcourt, Edward set course for the port of Le Havre and arrived 13 July. As soon as they were on shore he knighted his eldest son, Edward of Woodstock, and made him Prince of Wales. Known as the Black Prince by the Victorians because of the colour of his armour, the boy was only sixteen years of age, but his father made a wise decision in choosing Sir John Chandos as the boy's mentor and 'guardian'.

Sir John was descended from Richard de Chandos, a comrade of William the Conqueror. The family originally settled in Herefordshire, bearing their coat of arms. The junior branch subsequently moved into Derbyshire, between Ashbourne and Derby, and were also entitled to adopt the Chandos arms together with the privileges and commitments that this entailed. The coat of arms appears in a stained-glass window in the village church of Mugginton.

The year of Sir John's birth is uncertain, but, as a young man by the late 1330s, he was fighting in France and Flanders on behalf of Edward III. In 1337, he took part in the Siege of Cambrai close by Valenciennes (near the French and Belgian border) in which he excelled. He was considered 'courteous, skilled and true', and an important negotiator with the enemy – qualities that recommended him to Edward III as an ideal advisor for his son and heir.

After the unloading of horses and equipment in the harbour of Le Havre, a conference was held on how to proceed. The decision was for the Earl of Huntingdon, together with 100 men-at-arms and 400 archers, to remain with the fleet and travel at sea in unison with the remainder of the army as they marched along the coast towards Paris. The marching troops were formed into three columns, with the archers and foot soldiers nearest the sea and within sight of the fleet. On arrival at Barfleur the town surrendered. The townsmen were rounded up and confined aboard the ships, so there was no danger of reprisals to the army's rear. The women and children were unharmed, but as much as possible was seized in the way of provisions and valuable portable items.

Their march continued until they reached Cherbourg, a port and wealthy town, but too well fortified to waste time in attacking, so they skirted round it. Several other towns were sacked, and where

there was resistance houses were burnt to the ground. Having reached the city of Caen, where the river flowed slowly through at a depth to support large ships for a distance into its estuary, Edward wisely chose to load all the valuables and livestock they had seized into boats and barges and sent them on board the fleet for transportation to England, together with important prisoners taken en route. The latter could be ransomed at a later date. Several incidents took place – some good, some bad – but they finally arrived at the River Somme.

By this time Philip VI began to realise the danger and left Paris in a hurry, sending messages to knights and rulers of several Continental countries requesting urgent assistance.

Meanwhile, Henry and his army had managed to cross the Somme after finding the remains of a bridge that could be repaired, and set up camp further along the riverbank.

Suddenly Philip appeared accompanied by the kings of Bohemia and Majorca, and was encouraged by Edward to cross to their side. However, knowing that further troops were on their way to join him, Philip refused, despite the fact that he had gathered a considerable force of local men and had been joined by the Genoese. Philip returned to Abbeville to await further reinforcements and spent the evening in the company of his knights. In order to prevent the English returning across the river, he left Sir Godemar and a large force to protect the crossing.

Next morning, when the tide was at its lowest, Sir Godemar began an attack by using the Genoese with their crossbows, causing several casualties. The English chargers were quickly mounted and ridden into the low water, creating much jousting with the French. Froissart, who was present, later wrote that the 'Genoese also did much damage with their crossbows, but the English archers shot so well together that it was an amazing sight to see'. The mounted men managed to break through the French lines and the remainder of the troops followed and spread out through the fields, causing the French to take flight. They were pursued for three miles to ensure the danger was passed for the present.

As soon as Philip received the news he was furious, as it was his intention to attack the English by the river. He hurried to view the scene, but was unable to cross as it was full tide. Having no alternative he returned to Abbeville to prepare for battle.

Military Macclesfield

Edward and his forces spent the night in the open countryside, and the next day they moved towards Crécy. Appreciating that his force was calculated to be only about one-eighth of that Philip had mustered, Edward sent three of his commanders to reconnoitre the area in order for him to judge the best position for his troops.

The same day, Friday 25 August, Philip was also preparing his strategy, having been joined by several more Continental armies. Both contenders rose early next morning to attend Mass, knowing that the day of battle had arrived.

* * *

With the strategy well prepared, Edward's constable and marshals were ordered to divide the army into three, but first he had created a large area into a park close to a wood. There was only one entrance, and into the enclosure all the wagons, carts and horses were placed. All men-at-arms and archers were to be on foot, and were marched to their positions on the preconceived plan.

Circumstantial evidence suggests that the Macclesfield archers were part of the young prince's force, for many of his supporting knights had north of England connections, such as Sir Richard Stafford, 'Lord of Man', Sir Thomas Holland, Sir Bartholomew Burghersh and Lord Delaware. Sir John Chandos was, of course, amongst the number together with about 800 men-at-arms, 2,000 archers, 1,000 light infantry, including the Welsh. Each knight marched beneath his pennon or banner, or amongst his men.

The second group consisted of fewer knights supported by 500 men-at-arms and 1,200 archers; whilst the third section, led by Edward III, had several knights, 700 men-at-arms and 3,000 archers.

As soon as his men were in place Edward mounted a small riding horse and rode slowly round the ranks, white baton in hand, encouraging everyone with heartening speeches. Each knight knew exactly what was expected of him, and at midday Edward finished his inspection and returned to his division. The men were told to eat, drink and relax, and with the cooking pots, kegs and provisions repacked in the carts and wagons, they sat down with their helmets and bows in front of them.

The Middle Ages

After attending Mass, Philip sent his four most trusted and experienced knights to view the English army. On their approach to the English position orders were given to leave them at liberty to view the situation and allow them to return to Philip with their advice. On their return, Philip, anxious for their observations, turned to Le Moine de Brazeilles, the most trusted and loyal knight of the King of Bohemia, and asked for their combined recommendations. Le Moine reported that the English army were in three divisions, showing no sign of retreat, and obviously waiting for Philip's action; they appeared fresh and ready for battle. Philip was advised to hold off the attack till the next day when the French army would be rested, and sufficient time given for those in the rear to arrive, otherwise it would be late in the day without a strategy in place.

Philip accepted the advice, but fate decided otherwise. As those in the van of the French attack were told to stand down, those in the rear were advancing quickly to catch up. This created confusion, for those in the front line were eager for glory, and as Froissart wrote, 'Neither the King nor his Marshals could restrain them any longer, for there were too many great lords among them, all determined to show their power.' The outcome was a completely disorganised French army, far too large for its own effectiveness; the roads for retreat were blocked and those in the rear could only surmise what was happening along the front line.

Edward's army rose to its feet at the enemy approach, all perfectly disciplined. The archers formed up in two wedge-shaped positions, one at either end of the formation of foot soldiers, with the second division in support if needed. Edward held his troops in reserve, and amazingly would not find it necessary to engage in the action.

As soon as Philip sighted his foe he ordered the Genoese to advance whooping and calling to entice his enemy into battle, but young Prince Edward, no doubt under the watchful eye of Sir John Chandos, held back.

Twice the Genoese moved forward, yet still there was no English response. At the third advance the Genoese crossbows were levelled and shooting began.

Medieval warfare – England v France. It gave opportunities to local families, such as the Leghs, to win their spurs (a phrase coined by Edward III when speaking of the Black Prince at Crécy, 1346).

The prince's men heard their command, took one pace forward, and let go a barrage of arrows that were so thick and even it shocked the Genoese. They had never encountered this before and were utterly confused. Philip, in his fury, told his knights to cut down the Genoese archers as they were in his way. On hearing the command the blind King John of Bohemia, known as John of Luxembourg, asked

what was happening. Learning of the Genoese rout, and already in battledress, he insisted on being guided forward far enough to strike a blow with his sword. In the event he was captured and became Edward's most valuable prisoner.

The battle continued all day, during which many fell increasing Philip's distress and he turned to Sir John of Hainault, who had been persuaded by Philip to support the French. Sir John's advice was to retreat, but Philip soon observed the bowmen of the Count of Alencon and the Count of Flanders orchestrating a successful attack on the archers of the Prince of Wales. Keen to join them, Philip tried to force his way through a throng of arches and men-at-arms, but the more he advanced the more men he lost.

At one point the second division was sent in to support Prince Edward, and as the fighting continued Sir John Chandos and Sir Reginald Cobden sent a knight to King Edward to ask for help. Edward asked if his son was still alive, wounded or stunned; the knight replied, 'No, thank God!', but insisted that the young prince needed help. Edward replied that he must return and tell the prince not to send for him again that day, 'but let the boy win his spurs'. The commanders, on hearing the reply, regretted sending the message for help and fought harder than ever.

Philip left that night and was advised to ride as far as possible. Reaching Amiens next morning he could go no further and lodged in the abbey, anxiously awaiting news of his army. Edward, satisfied with his great victory, ordered no celebrations. Next morning, after ensuring no regrouping of the French army had taken place, he ordered a report of the dead on the battlefield, amongst whom were eleven princes who had supported Philip. A three-day truce was granted for burial of the dead, and he ensured that all the knights were buried in consecrated ground.

The Siege of Calais

The following Monday Edward's army marched towards Boulogne, causing havoc en route, until they reached the large town of Wissant where the whole army obtained quarters and stayed for the day. By Thursday they arrived at the well-fortified town of Calais;

there, Edward prepared for a long siege throughout the winter and following summer.

A new town was built, markets were held every Wednesday and Saturday, English goods arrived daily by sea, and food was provided from Flanders. There were haberdashers' and butchers' shops, with stalls set up for selling cloth and bread; supplementary food supplies were obtained from the large surrounding countryside.

As soon as the commander of Calais realised Edward's intention he ordered the poorer people without a store of supplies to evacuate the town at once. On a Wednesday morning 1,700 men, women and children set out to try to pass through the English settlement. Learning of the reason for their exodus, Edward ordered a hearty meal to be provided for all of them, along with a gift of 2 pence each and permission to pass unharmed.

On 29 October Edward's beloved wife Philippa arrived with a very large contingent of her ladies. During the king's absence David II, son of Robert the Bruce of Scotland, had invaded England, but Philippa rallied her troops and accompanied them to the battlefield where a victory was achieved at Neville's Cross. On returning to London she had the prisoners confined to the Tower then hurried to make arrangements for her journey to France. Great celebrations took place on her reunion with Edward, which was followed by a disconcerting event.

The burghers of Flanders had remained loyal to the English; only Count John had defected to the French, but, having been killed in the battle, his young son and heir was preparing to marry a Frenchman's daughter. His burghers disapproved, and when Edward offered a marriage with his daughter Isabella, they readily agreed. The boy refused, but after some time in the custody of his burghers, he longed for freedom to go hawking and sporting so agreed to their demand. He accepted jewels and gifts from Edward and Philippa, and arrangements were made for the wedding. Allowed to hunt once more, and seeming perfectly happy with the arrangements, his guards were reduced in number, and with only two accompanying him they set out to go hawking.

As they arrived in open country the young count's two hawks flew off after their prey. On the pretext of encouraging their flight, he

The Middle Ages

charged after them whooping and hallooing, but before his guards could catch up, spurring on his horse he eventually reached Paris, much to the delight of Philip and the fury of Edward. To the French he was a hero, to the English a traitor. Edward, however, accepted that the plan had not been conceived by the burghers of Flanders, and accepted their sincere apologies.

During the summer of 1347, when the siege was reaching a conclusion, Philip organised an army to relieve Calais. However, as his way was blocked by the Flemish from the east, Edward realised that the French had only two alternative difficult routes.

To prevent use of the sand dunes along the edge of the sea, the English ships were brought close to the shore and were loaded with men bearing both crossbows and longbows, bombards, catapults and similar weaponry.

The second approach to the south of Calais was an area of swamps and dikes, only passable by a road leading to just one bridge at Nieulay. The Earl of Derby was chosen to defend the bridge with a large contingent of men-at-arms and archers. Although the local men of Tournay managed to capture a nearby tower defended by only thirty-two English archers who, despite a fierce fight, were all killed and the tower destroyed, Philip appreciated his remaining difficulties.

The decision was for four envoys to make an approach to Edward via the Earl of Derby. They were given safe conduct to see the English king, and presented Philip's proposal. The latter's request was for a joint council in order to select an area where the battle could take place. Edward's reply was firm and polite, pointing out that he had been there a year and lost many men in skirmishes and otherwise, and was there to reclaim what was lawfully his. 'Kindly tell him from me that I have every right to be where I am ... [and] that if he and his men cannot get through, they must carry on looking until they find another.'

The pope decided to intervene in the hope of settling matters, but neither king would relinquish his claim. Finally Philip withdrew his army, much to the dismay of the inhabitants of Calais, who had no choice but to throw themselves on Edward's mercy. Half-starved and fearing death, they conveyed their request to the captain of Calais, Sir John de Vienne, who appeared at the city gates under a flag

of truce. Two English envoys were sent and returned with the appeal for clemency, adding their own appeal after viewing the appalling condition of the French citizens.

Edward's barons added their pleas, and seeing all his nobles united against him, he reconsidered his answer. He sent Sir Walter Manny with the message that he expected the six most predominant citizens to come out, heads and feet bare, halters around their necks and bearing all the keys to the city and castle. He would then decide what fate they would suffer.

On receiving Edward's demand, Sir John de Vienne asked Sir Walter to wait before the inner gate whilst he informed the people of Edward's decision. The inhabitants, so weak they could hardly stand, were reduced to tears, but the wealthiest and most prominent of them stepped forward, despite pleas from his family, and offered himself as a sacrifice. This encouraged five more to join him – all the most prominent burghers. They stripped off their shirts, trousers and shoes, placed halters around their necks and were led out by Sir John, who returned after their departure.

Hearing of their approach, with a heavily pregnant Philippa at his side and surrounded by his nobles, Edward awaited their appearance. The English knights were full of pity as they saw the prisoners kneel before Edward and plead for their lives, but, full of anger, he remained undeterred and ordered them beheaded. Desperate pleadings were made by those close by; again Edward refused, saying so many of his gallant men had died. Finally Philippa threw herself at his feet in tears, and the king, anxious for her well-being, could resist no longer. Rising to her feet she thanked him profusely, had the halters removed and the men brought into her tent. There they received a good meal, new clothes and were given permission to settle elsewhere. Each was given an escort of six nobles to see them safely through the English lines, and after reuniting with their families settled in different towns in Picardy.

The remainder of the population was given permission to leave, for Edward was intent on repopulating the port with Englishmen. So important was it for English trade that on his return to London he chose thirty-six wealthy and highly responsible citizens, together

with a further 300, to begin the process. They were all given special privileges and liberties, encouraging others to follow.

The Prince of Wales

Those returning from campaigning in France would have received some small share of the value of their lootings as reward for their sacrifices, encouraging the Macclesfield contingent to become a rebellious group, known for their 'insolence and arrogance'. After Crécy a favourite tale was told by French mothers to their children, that if they did not behave, the Cheshire archers would 'come and get them'.

Peter Legh, the son of Robert de Legh of Adlington Hall, home of the Leghs since 1315 (whose family claimed descent from Gilbert de Venables, a companion of William the Conqueror from Normandy and knighted by him in 1086), was known to have taken part.

The outstanding performance of the Macclesfield archers had evidently been noticed. Their important position was indicated by the action of the Prince of Wales on his return to England. His grandmother Isabella was encouraged to exchange Macclesfield manor and forest for two of his manors in Wiltshire and Dorset, and Isabella's letter of agreement was finally recorded in the prince's register on 21 May 1351.

At almost twenty-one years of age it could have been Edward's decision, but he was probably urged by someone to do so – either his father or Sir John Chandos. Sir John, nearest to the prince during the Battle of Crécy, was in a position more than anyone to appreciate how well-trained the Macclesfield archers were, and it was imperative for them to be ready for duty when necessary. This meant that the manor and forest were once more integrated into the jurisdiction of the Earl of Chester, who was, of course, Edward himself. And Sir Thomas de Ferrers, Edward's justiciar of Chester, together with his chamberlain and clerk, settled the account of outstanding debts due to Isabella.

During the next few months it became apparent that the problems, which had accumulated in Macclesfield and its forest due to Isabella's lack of controls, needed the personal attention of the prince. As a consequence, in August 1353 he was finally able to organise his first

visit to Chester, where he held court and personally heard several complaints of injustice that had taken place in the Macclesfield manor and forest. In early October he came to the manor before returning to London by the middle of the month, perhaps to review the recovery after the visitation of the pestilence.

Following the return from France the horrendous plague, the Black Death, had arrived. It has been reckoned that half the population in the Macclesfield area died, as in many other areas. The death toll was obviously much greater than that recorded because other family members are likely to have died about the same time and before the next tenant could be enrolled in the court rolls. From a practical point of view, this left a considerable number of forest properties vacant and the revenue greatly depleted, although the heriots would have resulted in some compensation.

The plague had begun in the Macclesfield manor and forest during 1348, and was at its worst late in 1349. In only six months, sixty-six heriots were collected, and for the whole year eighty-eight. A heriot was due to the landlord on the death of a tenant, and was usually taken as the best live beast or dead chattel. It had arisen from the custom of a knight providing a horse and armour for each of his tenants called to arms. If the tenant died or was killed, the horse, or its replacement, and the armour were returned to the knight – a custom that had conveniently been adapted and continued.

Fortunately, the plague subsided after two years, and by 1355 only six of Prince Edward's tenancies remained unoccupied out of 134 to 139. Someone who had already become one of the tenants around 1351 was William Jodrell.

The first mention of a Jodrell is Benedict Jodrell of Shallcross Hall in Derbyshire, just to the east of Castleton, near Hope. He was a forest bailiff involved in a court case recorded in the reign of Edward II (1307–27). His position meant he was of some standing amongst the community of his area. William Jodrell was descended from the Derbyshire family and was most likely a younger son of Benedict, or certainly a close relative. He was called to serve as an archer in the army of Edward III, by which time he had taken a holding at Yeardsley in Taxal, situated in Macclesfield Forest close to the Derbyshire border. He was duly enrolled as a tenant of

Yeardsley, having been given permission in the name of Prince Edward of Woodstock as landlord of the forest. It would be important to have men of good character with archery and forest management skills settled in the forest. They were also liable for military service, and it was not long before once again the call came. (This was around the time that Richard Stanley, a descendant of 'Grim', held the forestership, which he included as part of his daughter's dower when she married Roger Simondessone of Mottram-in-Longdendale in 1357.)

* * *

Philip VI of France had died in 1350 and was succeeded by John II, which initially created a lull in the war with England, but soon caused internal problems for the French king.

Peace talks between the two countries failed in 1355, and the prince, then twenty-five years old, was determined to return to France

Effigy of Prince Edward, known as the Black Prince by the Victorians.

with his father for a series of campaigns. On 21 May, having been in possession of Macclesfield Forest for exactly four years, he sent an order to Chester for 200 of the best and most skilful archers from all the county hundreds to be 'tested', from which the best 100 had to be chosen. The Wirral forest provided very few, which suggests that the majority were from the Macclesfield area.

On 24 June young Edward sent an amplification of his previous orders, i.e. 300 archers were to be sent to Plymouth by three weeks from midsummer, and an additional 100 archers from Flynt in Wales. Three weeks' wages were to be paid in advance – stated as 6 pence a day for the Cheshire archers and 3 pence a day for those from Flynt. White and green cloth had to be delivered to them for their coats and hats as previously supplied. Whilst four of the designated leaders were to have charge of one moiety each for different areas, there were to be two leaders for the two moieties of Macclesfield, namely Sir John de Hide and Robert II, son of Robert de Legh, who received 66 shillings and 8 pence 'war fees' for a year's service.

Without Edward's 'special permission', no one could go to war with any other company under pain of forfeiture of land and goods, etc.

The prince also sent strict instructions to Robert de Legh Snr, forester and lieutenant's steward, to keep Macclesfield Forest well-guarded and ordered the foresters to be diligent or they would be punished, for he would 'hate his game to be destroyed or ruined in any way during his absence beyond the seas'.

The archers from Cheshire and other counties were duly assembled in Plymouth by the appointed day, and there is no doubt that William Jodrell from Macclesfield Forest, and possibly Benedict from Derbyshire, were amongst them. From their point of view, it was vital that the Continental markets should be accessible for the wool trade. From later evidence the family were concerned with sheep breeding.

Evidently, despite the prince's edict, some of the Cheshire archers had 'gone off in companies of other persons in defiance of the general proclamation', choosing instead to join those who offered more money and a larger share of the spoils as mercenaries.

The prince sailed to Bordeaux in the autumn and set out across France with a large contingent of Gascon and English soldiers.

The Middle Ages

After several sorties, he returned to Bordeaux in December to plan an incursion north after the winter. It was at this time that he gave permission for a certain few to return to England for extra arms and other requirements. One of them was William Jodrell. After the problems of recruitment it was essential for each of them to carry a royal warrant, which gave permission for a certain purpose; otherwise they could have been detained as deserters and punished accordingly.

The one issued to William Jodrell was written in Norman French, which when translated reads as follows:

> Be it known to all that We the Prince of Wales have given permission to William Jodrell, one of our archers, on the day of the date of these present, pass to England. In witness whereof of this present writing we have caused our seal to be put. Dated at Bordeaux the 16th day of December, in the year of grace 1355.

This royal warrant is still held by the family descendents, although a photocopy of it has been deposited in the John Rylands Library, Manchester, together with other documents relating to their Cheshire estates.

Amongst the knights at Bordeaux were Sir John Chandos and Sir Bartholomew Burghersh the Younger. The latter had remained an important military associate of the prince, and justiciar of Cheshire from 1353; the former had become steward of Macclesfield manor at the same time and installed Robert de Legh as his deputy. Sir John was also a founder member of the Order of the Garter, instituted by Edward in 1348–49.

There is little doubt that they had recommended William Jodrell for his mission as one who could be trusted to obey a command; both would know him from their connections with Macclesfield. With his mission completed Jodrell joined the 2,000 men at arms and 6,000 archers, both regulars and irregulars, to march north for Normandy.

By 29 February 1356, short of bows, arrows and bowstrings in parts of Gascony, Prince Edward sent Robert Pipot to England to buy 1,000 bows, 2,000 sheaves of arrows and 400 gross of bowstrings, but

no arrows could be found in England because his father, Edward III, had taken all that were available for his own use. Robert Pipot was then redirected to visit the fletchers in parts of Cheshire to collect all the arrows they had on hand, and to tell the fletchers to 'continue working at their craft for the prince until his need is satisfied'. He also instructed John de Brunham, his clerk and chamberlain of Chester, to pay the fletchers from time to time 'such sums as he thinks will serve to encourage them in their work'.

On 15 March 1356, Edward III ordered a further 300 archers to be sent to join his son, with 200 from Cheshire. Again the rendezvous was Plymouth, where they would be clothed and receive eight days' wages until their departure.

The prince's council in England sent a further instruction on the 27th for John de Brunham to pay all the money due to the fletchers for their labour, and all the bows, arrows and bowstrings, and submit an account of the numbers bought and prices paid. An interesting instruction followed granting payment to be made to 'Little John of Berkhamstead' for travelling to Cheshire to collect the bows, arrows and bowstrings, before taking them by land to Plymouth, for which he would receive 6 pence a day. This was followed by a message from the king to 'hasten' to Lincolnshire to collect a further batch of arrows, but on the way to find as many arrows as he could between Cheshire and Lincolnshire.

Meanwhile, in France, Prince Edward was on his way to meet up with his brother, the Duke of Lancaster, yet for some reason suddenly he changed his plans.

Poitiers

Earlier the Duke of Lancaster had been assigned a mission in Normandy, but was delayed. On receiving news of the prince's change of mind, he marched to join him.

King John II of France and his troops, having been involved in quelling an uprising in support of his cousin Charles of Navarre, was unaware of the prince's movements. When informants arrived he made haste to cut off the prince's forces.

By this time the English, although supplemented by Gascon troops, were reduced in number to about 7,500, having been involved in

skirmishes en route. As they marched along the road to Poitiers, a town situated 140 miles to the north-east of Bordeaux in south-western France, news arrived that the French were ahead. Four knights, one of whom was Sir Bartholomew, were sent to reconnoitre the French position, but the facts were not good.

As later stated by the chronicler Froissart, the French were reported to have three divisions of 16,000 each. Even if his figures were a misjudgement, there were at least 35,000 men ready for action, which meant the French forces were numerically superior by four or five to one.

With incredible tactics, and against all the odds, Prince Edward won and John was captured and held for a considerable ransom. Again it was the archers who had played such a significant role. They had dug themselves in and were well-hidden behind thickets and hedges along each side of the road. The French army, led by their most gallant French and German knights, were forced to use the road, otherwise they would be unable to charge towards the enemy. Unaware of the hidden opponents until it was too late, they were well down the road when the English archers let fly a volley of long, barbed arrows. These were lethal, piercing armour and bringing down horses.

On hearing what had happened, men in the French ranks began to desert. The prince's men-at-arms surged forward, mounted their horses and dashed into action. Sir John Chandos, always at the prince's side, told him to ride forward and win the day. A tremendous struggle ensued, and although John fought bravely, it was all in vain. At the end of the day many of the English archers had taken four to six prisoners each.

One of the casualties that day was Robert Legh of Adlington, who did survive. The Cheshire contingent of archers fought gallantly in the battle for Poitiers, and Froissart wrote:

> If the truth must be told, the English archers were a huge asset to their side and a terror to the French; their shooting was so heavy and accurate that the French did not know where to turn to avoid their arrows. So the English kept advancing and slowly gaining ground.

This was a great victory for the prince, and three years later Robert was described as one of the prince's esquires and leader of the

Macclesfield hundred archers. They returned to England with their prisoner, John II of France, and carts crammed with booty. Prince Edward was always generous to those who were loyal and served him well, so the most deserving archers were rewarded. First to receive a grant, however, was an important member of the prince's staff.

On 1 February 1357 the prince granted Richard Doxeye, his baker, 10 marks a year for life for good service in England and Gascony, payable out of the profits from the prince's (corn) mills and oven in 'Mackelesfeld in two equal parts at Easter and Michaelmas, until the prince could procure land and rent for him 'elsewhere to the same value'.

A later rent roll suggests that on returning home William Jodrell invested his hard-earned gains in enlarging his holdings in the Yeardsley and Whaley area of Taxal. The prince granted William two oaks in the forest with which to repair his houses, by order of 12 May 1357, requesting the master forester to deliver them to him. From this time the Cheshire Jodrells became, in effect, professional soldiers. When not on duty they would have attended to their wool trade and property.

On the same day William de Chorlegh was made bailiff of the 'parkwike' (parkland) of Macclesfield, granted by the prince 'as a reward for his great labours in Gascony, provided he give good service...'

On 4 July, when Richard Stanley's daughter married Roger Simondsone of Mottram in Macclesfield Forest, Richard asked that the marriage be by licence, suggesting a more influential affair, which had to be paid for. The reason was that Roger Simondsone had given good service at Poitiers, and evidently it was Richard's way of rewarding him.

Another beneficiary of the prince's largesse was a Macclesfield character called Adam Mottram, who had been appointed revenue collector in the autumn of 1347. He was also hereditary gaoler and had become very adept at collecting heriots. His overzealous behaviour began to cause many problems, and on Prince Edward's visit to Macclesfield in 1353, he had generously put right Mottram's misdemeanours. After taking part in the Poitiers campaign, and evidently fighting well, Mottram received the prince's pardon. He eventually died a wealthy man.

The Middle Ages

Sutton Hall, in the parish of Sutton south of Macclesfield, site of the former hunting lodge of Prince Edward and administrative centre of the manor and forest. From here Edward issued orders on his occasional visits.

Others who were begging pardons from the prince comprised a group who considered that they had all served well at 'Poyters'. The characters were Robert Legh, John Cotton, William del Downes and John de Northlege, who were all involved in an affray between Legh and Adam de Mottram 'in the town of Mackelesfeld'. The prince, in consideration of their good service in Gascony, especially on the day of the Battle of Poitiers, pardoned them by charter on 13 July 1357.

Recorded on 16 January 1358, Nicholas de Downes was granted a royal pardon because of his Gascon services, but the intention was not to pardon him from any trespass he had made in Macclesfield Forest since the campaign, only the previous ones of having taken 'vert and venison'.

Even as late as 1 May 1358, the prince ordered that Hamon de Baggelegh was to have two oaks from the Forest of Lyme, within Macclesfield Forest, for repairs towards the ruinous state of Baggelegh's houses 'in reward for his labours and expenses in the prince's company in the parts of Gascony'.

Four days later another order exempted Richard de Swetenham for life from taking part in jury service at the assizes, as acknowledgement of his good service in Gascony.

Swetenham had been summoned to take part in the assizes by the sheriff and the 'pokere' of Macclesfield. The latter, although indicating park-keeper, was apparently a position of patronage and, as he had few finances to deal with, he found himself seconded as a collector of other finances due within the Macclesfield hundred when occasion arose.

Last, but by no means least, Sir John Chandos was given the manor of Drakelow and 40% of certain tenements of Rudheath for his contributions in Gascony.

After visiting Vale Royal on 10 September 1358, Prince Edward moved his court to Macclesfield manor, from where he sent out a considerable number of orders to various parts of the country, including North Wales. During his stay he granted John Chandos two oaks from the forest of Macclesfield and twenty-four steers from his Macclesfield stock as a gift before leaving on the 15th to return to London via Stone in Staffordshire, and Coventry. He reached the capital on 1 October.

The uneasy peace with France followed until, on 1 March 1359, an order was issued from London. It stated that as the prince was 'thinking of crossing soon to the parts beyond the sea with a strong force', once again 300 of the best archers were to be chosen from all the Cheshire hundreds and equipped well with all that was necessary, including, of course, bows and arrows, and that they must be ready to leave when the call came.

A short while later it seemed that all was well, for Edward III had signed a treaty with King John II of France, although still captive in England, by which the latter would surrender the whole of south-east France, from Poitou to Gascony, with Calais, Guisnes and Ponthieu, and also pay a ransom of 4 million crowns for those held captive after Poitiers. In return Edward III gave up his claim to the French throne and the provinces north of the Loire river. However, the States-General upheld the repudiation of the treaty by the French regent. Edward III at once began preparations for war and advised his son accordingly.

It was at this time that Prince Edward awarded Robert Legh the Younger of Adlington the leadership of those from the Macclesfield hundred, and Adam Mottram was granted replacement of the horses lost whilst accompanying the prince during the Gascony campaign.

On 10 June 1359 Sir John Fitoun (Fitton), son of Richard of Bolyn, a small hamlet approximately 8 miles to the north-west of Macclesfield town, presented his petition to the prince. Amongst the archers chosen for the campaign in France were twelve whom he had clothed and maintained, and had continued to do so since the original order. As compensation he asked to be granted leadership of the twelve; this was granted, together with the non-hereditary title of knight.

The Fitouns were a well-respected family, so much so that John and his father Richard of Bolyn, together with John's cousin Thomas of Gawsworth, had been considered by the justices to be amongst 'the best and most lawful men' and as such were to be part of an inquisition shortly to be held in Macclesfield.

During September the journey south began in order for the soldiers to join the king and his son near Sandwich. The prince was encamped at nearby Northbourne, but on the way Robert Mottram and Thomas Asshton were so ill that they obtained permission to return home and not take part in the expedition. By 26 October, Robert Legh and Sir Ralph de Modberlegh (Mobberley) gave their assurances as to the loyalty of Hugh Downes and John Brown from the Macclesfield contingent, who were also allowed to leave.

Together with their enormous force, the two Edwards set sail on the 28th, and arrived the same day, although it would have taken two or three days longer for everything to be taken ashore. Fearing that the French would lay the country to waste before their arrival, a considerable array of baggage went with them containing tents, pavilions, forges and ovens, in the hope of being equipped with everything that was needed.

* * *

There was little gained by this new French endeavour, during which Prince Edward led a division of the army. Edward III, short of finances,

faced troops clamouring for pay. All that he could propose was 'a good share of the spoils', otherwise they could choose whether or not to serve him. In vain he laid siege to the city of Rheims, and finally withdrew on 11 January 1360. Next followed a trek through Burgundy and the seizure of Tonnerre. Then they moved on and encamped at Guillon on 19 February, remaining there until Duke Philip paid the king 200,000 moutons. A further move to Paris provided no response from the regent, so the army marched towards Loire on 6 April. At last the regent sued for peace, and the formal treaty, signed on 8 May at Brétigny near Chartres, was more or less the same as that concluded with John, except the fate of Brittany was left undecided.

Ransoms for all hostages on both sides were finally agreed, and Edward III landed at Rye on 18 May – his son Edward (the Black Prince) and his troops seem to have arrived a little later. The treaty would finally be ratified in October of that year, when ransoms were to be paid with an exchange of hostages, who were all treated well. The king was again accompanied by his son, at which point John was safely returned to France.

After the return to England in May the prince had once more concentrated on his various estates, and many orders concerning Macclesfield manor and forest were issued, amongst others.

Young Sir John Fitoun of Bolyn had died whilst in France, and the prince granted his widow in marriage 'to his yeoman John de Kentwood for good service'. He learnt, however, that knowing of his son's death Richard Fitoun of Bolyn and Richard's brother Hugh, rector of Wilmslow, had taken the widow to her relative William Maynwaring 'for safe keeping until further notice', and had made her promise, by payment of a large sum of money as a guarantee to Richard's son Hamnett, that she would not remarry without their permission. The prince judged the deed done 'in contempt of him'. He ordered Richard Fitoun to deliver 'the woman' to his lieutenant and chamberlain.

Robert Legh, described as Sir John Chandos's lieutenant, manager and keeper of the prince's forest of Macclesfield, was permitted to give four oak trees 'fit for timber' to Roger Swettenham as a reward for his good service 'in the last expedition' to France, and formerly in Gascony.

The Middle Ages

An interesting order issued on 12 September 1360 requested that 100 'great beasts' from Cheshire, and a like number from North Wales, were to be driven south to London to await the prince's return from Calais. This presumably referred to beef stock, stipulated to be 'large and vigorous', as small ones could not make such a long journey with the 'severe and heavy season now approaching'. Some had to be taken from his Macclesfield stock, supplemented by purchase elsewhere in Cheshire. All other orders relating to his manors were concerned with repairs and additions, especially the one in Macclesfield.

After returning from his brief visit to France in October 1360, when Prince Edward was present with his father for the ratification of the treaty, he apparently learnt the details relating to the actions taken by the Fitoun brothers of Bolyn and Wilmslow. An entry in his register, dated 10 February 1360, appears on Folio 222.

During the night William de Bulkelegh and several armed men had broken into Alderley manor (a couple of miles west of Macclesfield town), 'ravished' Christian, Sir John's widow, seized his son and heir Richard, and disappeared into Shropshire. It seems that Christian had been rescued by Richard of Bolyn (grandfather of the captured boy and father-in-law of Christian) and taken her to her relative William Maynwaring. The prince ordered that those guilty of the crime were to be arrested and held until he decided what to do with them.

The succeeding order dated 24 November 1360 was sent to Sir John Chandos, instructing him to give Sir John de Hide '12 oaks fit for timber' from Lyme Wood as a gift. As the latter would have fought under Prince Edward's command as leader of one section of the forest archers, the gift was presumably the prince's way of allowing Hide the equivalent value of the booty due to him.

On 29 May 1361, whereas the foresters had been allowed many privileges through their guild, with all the problems that had arisen on their return, resulting in petitions to the prince as lord of the manor and forest about their lawlessness, those in the township were desperate for their own local form of justice. On 29 May 1261, with permission from his father Henry III, Edward, as eldest son, granted 'that the Burgesses of Macclesfield may have a Merchant Guild with all the rights belonging to such a guild', specifying that it was a

free borough. This allowed the burgesses to be free from paying tolls anywhere in Cheshire on roads, bridges, ferries or fords; stall rents in any market; and a tax on any bulk of goods or any other duties except on salt from the Wiches (obviously still an important source of revenue). They could pasture their animals in the forest and use wood to maintain their houses and hedges, but were forbidden to allow their pigs to feed in the forest when there were acorns, for those were intended for the prince's pigs.

With regard to law, they were to be sued or judged only within the borough, unless the crime was such that it had to be tried at the prince's court in Chester. When using the royal corn mill, one-twentieth of grain had to be paid when ground, and any bread made to be sold was to be baked in the royal bakehouse. The burgesses could give, sell or mortgage their burgages, except to religious houses, but pay 12 pence (equal to 1 shilling) each year, which freed them from manorial dues. This was a convenient way for the prince to hand over a good deal of responsibility to the townspeople, and hopefully reduce considerably the burden of his constant orders to the chamberlain of Chester.

His next important move, particularly as he had reached thirty-three years of age, was to marry his cousin Joan, Countess of Kent, a widow with three children, on 10 October 1361 at Windsor. She was the daughter of Duke Edmund (Langley) of Kent, the youngest son of Edward I by his second wife, Margaret. They took up residence in the moated castle of Berkhamstead in Hertfordshire.

Unfortunately complaints of trespasses in Macclesfield Forest poured in during the autumn and winter months, provoking serious warnings to the foresters from the prince. Writing from Berkhamstead on 4 December 1361, Prince Edward wrote in angry terms to his chamberlain that Macclesfield foresters were being negligent and careless, as great damage had occurred, incurring a great loss of profits. The foresters were to be told that unless they proved to be 'diligent and persistent' in their duties, he would have them removed and seize the lands belonging to their bailiwicks (i.e. the area of forest or land under the defaulting forester's jurisdiction).

Finally, on 2 May 1362, both the justiciar and the clerk in Chester received a very stern warning, reminding them that when Edward was

last in the city he had forbidden anyone to join companies of armed men, or those with bows and arrows, that were riding 'with warlike pride, committing many felonies, outrages and trespasses' against his people, under threat of forfeiture of their possessions. By July 1362 he was ready to depart once more for Gascony, having received from his father the newly created principality of Gascony and Aquitaine, of which he was therefore prince, paying 1 ounce of gold to his father each year for the privilege.

As a consequence an order requesting 160 of the most competent archers was received in Chester. They were to be tested and arrayed 'without sparing anyone', clothed in white and green and ready for departure by the Nativity of Our Lady (8 September). With winter approaching preparations were still underway, until finally the royal couple sailed for Gascony in February 1363 and landed at La Rochelle, the Atlantic coastal port some 120 miles north of Bordeaux in the newly formed principality of south-western France, with its southern boundary bordering that of part of northern Spain. There he was met by Sir John Chandos, his lieutenant, who accompanied him first to Poitiers, a distance of some 85 miles to the north-west, then to Bordeaux, 160 miles to the south-east, enabling the French lords to pay homage.

Finally Edward settled his court and household in Bordeaux, but on occasion they moved to Angoulene. Exactly which of the Macclesfield knights and archers had been commandeered to be part of his bodyguard is not known, but the English knights were given profitable positions and the court was said to be ostentatious. Under the circumstances one must presume that the soldiers also reaped great benefits and pleasures, which incurred the jealousy of the Gascon knights and their followers, feeling that they were being treated unfairly and with disrespect.

In April 1364, King John II of France died and was succeeded by his eldest son, the Duke of Normandy, as Charles V. This was also the year of the birth of Prince Edward's first son, Edward, on 27 July in Bordeaux.

Meanwhile skirmishes and small campaigns continued in France, with Prince Edward mainly involved in retaining English gains.

During the summer of 1364, apart from his son's birth, the war in Brittany was suddenly resumed, and Sir John Chandos was given permission to lead a force north, which won the Battle of Auray. There is little doubt that amongst their number were several of Macclesfield's finest archers.

During 1365 Peter (Pedro) of Castile in Spain was forced out of his kingdom and replaced with his illegitimate brother Henry. As Castile was still very much an ally of the English (it had been so since the days of Edward I), Peter asked King Edward for help. The king, unaware of the true circumstances of the situation, sent John of Gaunt as Duke of Lancaster, with a further 400 archers to assist his son in reinstating Peter. Many of the English and Gascon troops were against the idea, but succumbed when the prince received 100,000 francs from his father, to which he added his extensive silver plate, in order to pay his army. This had all taken time. Meanwhile, on 6 January 1367, the prince's second son, Richard, was born in the abbey of St Andrew at Bordeaux.

On the Sunday following Richard's baptism his father left Bordeaux and was joined by John of Gaunt at Dax to complete his mission. The Gascon troops were supplemented by German mercenaries, and with Prince Edward and Peter of Castile riding under both Gascon and English flags, they headed south. To cross the border into Spain entailed negotiating a high pass in the bitter cold of mid-February, but they succeeded by dividing into three contingents.

Henry of Castile was well informed of their movements and was gathering a considerable army around his headquarters at St Domingo de Silos, where more than 60,000 men eventually rallied. Appreciating that Prince Edward was in a desolate district for supplies and shelter, both for his men and horses, by using this information Henry instilled confidence in his troops that victory was inevitable.

Edward, having experienced similar situations previously, hurriedly moved his army on, and on 2 April learnt that Henry's army was encamped within a short distance at Najera. Primed and ready for battle, he decided to attack the following day. The battle that ensued was an intense, brutal affair with much hand-to-hand combat. Lances and swords caused havoc on both sides, with riding lancers grasping

their weapons with both hands and thrusting them with great force into their enemy's armour and bodies. And not only swords, but the hurling of stones ensured that helmets were crushed and headpieces were smashed. 'The English archers well practised, kept up a rapid fire, doing great harm to the Castelians.' Faced by such a force, Henry's army was finally scattered and he escaped.

Peter knelt before Edward, thanking him for the victory, then returned to Burgos, promising that the reward for the English and Gascon services would be paid. As Edward waited for his payment during the summer months he became disillusioned and suspicious of Peter, who had persuaded him to take quarters at Valladolid, a cathedral city 150 miles north of Madrid, while he went south to Seville for the money. Edward began to receive information about his so-called ally, which suited the latter's conferred soubriquet of 'the Cruel', and in disgust he decided to withdraw. However, before his retreat began the terrible heat took its toll and dysentery and starvation spread rapidly through the camp. Suddenly Edward fell seriously ill with suspected poisoning, from which he never fully recovered. Yet, determined to cross the border, he made treaties en route, gaining passage for the remnants of his army through the various regions and finally arriving in Bordeaux during September. With him was the Duke of Lancaster, who he eventually suspected of becoming too powerful and a danger to the English succession.

With the after-effects of his illness and bitterly disappointed, the prince lost patience with his French support and consequently his popularity declined. After sending companies across the border to harass the French countryside, he evoked the anger of Charles V.

Meanwhile, after a brilliant military career and still unmarried, Sir John Chandos had retired to northern France in May 1368 where he had been granted estates in Constantin. Desperate for help and unable to ride his horse, Edward sent for Sir John's assistance. In December a French uprising saw Poitiers regained by the French, and Sir John, in an effort to draw off the French, fought gallantly at the bridge of Lussac, but was badly wounded. He died the next day in Mortimer much to everyone's grief, including the French king. Although he willed his estates to his two sisters and nieces, they were

never received; however, a superb monument in French was placed over his grave in Mortimer.

Although Peter of Castile had regained his kingdom, Henry retained the most affection from the people. Finding himself abandoned by the English, Peter was forced to face Henry's reassembled army at Montiel early in 1369. His army suffered defeat and he quickly retreated into the city. His position was untenable and, having been coaxed out of hiding by Henry, the latter took the opportunity to stab him to death on 23 March 1369.

The death of Sir John had devastated the prince, but when Charles V raised two armies in the spring of 1370, aided by John of Gaunt's arrival with a considerable army in the summer, he left his sickbed to be carried on a litter in order to lead 12,000 lancers,

The superb brass of Sir Hugh Hastings of Norfolk, founder member of the Order of the Garter. Edward III and other members, including Sir John Chandos, are depicted in the borders.

1,000 archers and 3,000 foot soldiers into battle. Limoges was taken after a month's siege, during which the prince's miners (forerunners of the Royal Engineers) demolished large parts of the city walls by the end of October. The casualties amongst the citizens were appalling, but the Duke of Lancaster begged mercy for the bishop, who had instigated the city's refusal to open its gates. Edward returned to Cognac, leaving the bishop with a pillaged and burning city.

Early in the new year of 1371 Prince Edward's eldest son died, and, grief-stricken, he was advised to return to England. For once he accepted the advice, and returned with his family and household during January, landing at Southampton. His health improved for a while, but an attempt to reach the French coast with his father in August 1372 had to be aborted. On 5 October he relinquished the Gascony principality, considering that its revenues no longer exceeded expenses. Exactly what happened to the remaining Macclesfield bowmen is not known – perhaps some were left behind or chose to stay – and how many had died whilst on campaign will never be known.

During the remaining few years of Prince Edward's life, opposition between himself and his brother, the Duke of Lancaster, grew. His dysentery returned in virile form until his weakness was so great that, knowing death was approaching, he extracted three promises from his father: his gifts were to be acknowledged, all his debts paid and his son Richard had to be protected. He died on Trinity Sunday 1376, a strange coincidence since he had been born on Trinity Sunday 1330 – hence his lifelong devotion to the Holy Trinity.

Richard II

After the Black Prince's death in 1376, his young son Richard succeeded to the throne as Richard II in 1377, after the death of his grandfather Edward III on 21 June, who had reigned for almost fifty-one years.

Whilst a minor Richard came under the influence of his guardians, known as the Appellants, and many English possessions in Brittany and Gascony returned to the French throne. The great battles of previous years were gone and both countries, weary of war and experiencing internal problems, sought diplomatic solutions instead.

It was during these losses in France that, in 1376, John Jodrell of Cheshire found himself captured, and a ransom of 1,000 francs was asked for his release. Despite the fact that at Poitiers in 1356 he had acquired a silver salt cellar belonging to King John II of France, he claimed to be penniless at the time of his capture. Whether or not this was a ploy on his part is not known, nor is the outcome of his situation. He was apparently a younger brother of William Jodrell, and is shown on the family tree as unmarried and appears to have died young. It does seem improbable that his family would have ignored his plight, but to date nothing further is known.

In 1384 the uneasy truce between England and Scotland, which had lasted thirty years, came to an end and the prince's uncle, John of Gaunt, hurried to Edinburgh the following year with a large army. He was able to hold the city to ransom, but one year later a French army arrived in Scotland to support the Scots against the English. John of Gaunt marched north again at once, taking Richard with him. The French, expecting great honours, were appalled by the guerrilla tactics of the Scots, although it did have the desired effect of sending the English army back over the border.

Disillusioned, the French returned home after petty squabbles with their Scottish allies, but still the truce held, although somewhat weakened. However, in 1386 the French prepared for an invasion of England. Taxes were imposed and great preparations made along the Channel coast with the intention to embark from Sluys. The French sent out orders for as many large vessels as possible to join their armada and many came from Holland and the Low Countries, but not from the Duke of Brittany nor Flanders. As many as could be acquired from the Mediterranean added to the formidable mass of ships.

Exaggerated rumours soon spread throughout England and Richard signed orders banning games and frivolities, and set in place facilities for males from the age of six years upwards to practice archery. Various command posts were set up around the coast garrisoned with men-at-arms and archers, and Calais was reinforced. Lookouts along the south coast were to report instantly if they saw the French fleet

The Middle Ages

approaching. It was reckoned that there were 100,000 archers in England and 10,000 men-at-arms, although John, Duke of Lancaster, had taken a force to Castile.

English fishermen went out towards the coast of Boulogne and Wissant as usual, with instructions to report on any French movements to Sir Simon Burley, governor of Dover Castle. He also received messages from the men of Calais. Despite the two countries preparing for war, both French and English fishermen shared a camaraderie, which provided much information on the activities taking place in French ports. Yet, despite the enormous sums of tax collected and the immense preparations, the attack was delayed till December, when it was considered the wrong time of year, and then it was postponed indefinitely.

It was during this year of 1386 that Robert Legh III of Adlington was knighted and granted a coat of arms. His father had died in 1382 and he had inherited the estate as heir. The device was a unicorn's head, representing purity and knightly honour. This is usually more favoured in Scotland, which suggests that at some point Robert had distinguished himself during the Scottish campaigns. About this time Robert's cousin, Peter Legh of Lyme, was appointed commander of Chester Castle by Richard.

It was known that the Leghs were much favoured by Richard II. When his father, Prince Edward, was in danger of losing his life during the Battle of Crécy, one of the Cheshire knights, Sir Thomas Danyers, was amongst the contingent of archers who managed to save the boy – Danyers also recovered the royal standard. His reward was an annuity of £40 per annum from the royal manor of Frodsham, close to the Mersey, which was to be exchanged for land to the value of £20 when suitable in time and place. On his return home, despite triumphs, disgrace, fines and a pardon, the annuity continued, and on his death in 1353 it was allowed to his granddaughter Margaret.

After being twice widowed, Margaret married Peter Legh, who, together with his brother John, was a bailiff of Macclesfield borough from 1382. The next year Peter leased the herbage of Lyme Hanley in Macclesfield Forest during the minority of Richard II.

In the summer of 1388 the Scots attacked northern England and the English army suffered a humiliating defeat at Otterburn on 5 August, resulting once more in a truce. It was during these military actions in Scotland that Roger Jodrell supplied six archers for the English army. As the son of William Jodrell, who had died in 1375, he had been enrolled in the Halmote Court of Macclesfield Forest as heir of his father's estate on 27 January 1376.

The Leghs were also involved in the Scottish incursion, particularly Sir Robert of Adlington, who was obliged to supply both men and arms when required as a knight of the realm. The latter was granted a pension by Richard and made constable of Oswestry Castle.

* * *

During his struggles to gain personal power from his Appellants, King Richard had initially appointed his dearest friend and confident Robert de Vere as Duke of Ireland in 1386. Within the year he made him justiciar of Chester, on 8 September 1387, adding North Wales two months later.

In support, de Vere raised an army of 5,000 in Cheshire, which included many important archers reinforced by a Welsh contingent, and marched south, but was defeated by Henry Bolingbroke, son of John of Gaunt, at Radcot Bridge on the Thames in Oxfordshire and fled to the Continent. De Vere was later accused of desertion at the first sign of trouble, and left a reluctant army to fight skirmishes before disappearing into the countryside and quietly making their way home.

Richard was compelled to allow a life grant of Chester to the Duke of Gloucester in 1389, much to the chagrin of those in Cheshire. De Vere would remain exiled in France until he was gored by a wild boar while out hunting in 1392 and died from his wounds.

* * *

Expecting to be crowned on reaching his majority, Richard found his request denied by the Appellants. Faced with no alternative, at twenty-two years of age, in May 1389, he seized power. He soon realised that he did

not have the option of diplomacy in relation to a situation slowly arising in Ireland, and was finally forced into taking military action.

First was the campaign of 1394–95 in which Roger Jodrell took part and became esquire to the king. This was a role that meant carrying out certain duties in the service of the sovereign or a knight. Also involved was Robert Legh III of Adlington and Sir Laurence Fitton of Gawsworth. The campaign lasted for nine months at great cost, but the wealthy merchants of English cities felt the payment of taxes well worthwhile. The army consisted of 4,000 knights and 30,000 archers, and whilst the Irish relied on javelins they were no problem for the English archers, who, as usual, achieved a successful campaign for Richard. The four kings of Ireland paid homage to Richard and were all knighted by him in Dublin Cathedral.

In 1398 Peter Legh had evidently decided that the time was right to lease a piece of land and pasture in Lyme Handley, previously let at £20 per annum, in exchange for his wife's annuity. Having achieved the grant from Richard II on 4 January, a convenient forest dwelling was built shortly afterwards allowing Peter his title of 'Piers Legh I of Lyme' and commercial advantages within the borough, manor and forest of Macclesfield. Eventually, although the main residence remained the Danyers house at Bradley in Cheshire, Peter Legh built up his herd of red deer, the descendents of which still inhabit the parkland surrounding Lyme Hall.

Richard's second campaign began early in 1399. Having spent Christmas in Lichfield whilst en route to Ireland, Richard was a guest of his former secretary, by then Keeper of the Great Wardrobe, John de Macclesfield. Early in the New Year he was entertained and feasted sumptuously in John's newly completed 'castle' with its grand entrance facing south, close by Milne (Mill) Street in Macclesfield. The stay was short, and Richard, accompanied by his personal bodyguard of Cheshire bowmen, all wearing Richard's device of the white hart and numbering between 200 and 300, arrived shortly in Ireland. Again Roger Jodrell took part, along with Sir Lawrence Fitton of Gawsworth and their best Macclesfield hundred bowmen. They were to muster in Chester on instructions from the king, to be inspected by his officers for service in Ireland.

The entrance to John of Macclesfield's castle before demolition in the 1920s.

The Middle Ages

Unfortunately Richard's uncle John of Gaunt died on 3 February, and Gaunt's son Henry Bolingbroke inherited his father's land and title. All had previously been well, but Richard became aware of many court intrigues fuelled by his cousin, who planned a usurpation of the throne. He acted quickly, depriving Henry of his English possessions, but sent him into exile instead of a ten-year banishment. Learning of Richard's intended campaign in Ireland, Henry, by then in France, swiftly sailed for England and landed at Ravenspur on the Yorkshire coast (a harbour town lost to the vagaries of the North Sea in the nineteenth century), where he was joined by many northern lords, the most powerful being Henry Percy, Earl of Northumberland.

* * *

Henry Percy (1342–1408) was a powerful personality. During the years 1359–60 he was a troop leader in France, and was knighted in the latter year by Edward III. He subsequently became a warden of the Marches towards the Scottish border, constable of Jedburgh Castle, and, in 1366, a Knight of the Garter. After leadership in France, his strong will and uncouth behaviour found disfavour in London at times, but with the death of Edward III he was raised to earl marshal, which was disputed by a relative of Edward I. However, the Scottish incursions into northern England became his major priority, especially when Carlisle was threatened. Intervention by the Duke of Lancaster, who effected a truce with the Scots, angered Northumberland, causing a rift amongst the barons, forcing King Richard to intervene and compel reconciliation.

The troubles with Scotland continued, but Northumberland and his son, Henry, who had acquired the soubriquet 'Henry Hotspur' by the Scots due to his rapid manoeuvres when attacking them, grew disillusioned by what they considered were Richard's declining abilities to rule. These, they considered, were causing misgovernment of the realm. On receiving an order from Richard in 1399 to join his Irish campaign, they refused, resulting in Richard issuing orders for their banishment. Before Northumberland could surreptitiously escape into Scotland, Lancaster fortuitously landed in Yorkshire and, seizing the opportunity both father and son, together with their large army, joined Northumberland's former nemesis.

Richard soon learnt of the events that had taken place in Yorkshire and, having no alternative, effected a hurried return to Wales, choosing Conwy Castle as his eventual refuge. Having been promised safe conduct by Henry, Duke of Lancaster, if he would negotiate, he set out with the two envoys but was ambushed and taken as a prisoner to Flint Castle, although he could easily have escaped by sea. News of his death was deliberately circulated and his supporting Cheshire lords and soldiers gradually faded away. He was taken first to Chester Castle, then Lichfield, but the unfortunate Peter Legh of Lyme was beheaded in Chester for his loyalty to the king. His body was initially taken into the care of the Carmelites of Chester, but was subsequently returned for burial to Macclesfield. His head, however, was mounted on a pole on the highest tower of the castle as a warning to others. After his execution his nephew, Robert Legh of Adlington, had quickly changed sides and supported Bolingbroke.

By a strange turn of fate Henry Percy began to sense the growing dissatisfaction amongst certain earls and people in the provinces outside London with Bolingbroke, who had succeeded as Henry IV. And despite the fact that the usurper had decided to remove Richard's corpse to the capital and lay it in full view of the people as proof of his death, a rumour arose that he was still alive and concealed at Sandiway, a hamlet some 4 miles south-west of Northwich in Cheshire. Richard, however, had initially been taken to London from Flintshire, held in the Tower and forced into abdication in favour of Bolingbroke, who was then crowned. Having succeeded in his mission, Henry despatched Richard via Kent to Pontefract Castle where he had mysteriously died early in 1400. His burial place was said to be the royal residence of Langley, but still doubts persisted.

Although some three years had passed since Richard's death, Northumberland once more reconsidered his position in relation to Henry IV, and took action. He sent four earls who were sympathetic to his cause to seek out others of similar persuasion. Unfortunately they were all discovered and beheaded. Still, undaunted, Northumberland raised his standard and was soon joined by the chief barons of the Venables and Vernon families of Cheshire, the mayor of Chester, and several priests and their followers from the surrounding villages. Also quick to support

were some Cheshire archers, but loyalties were divided. They rode south and met Henry at Shrewsbury, who, having heard of Northumberland's actions, hurried with an army to put down the rebellion. Most of the Cheshire archers, despite routing a section of the king's army, were finally killed. Although Sir Richard Venables survived the battle, he was executed afterwards and his estates were given to his brother as a supporter of the king.

Amongst the king's supporters that day was Robert Legh III of Adlington, who also survived the affray. He was later able to provide 'a hundred defensible able-bodied men in good array' to ride with him and Henry's son into Yorkshire.

Henry Hotspur did not survive; he had been slain on 21 July 1403 during the battle. Henry Percy, being faced with the reality of the situation, begged pardon of Henry IV and presented his young grandson, the son of Hotspur, to the king.

Sir Laurence Fitton also proved loyal to the king when, by order of 11 January 1404, he was sent to defend the king's territory in the Welsh Marches when it was known that a certain Owen Glendower intended to orchestrate a revolt.

Macclesfield had lost its special royal relationship, but, as always, in order to survive sovereigns need their supporters, and it was not long before John of Macclesfield, although losing his position as Keeper of the Great Wardrobe, was still retained in the king's service. He was also given permission to travel once more to seek an audience with the pope in Rome by Henry IV, having completed a similar mission previously for Richard II.

Also of interest is John Stanley, second son of William, who accompanied de Vere to Ireland in 1386 and remained as lord lieutenant. He was with Richard II in Ireland again in 1399. Despite this he was granted the Isle of Man by Henry IV in 1406, by which time he was knighted and had become Sir John of Lathom and Knowsley (Lancashire), Lord of Man, Sheriff of Anglesey, and Justiciar of Chester. He was appointed steward of Macclesfield Forest, surveyor, chief forester and rider, with responsibility for the forests of Delamere and Mondrem, and steward of Prince Henry's household (the future Henry V) – the latter office he held till 1412.

Military Macclesfield

After the king's death in 1413, during Henry V's reign, John of Macclesfield, whilst on a further visit to Rome in order to obtain confirmation of his landholdings, unfortunately fell ill in Basle, Switzerland, and had to return. He died in April 1422, but his place of burial is unknown. His death barely preceded that of Henry V on 31 August, leaving his nine-month-old son to succeed as Henry VI.

Earlier generations of the Macclesfield family had sought and won royal favour, and two had served as justices: William for Macclesfield and John for the Wirral. The latter was also mayor of Macclesfield in 1358/59. From an earlier generation there is a record of a William de Macclesfield serving in Edward I's army at Conwy Castle, whilst an Alan de Macclesfield is recorded as a Beaumaris burgess sometime before 1352.

Conwy Castle, built by Edward I 1283–92. One of the ditchers involved in the construction was a member of the Macclesfield family. Photo *c.* 1860.

Agincourt

Although the reign of Henry V had lasted little more than thirteen years following his father's death on 20 March 1413, he was highly regarded and respected both on and off the battlefield. At twenty-six years of age when crowned, Henry was tall, athletic, loved music, hunting and military pursuits. However, he was not without intelligence and appointed men 'whom he considered to be honest and fair to be judges throughout the kingdom'. He gave notice for a general pardon to 'all evil-doers except those who have committed murder and rape', which had to be claimed before 1 August 1413 (John of Macclesfield received his pardon on 13 June). And the following year John Stanley was granted his forest offices for life; however, he died in 1414.

In what appears to have been a further reconciliatory measure, Henry adopted the white hart as his badge – the same device as that of Richard II.

There is an effigy of a knight close to the altar of St Michael's Church on the left-hand side when facing the east window, which has been assumed to represent one of the Downes family of Pott Shrigley and Taxal, whose family provided foresters for their area of Macclesfield Forest, and whose coat of arms includes a buck. Certainly it represents a knight, unusually depicted with either a deer 'couchant' (lying with its head held up) or 'lodged' (a stag in the same position but brought down in the chase) underneath his head. Supported by a helmet of the type used in tournaments rather than in battle, the two create a convenient pillow for their knightly effigy, whilst the customary hound lies at his feet. It is possible that this effigy is of Peter Legh I of Lyme with the deer representing the white hart of Richard II, allegorically signifying the subject, i.e. Peter Legh, being brought down in the chase when beheaded in Chester, or the king's demise, or conveniently both.

The Legh family, as well-known members of the Macclesfield community, would desire a local Christian burial. At this time one would have expected their family members to be buried in the mother church of Prestbury, not Queen Eleanor's chapel of All Saints. The Abbot of St Werburgh's, Chester (now Chester Cathedral), was entitled to the tithes of Prestbury Church and its presentation, and

possibly fearing for his own safety, would have been reluctant to have the body of a so-called traitor buried in the church during the lifetime of Henry IV. As the armour is of the period, and the cropped hairstyle ironically brought into fashion a decade later by Henry V, it does suggest that the effigy was created after the pardon was received by the family during the latter's reign.

(When restoration work was underway in 1884 a large stone medieval coffin was found in the vicinity of the effigy. It had been disturbed at some time and contained a body with its head placed on the feet. Because of the latter positioning of the head, it was presumed that it had happened at the time of its disturbance, for it seemed to have originally been buried just outside the north-east corner of the earlier chapel. The coffin was reburied where it was found, and now lies just inside the north-eastern end of the church. This is a convincing indication that it could be Peter Legh I, who was beheaded at Chester and possibly originally interred just outside the chapel before his effigy was subsequently placed inside, close to both his coffin and the altar. When the chapel was extended in the early eighteenth century on the northern side, it was necessary to remove

This effigy near the altar of St Michael's Church is almost certainly that of Peter Legh I of Lyme, beheaded in Chester by the future Henry IV in 1399.

the original chapel walls and dig down deep to the foundations, which would have revealed the coffin. At present, however, one can only conjecture and present the facts.)

The Leghs would continue to prove that they were a far more significant family in relation to Macclesfield at that period than the Downes. It is also interesting to appreciate that in 1414 several additions were made to Queen Eleanor's chapel, including a tower and spire, suggesting contributions from the premier families of the borough, manor and forest, whose coats of arms were added in stone to the building – a recognition perhaps of the gratitude due to the pious Henry V, who had sought to bring about a unity and loyalty amongst those in Macclesfield borough, manor and forest. That unity and loyalty would surely have allowed Peter Legh his effigy, and soon it would be once more put to the test and not found wanting.

* * *

Henry V had carefully studied the art of warfare and began to use artillery to a much greater extent than any other previous commander. After settling affairs in Wales, Scotland and Ireland he turned his attention to France, and during the second year of his reign presented his legal claim to the French throne with emissaries sent across the Channel. If refused, his ultimatum was that he would substantiate his claim with force. As expected, the claim was denied.

Henry prepared for invasion, and in 1415, as he assembled his army at Southampton in readiness for departure, he learnt of a second planned assassination attempt on his life. The first, by Oldfield and the Lollards in Wales, he had quickly suppressed, but the second was instigated by three nobles – old enemies of the House of Lancaster. Henry acted quickly and they were executed for treason. Fortunately his immediate family members were loyal, and from them he received great support.

The departure took place on 14 June 1415 in what was said to be an armada of some 1,000 ships. Henry V had inherited only a half-dozen vessels from his father, but soon realised the necessity of a permanent royal navy. At the time of sailing he had managed to purchase, construct and capture sufficient ships to raise the total to thirty. Whilst they were

adequate to control the Channel, the Cinque Ports and merchant vessels were brought into temporary action when necessity demanded by providing an adequate complement, as on this occasion.

After three nights the fleet finally arrived at Clef du Caus in Normandy, and the army of some 2,000 men-at-arms and 6,000 archers disembarked. Amongst the Cheshire bowmen were Peter or Piers Legh of Lyme (son of Piers Legh executed in Chester) and his contingent; Roger Jodrell (presumably with his forest archers), son and heir to William who had served the Black Prince but had died in 1375; and Robert Legh IV of Adlington, whose father Sir Robert had died in 1408. Last, but by no means least, was John Savage (or Sauvage) II, whose family were from Stainsby, Derbyshire, but who had become very much involved in Cheshire affairs and also the Macclesfield manor and forest.

The original Savage had accompanied William the Conqueror to England in 1066, gaining wealth and important connections. In the fourteenth century the first mention of the name in Cheshire was at Rock Savage, a stronghold near Runcorn, close to the River Mersey (this later disappeared with the creation of the Manchester Ship Canal). This branch of the family had possibly migrated from Derbyshire at the same time as the Jodrells and Sir John Chandos after the devastation of the plague. By 1402 John Savage, no doubt through administrative involvements in Chester during Richard II's reign, certainly knew John of Macclesfield, for together they accepted a twelve-year licence to provide a profit of 40 shillings each year from the turbary of the parkland. The 40 shillings was stipulated to be used for the purchase of timber from Lyme wood to enclose the park area pertaining to Macclesfield manor. There was a valuable area of peat near the hamlet of Gawsworth that was let in strips to individuals who were in possession of burgages within the borough, which suggests a profitable undertaking. Apart from serving in a military capacity when necessary, John II, therefore, appears to have been conversant with the administration of forest law.

When both equipment and men were ashore, Henry V wasted no time in placing the port of Harfleur under a six-week siege until it finally capitulated. Conveniently situated on the mouth of the Seine

Estuary, he needed the port for his intended advances to Paris. He had not reckoned on the effect of his intention for his men to live off the land, and a devastating bout of dysentery began to take its toll. Realising the urgency of reaching Calais, still firmly held under the English Crown, he began the march to reach the port. The shortest distance was some 150 miles, but added to this was a forced detour in order to cross the River Somme. The army began to suffer terribly. Deprived of decent food and dwindling stores, as one French chronicler recorded, 'without tents, bread or water ... with only walnuts for food ... [and] labouring against the rain and cold' they struggled on towards Calais. At some point well into the journey Robert Legh of Adlington died together with approximately one-third of the men who had originally set foot on French soil. It was a devastating situation for Henry.

On 24 October, as they neared their destination, they suddenly sighted an immense French army blockading the road to Calais. Previously the odds were overwhelmingly against the English, and as before, despite the fact that Henry had prioritised his artillery to a greater extent than Edward III, he had still retained confidence in his exceptionally skilful contingent of archers.

The French, as usual, were relying on reverse tactics, swelling their ranks with mounted knights and noblemen who, together with their horses, were heavily armoured, and with hundreds of foot soldiers who greatly outnumbered their archers. In total, the vast army was reckoned to be between 50,000 and 60,000 strong, in comparison to Henry's remaining force of some 5,000. But, as at the Battle of Crécy, the French nobility crowded into the van of their formation in order to vie with each other for their moment of glory.

Apart from the cavalry on both sides, other contenders were to remain on foot, facing each other across muddy fields. Woods stretched along either side around the villages of Agincourt and Tramecourt, and, as the English army came to a halt, there was a deathly silence. Everyone waited until three French knights came forward to speak with Henry, who conveyed the message that he was ready to engage. The arrogant response was that the French would join the battle 'at their own pleasure'.

Henry quickly held council with his commanders, who agreed that as supplies were almost non-existent, it was essential to attack as soon as possible. As it was growing late in the day the archers were set to work sharpening and preparing staves. The English formation was to be a single line between the woods on either side, with armoured men interspersed with the 'wedges' created by the archers, each of which was protected by an array of their lethal staves likened to the quills of a hedgehog.

The vast French army, due to the narrowness of their effective movements, lined up in three relays, one behind the other, with their knights and nobles ready to charge down the English archers when the order was given. All settled down for the night to await the outcome of the following day.

Early next morning (25th), the French remained immobile for three hours. Henry began his advance, then, halting his army within bowshot, gave the order to shoot. A hail of arrows had the desired effect and provoked the French cavalry into charging forward. The deadly arrows pierced armour and horses, but many of those who managed to ride through were soon impaled on the menacing spikes of the staves. Those who did survive quickly turned in panic and rode straight into their advancing foot soldiers trudging through the mud. The sheer mass of French bodies was proving once more to create a totally ineffective operating strategy.

Trying to avoid the staves their foot soldiers were forced into three columns, which at first drove their English counterparts back 'a spear's length'. The archers were primed, and each let arrow after arrow fly into the flanks of the three wavering columns. Disaster for the French was unavoidable as bodies of both living and dead piled up, allowing the English archers to mercilessly butcher their opponents with their clubs and daggers.

At first prisoners were taken, but when the second attack began Henry ordered them killed, fearing retaliation due to his depleted numbers. Reluctant to lose ransoms, many hesitated, but Henry chose a band of archers to carry out his orders, realising that there was no alternative. The second attack had barely begun, when, to the astonishment of Henry's troops, their opponents suddenly took flight and the battle was won.

The Middle Ages

The English casualties were little more than 500, including an earl and six or seven knights. French losses exceeded 5,000, including half the heirs of French nobility.

Peter Legh of Lyme was knighted by Henry on the battlefield (as was customary) and adopted his French Christian name of Piers, to become known as Sir Piers Legh of Lyme. John Savage II was also knighted and seems to have gained particular favour with Henry V. Roger Jodrell also gained favour in some way, for a letter of attorney confirming some land acquisitions by him was issued in 1416 on the authority of Sir John Savage and John de la Pole, joint justiciar of Cheshire, after the army's return to England. Robert Legh IV did not survive, leaving his five-year-old son, Robert V, as ward to John Savage, who administered the minor's Adlington estate.

* * *

During 1416 several attempts of mediation were made between France and England, but the French stubbornly refused to co-operate. As problems in eastern Europe increased, King Sigismund of Hungary, Bohemia and the Romans was elected Holy Roman Emperor, and managed to bring to an end the schism within the Roman Catholic Church whereby two popes, one in Avignon and one in Rome, had vied for supremacy.

Henry, who had returned to England with his army, was once more in France during 1417 and would remain for three and a half years. In 1420 his claim to the French throne was finally recognised by the Treaty of Troyes, a city situated on the Seine, some 100 miles south-east of Paris. There, in the cathedral, Henry married Catherine, the daughter of Charles VI of France, in June of that year and returned with his bride to London early in 1421. It is said that he instantly fell in love with the young woman, but soon appreciated that she lacked intelligent conversation, which a man of Henry's abilities would obviously desire. Leaving his pregnant wife, by June he had assembled his army once more and sailed to France, having learnt of the death of his brother Thomas, Duke of Clarence, and many of his soldiers under siege, and was anxious to prevent rebellion spreading quickly. Amongst his army was Sir Peter Legh II of Lyme

and other Macclesfield bowmen. They first advanced from Paris to the River Loire, close to Orléans, but the dauphin refused to be drawn into battle.

Henry changed plans and, having returned north, decided to lay siege to the strategically important fortified town of Meaux, some 28 miles slightly north-west of Paris. It was another protracted siege during which Sir Peter was badly wounded. He was taken to Paris in the hope of recovering, but died there in the weeks before Meaux capitulated in May 1422. He was brought home for burial, and one must assume that his corpse was accompanied by at least some of his archers.

(Whether or not the Legh chapel was created at that time within the chapelry of All Saints and All Hallows, now St Michael's parish church, to receive Sir Peter II's body is difficult to determine. However, as the church was enlarged and restored by a descendant, called Peter Legh, in 1620, it was obviously there at an earlier period. The descendant had written of the 'Perkin-a-Legh' who had served Edward III and his son 'in all their wars in France', and that Piers, using the French name, who had served Richard II loyally was executed at Chester, and 'Sir Piers Legh' had served Henry V. Whilst these details are correct, there are several errors in his statement, one of which is that the latter was slain at Agincourt. And the desire to prefix 'Sir' wherever possible, when not strictly true, was either from misconception or perhaps for effect.)

Meanwhile, in France, King Henry's men were struggling to find supplies, and soon he too was suffering from a serious illness brought on by dysentery, which in his frustration allowed him to take actions that the French condemned as atrocities. He prepared his will, stipulating burial at Westminster and assigning brother John, Duke of Bedford, the governance of France, whilst his younger brother Humphrey, Duke of Gloucester, was to be guardian to the son he had never seen.

The boy, born at Windsor on 6 December 1421 and christened Henry, was soon left with female nursery assistants when his mother Catherine returned to France. It would be some time before she saw her son again, but if she expected her husband to request her

Brass rubbing of Perkin-a-Legh, whose brass plaque is set on the west wall of the Savage Chapel in St Michael's parish church.

presence at his deathbed, the message never came. She did, however, accompany the body back to England, but then presented a problem for the well-thought-out protectorate, set in place to control the activities of the dukes of Bedford and Gloucester.

For six years Catherine, as dowager queen, was treated with respect and caused no problems within the machinery of government. Her return to France was no longer an option; however, when in 1428 it was rumoured that she intended to marry Edmund Beaufort, cousin of her deceased husband, Parliament decided otherwise. It quickly passed a statute whereby permission for her marriage could only be given by the sovereign when he had reached 'the age of discretion'. Catherine had other ideas, and during 1430 secretly married an inconsequential Welsh squire employed in her household. Her marriage to Owen Tudor, although it would only last until her death in 1437, produced

three sons, and an only daughter who died young. The protectorate was known to have been aware of the event, but chose to dismiss it as of no consequence, as Catherine herself had assumed.

Meanwhile, in France, the men of Orléans had been unified into a formidable fighting force in support of the dauphin, inspired by the legendary Joan of Arc, who persuaded the dauphin to be crowned King of France at Rheims in July 1429, with total disregard for the Treaty of Troyes.

The English protectorate was stung into action, and despite his young age Henry VI was crowned King of England at Westminster on 6 November 1429, a month before his ninth birthday. Intent on crowning him the rightful King of France, plans were immediately made. At substantial cost an enormous host, comprising the royal household of more than 300 and a considerable armed force, sailed to France in the spring of 1430.

French coronations were traditionally performed at Rheims, an obvious impossibility for Henry, who instead was crowned in Notre Dame on 16 December 1431, following his tenth birthday. The situation was fraught with complications, which ensured a rapid exit for the English court. They returned to London in January 1432, after which Henry never returned to France, although he had been welcomed tumultuously in Paris and Calais.

In 1433 Bedford married and returned to England at midsummer. After almost a year, during which taxes were enforced for yet another attempt to subdue the French, he returned to Normandy with a large force to retain English possessions. Whether or not Macclesfield or Cheshire bowmen were included is not known, but must have been a probability. By 1435, however, overtures for peace were being considered by Bedford, who unfortunately died the following year resulting in a recapture of Paris by the French. This gave Charles VII the opportunity to strengthen ties with Scotland when his son married Margaret, daughter of James I, in 1437.

Calais next came under attack by the French, and James I led a large Scottish force south to attack the town of Berwick. Whilst the Duke of Gloucester sailed for Calais with the fleet and a large army, the earls of Northumberland and Westmorland quickly rallied their northern troops,

which usually included at least a contingent of Macclesfield archers and forced James into a quick retreat. Suddenly, later in 1437, while quietly living in a Dominican friary at St Johnstone, James I of Scotland was hacked to death in bed, and his ten-year-old son became James II.

By this period Henry of Northumberland was the 2nd Earl, born February 1394, the son of Henry Hotspur. His grandfather, who had presented him to Henry IV as a child, had again rebelled against the king and was horribly executed in 1408. The boy had already been taken into Scotland for safety, but then effectually became a prisoner of war, although he was very well treated. After Henry IV's death various negotiations, and Henry V's leniency towards him following a petition for his release, were finally successful, resulting in the return of his property and title on 16 March 1416.

The Macclesfield Parkland

During the reign of Richard II, having no heir he had retained the parkland of Macclesfield manor, farming it out to Joan de Mohun. By a strange quirk of fate she was related to Henry IV's first wife, who had died at a very young age. At that time John of Macclesfield held the lease for the demesne, and was granted a renewal for the herbage and pasture from Henry IV at the start of his reign in 1400.

When in 1402 Henry IV married the widow Joan of Navarre she became Lady of the Manor and Forest, and the lease was then, as previously mentioned, shared with John Savage to fence in the manor's adjoining parkland. The two families were united further with a betrothal between John of Macclesfield's eldest son, John Jr, and Savage's daughter Margaret.

After receiving his knighthood in 1415, Sir John Savage II seems to have reconsidered his new position and status, for two years later the agreed marriage settlement with John of Macclesfield resulted in an annulment after court action had been taken. This, however, did not interfere with John of Macclesfield Snr's lease of the parkland, which he retained until his death on 7 April 1422, when it transferred to his son John Jnr. As his father before him, John Jnr was Lord of Bosley Manor, adjoining the southern Sutton boundary some 4 miles

south of Macclesfield township. Both he and his next eldest brother, William, died young and without children, allowing their Macclesfield family inheritance, including the fortified residence (castle) on Milne Street and several burgages, to be possessed by their younger brother Ralph, including the lease of the parkland.

Meanwhile, Henry V's marriage to Catherine of Valois had allowed him the title King of France, and this was accepted as her father's contribution to the marriage settlement. As Joan of Navarre was still in possession of her dower lands, Henry was compelled to allow Catherine income from his Lancastrian estates. After the birth of his son, young Henry, as heir, would have become Prince of Wales and Earl of Chester in due course, but Gloucester and the protectorate were in charge of his affairs, and the formalities never took place.

When still very young Henry VI came under the tutorship of the Earl of Warwick, who was initially alarmed at his precocious manner, due to the pressures of state forced upon the boy by the protectorate. Warwick took charge to ensure that he received a balanced education and taught him the use of arms. Gloucester, however, kept control of the child's literary education, but was warned not to overburden him with state matters.

In July 1437, Warwick was made regent of France, and after his departure Henry began to attend council meetings. This was the year not only of Catherine's death, but also that of Joan of Navarre, so presumably the revenue of Macclesfield manor and forest was administered by the protectorate.

Four years later, when Henry VI was twenty years of age, the Duke of Armagnac's offer of marriage to his daughter was enthusiastically welcomed, but a series of unfortunate circumstances and French interference saw the offer withdrawn. Efforts to bring about peace with France were made by Bishop Beaufort and William de la Pole, Earl of Suffolk, who managed a partial truce; however, marriage to Mary, one of Charles VII's daughters, was entirely rejected by the French king. The situation in which Henry VI found himself was akin to that of Prince Edward, when his father Henry III was initially unable to obtain sufficient income for a future queen to include in the marriage settlement. It was no doubt during the precursor in acquiring

sufficient funds that the manor and parkland of Macclesfield were sold to Ralph of Macclesfield.

Despite the earlier dispute between the Macclesfield and Savage families, at some point the demesne of Macclesfield parkland was then leased to Sir John Savage II and Robert Legh V of Adlington, which could have been the result of Robert's marriage to Isabel, daughter of Sir John. Unfortunately she died at an early age and childless. Robert's second wife, Isabella, was the daughter of William Stanley, mother of his heir Robert VI and five other children, but in 1438 it was Sir John Savage who obtained a renewal of the lease, evidently from Ralph of Macclesfield.

Two years later, no less a person than Humphrey Stafford, whose father, the 5th Earl of Stafford, had died fighting for Henry IV at Shrewsbury, approached Ralph, anxious to obtain the Macclesfield manor and parkland. Ralph was invited to Stafford's grand residence in the town of Stafford and was wined and dined. This was an intriguing request, especially as Stafford was by then head of one of the wealthiest families in England. Although only a year old when his father died, he had grown up to be a brilliant soldier and politician. He had served in the French campaigns of 1420–21 and was knighted by Henry V. As a prominent member of the privy council in 1424, his impressive record saw him become a Knight of the Garter before accompanying Henry VI to the Continent, where he was made constable of France and governor of Paris. He proved himself to be a great leader by recovering several strongholds before returning to England in 1432. His brilliant career continued, and on his brother's death in October 1438 he became Earl of Stafford.

The earl was a loyal supporter of Henry VI, and it was probably because of his loyalty that he was obsessed with obtaining a power base in the Macclesfield hundred where one or two of the important families were, on occasion, suspected of divided loyalties, especially as he appreciated how important the military support of both Chester and east Cheshire was. Even the parkland, as in the past, was important for assembling soldiers and stabling horses, together with beef supplies, etc., essential in warfare. Ralph was persuaded, but presumably agreed to exchange all his Macclesfield holdings for the

The Macclesfield family coat of arms over the fireplace in Little Moreton Hall. (Courtesy of the National Trust)

manor of Mere in Staffordshire. He was the last of his family to have a close connection with the Macclesfield area.

Surprisingly, this triggered a power struggle between Stafford and Sir Thomas Stanley, son of Sir John, who had held the lieutenancy of Ireland for Richard II. Stanley protested that he was overlord of the Bosley estate and that the exchange was illegal. This resulted in a considerable court case with Stafford, who brought the best lawyers from London north to defend his claim in 1443. Stanley, like his father before him, had also held the lieutenancy of Ireland, having been knighted by Henry VI shortly before, and was convinced that he would win. Needless to say Stafford triumphed, but the Stanleys would not forget.

Another surprise came on 22 May 1443 when the brother-in-law of Charles VII, Renée of Anjou, Duke of Lorraine, Count of Provence, entitled King of Sicily, agreed to Henry's marriage with his daughter Margaret. After more protracted negotiations a truce was signed at Tours on 28 May and finally the marriage took place, first by proxy in February 1445, followed by Margaret's arrival in England on 1 April with Suffolk, a marquis of some five months. The official marriage was performed on 28 April after Margaret had recovered from a bout of smallpox.

The Middle Ages

Although Margaret brought no dower from her impoverished father, she was allowed an English annuity of 10,000 marks, but additionally only received income from some of the duchy of Lancaster estates. She eventually gained several traditional dower lands, yet nothing, of course, from the Macclesfield manor – the income from the forest appears to have been used to help supplement an almost empty treasury due to war expenses.

* * *

There is scant information about the military involvements of the Macclesfield soldiers and archers over the following period, but in order to discover where they were possibly involved in action, it is necessary to understand the forthcoming complex national events.

The royal marriage was a happy one, but Gloucester came under suspicion by the royal couple, which ended his influence and allowed Suffolk to take his place, to the satisfaction of both Henry and Margaret.

Humphrey of Gloucester was a well-educated man, honoured as the founder of the Bodleian Library in Oxford, and a strong Lancastrian. It was written that his family were the best educated, and the sons 'the most intellectual of English mediaeval princes'. Unfortunately, as sometimes happens, some superior intellectuals allow their pride to take control, an unwelcome trait in those of an ambitious and volatile nature such as that of Gloucester. Henry took to travelling with a large band of armed men, for his fear of Gloucester grew, and he eventually issued a warrant for his uncle's arrest when he next arrived at court.

Before the warrant could be acted upon, that year of 1447 witnessed the natural deaths of both Bishop Beaufort and Gloucester. Suffolk was accused of the latter's murder, but was never officially charged. In fact Henry granted Suffolk his dukedom the following year and settled down to a few brief years of peace. He completed his foundations at Eton and Cambridge and carried out a series of tours around the country, while peace negotiations were continued in France by Edmund Beaufort, who unwittingly allowed a renewal of the war and the loss of Normandy.

During the court's perambulations north, Henry visited many places including Durham, where he caused problems with the Scots, yet although he was not officially earl he did visit Chester on one occasion, but apparently not Macclesfield. It is, of course, possible that some of the foresters and longbowmen were serving in the French campaigns, although by then Joan of Arc was gone, burnt at the stake in 1431 on trumped-up charges by the English assembly.

Meanwhile, Henry's lack of confidence in his advisers grew and his fluctuating loyalties allowed divisions to appear, causing unrest throughout the country. Suffolk was finally sent into exile for five years, but on his way to the Continent he was murdered by enemies.

In 1450 rebels from Kent, led by Jack Cade, forced their way to the outskirts of London and were met by a large force at Blackheath. After an initial retreat the rebels returned, and as Henry's soldiers panicked and fled, he followed suit.

During September of that year Richard, Duke of York, returned from Ireland and landed in Wales and was declared traitor. Henry, sensing danger, must have been behind the order for marauding bands of men in Cheshire to attack him. This could have been another opportunity for action on the part of the foresters.

* * *

Richard of York, born 1411, was the grandson of Edmund Langley, 1st Duke of York and brother of Edward, Duke of Cornwall (the Black Prince). The area of Langley adjoining Sutton parish in Macclesfield Forest was more than likely named after him, for Edmund is the one who set down French forest law as applicable to England and was known to hunt in Macclesfield Forest, like his brother Edward before him. His townhouse seems to have been Cockatrice Hall, named after the mythological creature, emblem of the Langley family, and situated on the eastern side of Milne (Mill) Street, Macclesfield, near to John of Macclesfield's small castle a little further up the hill.

Richard's uncle Edmund, 2nd Duke of York, died at Agincourt from the dreadful conditions. As he was childless, the York title and vast estates passed to Richard as his nephew and heir. These included

the extensive Welsh Marches and estates in Ireland (the latter were, however, still in dower) and the considerable English inheritance. By right, later proved by Richard with his formidable pedigree on three branches of the family tree, his uncle Edmund Mortimer was next in line to the throne after Richard II, but the swift usurpation of his uncle, Henry of Lancaster, had deprived Mortimer of the succession. Richard of York was also nephew of the Duke of Gloucester.

During his youth Richard had been made ward of the 1st Duke of Westmorland, and when fifteen was knighted by Henry VI, who made several grants to him over a period of time, no doubt from his inheritance. Although this idea of wardship has been credited to the Tudors, it suggests that Henry VI's action, in relation to the vast York inheritance, was the precursor to its official adoption. By this, whilst an heir was still a minor the sovereign was entitled to the income from the child's estates, which in this instance Henry VI had farmed out to the Duke of Westmorland, considering him an appropriate mentor for the young man. This ensured a regular source of income for himself without the usual problems of managing such vast estates. It therefore conveniently became Westmorland's responsibility, for which he would submit accounts and receive a portion of the income as payment. Presumably Westmorland, whilst regarded as the best academic for the position, was also the lowest bidder for the royal wardship, having considered all that was involved, for the king would expect a decent profit.

After Richard of York's marriage to Cecily, daughter of Ralph Neville, they had a large family, beginning with a son, Edward, born August 1439 and a second surviving son, Richard, together with three daughters. He was finally able to have his birthright legally agreed to by all parties, ensuring that Henry VI would remain king until his death, after which the Duke of York and his heirs would be entitled to succeed.

It would seem, however, that Richard, pleading poverty in Ireland, had not been given full control of his income when reaching his majority, for Henry had no doubt kept a large part of the finances as a loan, possibly hoping to restrain Yorkist power – hence Richard's fury at the expectation that he had to finance his Irish forces to subdue

what to him were ostensibly Henry's rebels. Disillusioned by Henry's treatment of him, he took matters into his own hands.

Having sailed from Ireland, he arrived in Beaumaris and, avoiding the guerrilla tactics of those in Cheshire, ordered to impede him, he managed to reach his Welsh estates, then, accompanied by his 4,000 soldiers, set out to face Henry. In the south of England two of Richard's loyal supporters were murdered as they marched to meet him, but finally he forced his way into Henry's presence. York, considering himself Gloucester's successor, was a determined man and Henry succumbed to this most powerful personality.

However, during 1453 a mysterious attack of what first seemed like a severe stroke, left the king mentally and physically impaired. Three months later his son was born, whom he failed to acknowledge, and a new council was demanded, but by Christmas his faculties and movements began to return with a recognition of his son. York, whose dominance had gained him the leadership of the protectorate, found his role ended and he was excluded from the council. This was the beginning of thirty-three years of what many considered civil war, but which has now been recognised as a feud between two of England's most powerful families.

The Wars of the Roses

There had been three contenders for the leadership of the protectorate until the king's condition improved, or could be diagnosed. The first was Henry's cousin Edward Beaufort, Duke of Somerset; the second was Queen Margaret, as mother of her son; and the third Richard, Duke of York.

The choice of Duke Richard for the position infuriated Margaret, especially when he gave orders to incarcerate Somerset in the Tower because of his discredit due to French losses. With Richard's removal from power came loss of protectorate control, and Somerset's release on 6 February 1455 allowed him to begin plotting York's downfall by advising Henry that Richard intended a usurpation of the throne.

As York approached London with the earls of Shrewsbury and Warwick, accompanied by 7,000 armed men, Henry believed Somerset's falsehood. What Richard did not know was that his

message in support of the king had been intercepted, and not having received an acknowledgement, suspecting a plot, he decided to see Henry in person. Henry, expecting the worst, had already left, heading north with 2,000 men supported by Somerset and Northumberland.

On 22 May 1455 both armies arrived at St Albans, and if any Macclesfield archers or foot soldiers were present, they would surely have been with the king at that time. Henry was within the city and York on the outskirts, demanding in vain for an interview, but Henry swore to kill all traitors. Richard began his military attack about noon and soon overran the town, resulting in the deaths of both Somerset and Northumberland. Henry received a neck wound from an arrow, but was not seriously hurt. At last Richard was able to reassure him of his loyalty and escorted him back to London to resume his reign.

In November of that year York, as the king's lieutenant, opened Parliament, but the return of Henry's illness, though not as severe as previously, saw York regain his position as head of the protectorate. Margaret's hatred had not abated, as she blamed York for the loss of her son's inheritance of the Crown, and this time her persistence once more deprived Richard of his powerful position.

For almost three years there was an uneasy peace, until Henry, his court and family, moved to the Midlands on Margaret's dictate, but Henry did attend councils in Westminster. In November 1458, after an attempt to murder Warwick, Margaret quickly moved to Cheshire with her son Edward, where she instructed him to give a gift of royal swans to all members of the gentry. Her apparent intention was to ensure Cheshire support and to persuade Henry to relinquish his throne in favour of his son. The council in London, however, needed York, and as his loyalty was not in question he was put in charge of the Commons with a remit to recruit 13,000 archers from different counties.

Learning that Warwick had escaped to Calais where he was constable of the port, Margaret decided to attack his father Richard Neville, Earl of Salisbury. Meanwhile, York and his associates had come under suspicion, despite their protestations of loyalty, and matters moved on apace.

In August 1459, with York at Ludlow Warwick's father left his main residence, Middleham Castle in Wensleydale, North Yorkshire,

with an army of around 4,000 men and marched south to provide Richard with support and join his son Warwick, who was due from Calais.

Queen Margaret had succeeded in her intentions and had amassed a considerable force, primarily from Cheshire, which included men from Macclesfield town and forest. They were strategically placed on the Shropshire border with Staffordshire, conveniently impeding the intended Yorkist muster. Henry VI, meanwhile, had marched from the Midlands to Nottingham determined that there would be no 'checkmate' on this occasion.

The queen instructed her general, Lord Audley, whose force was at least two or three times larger than that of the Yorkists, to stop Salisbury from joining Duke Richard. They met at Blore Heath, some 3 miles east of Market Drayton. The slaughter was terrible, but the Fittons fought hard. Richard and Edward Fitton, sons of the late Sir Laurence of Gawsworth, were killed alongside thirty-one of their men out of sixty-six. Their nephew Thomas, Sir Laurence's grandson, was knighted on the battlefield despite an overwhelming victory for the Yorkists. Lord Audley was also killed, and although Salisbury escaped, two of his younger sons were captured and taken to Chester Castle.

Despite his success, only three weeks later York hurriedly returned to Ireland, leaving his army to surrender to the king. Warwick, apparently in Calais where he was joined by his father and the Earl of March, devised a plan of action that culminated with all three earls sailing to the south coast of England and playing an integral part in the Battle of Northampton on 10 July 1460.

The battle was the first in England where artillery was used. Unfortunately for Warwick, as his men approached the Lancastrians, the driving rain had ensured that their cannons were useless. Although they suffered a fierce hail of arrows, some of which were no doubt fired by a remnant of Macclesfield bowmen in support of the queen, York's unexpected ally, Lord Grey of Ruthin, and his men defected to York's side – a move planned in advance. The king was taken captive on the battlefield and a considerable number of Lancastrians were killed. Salisbury was rewarded by promotion to the position of 'great chamberlain of England', which would be of little effect.

Even before battle commenced the Lancastrians had suffered a great loss with the death of Humphrey Stafford. After his acquisition of the Macclesfield manor and parkland, on 14 September 1444 he had been created 1st Duke of Buckingham, and this, his most northerly manor, was included on a map of 1448, revealing a plethora of his manors stretching across the Midlands and south. Before the Battle of Northampton he had met a group of bishops who arrived with an armed retinue seeking audience with King Henry. Stafford ordered them away, but a scuffle ensued, during which he was slain. His loyalty, particularly to Queen Margaret, was never in doubt and his will stipulated which of his numerous manors were to be sold on his death, including Macclesfield, but the latter was still retained.

John Savage II had died in 1449, so it was his son, John III, born 1422, who inherited. His father had been allowed a £10 grant each year for life from one of the Gloucestershire estates of the Duke of Buckingham. As Buckingham had been predeceased by his son, it was his grandson Henry who became the 2nd Duke at six years of age. In the same year – 1460 – John Savage III was appointed sub-receiver and steward of Macclesfield manor, giving him 'complete autonomy in his dealings with tenants and officials under him'. He also had to agree to live within the manor. So the Savage influence in Chester had been successful, despite the fact that John's wife was the daughter of Sir Thomas Stanley, which could have affected the position due to the earlier court case in relation to the ownership of Bosley Manor.

Three months after the Battle of Nottingham, York arrived with 500 armed men and broke into the Palace of Westminster to claim ratification of his succession, which was agreed to by King Henry on 31 October. Queen Margaret, by then in Wales, undertook to rally a rebellion in the north.

Salisbury had been left in London to hold the city, for York was very popular with the merchants and citizens, but he had little time to enjoy his promotion, for a Lancastrian force in the north had laid waste his Yorkshire estates, together with those of the York family. He hurried north from London with his son-in-law on 9 December 1460, arriving at Sandal Castle on the 21st, where they spent Christmas.

During this first period of the so-called Wars of the Roses, Robert Legh V of Adlington, by then in full possession of his Adlington estate, had concentrated on guarding his family interests. He seems to have left military affairs to be dealt with by his son Robert VI, born when he was just eighteen years old. The family's loyalty to Henry VI was tested time and time again, as the younger man received frequent instructions to organise and supply the military men of the hundred in support of the king and queen.

Surprisingly, the Leghs of Lyme did not follow suit, perhaps remembering all too well the execution of Peter Legh I at Chester, and presumably taking notice of the successes achieved by the Yorkists. It was Peter Legh's grandson, Peter III, who joined York's army at Sandal Castle in December 1460.

The battle took place at Wakefield on 29 December 1460, but there Richard of York was killed and the army defeated. Warwick managed to escape, but was unable to support Richard's son and heir Edward as Duke of York. Logic dictates that by this time the Macclesfield losses must have been considerable. Peter Legh, despite the defeat, was knighted on the battlefield. Exactly how he escaped is unrecorded, but he and his remaining men were still with Edward of York some two months later.

The unfortunate Salisbury, although he survived the battle, was somehow enticed out of the castle the following day and brutally beheaded – by whom was never established.

Another battle, at Mortimer's Cross in Herefordshire on 2 February 1461, was Edward of York's first victory. It took place close to the Welsh border, and as a consequence Owen Tudor and his son, Jasper, Earl of Pembroke, led an army in support of Henry VI. The family had increased their power in South Wales, but amongst the Welsh soldiers were units of French, Breton and Irish mercenaries acquired on appeals from Queen Margaret.

Unfortunately for Edward, on 17 February Warwick was defeated in a second battle at St Albans, after which the queen and her army moved north. On 2 March 1461, Edward of York was proclaimed king. Yet another battle at Towton had to be fought with the largest armies so far assembled – said to be the most ghastly battle ever to take place on English soil.

As usual the Yorkists were heavily outnumbered, and as his men were beginning to falter, Edward, observing a rare metrological effect whereby the sun appeared as three separate bodies that eventually merged into one, convinced them that it was a brilliant omen. The men responded with enthusiasm, and Edward adopted the sun in splendour as his emblem.

The battle took place on Palm Sunday, 29 March, during a fierce snowstorm. In total, it was reckoned that at least 50,000 men took part – more than half of whom never returned home. Young Edward, at only eighteen years of age, proved himself that day, and although his army was awaiting the arrival of the Duke of Norfolk with his force, the command initially was with Lord Fauconberg. The latter ordered the Yorkist archers assembled in the van to take advantage of the strong wind, and amongst them was Sir Peter Legh III and his bowmen. The first flight of arrows was sufficient to provoke the Lancastrians into responding rapidly, but the head-on wind and driving snow forced their arrows to fall short. It was a hard-fought battle that lasted for hours and saw Edward's army on the brink of defeat, when Norfolk arrived with his relief force. As hundreds lay dead or dying the snow became stained red with their blood, and it was said that nearby streams and rivers also ran red.

Many Lancastrian nobles died, including the Earl of Northumberland, but Henry VI with his queen and son escaped into Scotland. Sir Peter Legh III was rewarded in May by his appointment as governor of Rhuddlan Castle in Flintshire, and on 28 June 1461 the heir of Richard of York was crowned Edward IV. The following year Sir Peter was part of a royal expeditionary force into Scotland.

As King Edward acquired the wardship of the Savage estates, it ensured that young Henry Stafford became loyal to Edward as he grew into maturity in the care of Edward's sister.

* * *

Henry VI had escaped into Scotland via Berwick, which he surrendered to the Scots, ensuring a good reception. By the time of Edward's coronation Henry was recorded in Kirkcudbright on the Solway Firth, but Margaret and his son were in Edinburgh, where he joined them

during the summer of 1462. He granted the city a trading charter, whereby Edinburgh merchants could trade in England with duties not exceeding those of Londoners.

Margaret soon went abroad and openly used vigorous efforts in gaining the support of the French, who joined the Scots in advancing Henry's cause. She returned to Scotland in October with a small French force and, having pledged Calais to King Louis XI, she assembled an army and succeeded in taking the castles of Alnwick, Dunstanborough and Bamborough with Henry at her side.

It was in November 1462 that Edward IV left London with his expeditionary force in which Sir Peter Legh III and his contingent took part. Evidence confirms that the Savage family, amongst others, were supporting Edward by then, for in 1461 Sir John Savage the Younger and his son John were granted a lease of the king's mills on the Sutton and Macclesfield boundary, and also lease of the parkland, both for sixteen years, paying £5 8 shillings and £7 1 shilling respectively.

Edward's force finally reached the Scottish border and by January 1463 all three castles were again in English hands. Just over a year later Margaret and her allies harassed the border once more, but were forced to retreat as Warwick's army approached.

Rumours spread and, as Lancastrian support was still strong, a disguised Henry was known to frequent different localities in Wensleydale. He was finally caught at Waddington Hall, close to Clitheroe in Ribblesdale, and taken to London. There he remained for five years under guard and committed to his religious devotions, yet Edward ensured that Henry's allowance for maintenance was more than adequate. There were stories of ill treatment on occasion by some of those employed to serve or guard him, but there was no move against his life.

Warwick expected a dukedom for his support, which never transpired. Unknown to him and virtually everyone else, whilst Yorkist forces in the north had been hunting down the dethroned King Henry and crushing Lancastrian opponents in ensuing skirmishes, Edward had been on a secret mission. Put simply, he had fallen in love after a visit to Grafton – home of the elderly widowed duchess of Bedford. The nature of his initial visit is unclear, but the suggestion is that in 1461, whilst staying in Stony Stratford when granting pardon to Sir Richard Woodville for supporting the Lancastrian claim, he met Woodville's daughter Elizabeth. The young

woman had been married to Sir John Grey, a leading Lancastrian, having previously refused a proposal from a Yorkist knight. The marriage was happy and produced two sons, Thomas and Richard, but Sir John had been killed in 1461. Three years later, hearing that Edward was hunting nearby, she met and pleaded with him for restoration of her income promised in her marriage settlement. Edward had possibly adopted the same position as with the Savage estate and taken into trusteeship the lands of Sir John Grey.

Edward apparently could not resist the appeal from the beautiful young widow and, although she was able to regain her income by arrangement on 13 April 1464, only eighteen days later she secretly married Edward in the vicinity of Stony Stratford.

Although Edward managed many surreptitious visits to Elizabeth during the summer months, in September he met his Great Council in Reading, where they pressured him with regard to a marriage useful to an alliance with England. Warwick put forward his choice as Bona of Savoy, sister-in-law of Louis XI. At this point in time there was a truce with France until October, but Edward casually announced that he was already wedded to Dame Elizabeth Grey. The consternation was enormous, taking into consideration that not only had she been a Lancastrian widow, she was also of little pedigree, and therefore not fit for a king of his position. Nothing could be done, however; the die was cast, resulting in the abandonment of Warwick's intended French mission to negotiate a marriage settlement, much to his chagrin.

After being presented to the nobility in a splendid ceremony at Reading on Michaelmas Day, Elizabeth was crowned as Queen Consort in Westminster Abbey on 26 May 1465. In honour of the occasion, John Savage Jnr (i.e. John IV) was created a knight of the Bath on the day. It also inspired Edward to allow Elizabeth's large Woodville family many benefits, by promoting her father and male siblings to state positions and contriving significant marriages for her sisters.

Three years later Edward obtained a grant from Parliament to once again undertake an English invasion of France. An agreement between himself and Charles the Bold of Burgundy culminated three months later (early July 1468) in the marriage between Charles and Edward's sister, Margaret of York, causing Warwick further resentment.

His vengeance knew no bounds and, supported by other nobles, he promised Edward's brother, the Duke of Clarence, that he would make him king and offered him his eldest daughter in marriage. Also on offer was half of Warwick's vast estates, and Clarence succumbed.

When a French embassy arrived in England, Warwick was able to persuade them that Edward was governed by traitors, and felt confident to take action. He next contacted his brother, Alexander Neville, Archbishop of York, persuading him to await instruction in order to encourage insurrection in the north. By chance he was in Calais for Clarence's marriage to his daughter on 11 July 1469 when a rebellion broke out in Yorkshire. Edward, totally unaware of Warwick's scheming, immediately sent urgent messages to his brother, the Duke of Clarence, to Warwick and the Archbishop of York, asking for aid, then proceeded north with his army.

Meanwhile, in June of the previous year, Jasper Tudor, supported by Louis XI of France, had landed at Harlech Castle in Wales. He held sessions and assizes in the name of Henry VI and began to influence the surrounding area as the one remaining Lancastrian stronghold. When Lord Herbert heard of Tudor's actions, he carried out an attack and drove him out. A grateful Edward rewarded him with Jasper Tudor's title of Earl of Pembroke.

The stage was set for what is now considered to be the second phase of the Wars of the Roses.

Recommencement of War

Archery was still continuing to be an important part of warfare, but during the previous century English archers had become mounted, so that they could move more quickly with the cavalry on rapid marches and raids. The latter was considered the elite of any army, yet knights on foot supported by common foot soldiers with their bows and pikes were usually the deciding factor in delivering victory. Battleaxes, maces and lances, in addition to the ubiquitous swords, had been very much in use during the thirteenth century, but the mace had lost its appeal.

As their protective armour increased the infantry had become heavily armed, which extended to the cavalry and horses. In siege

warfare, such as that in France, or when attacking castles in the British Isles, engineers with their stone-throwing trebuchets were essential to operations, and by the late fourteenth century cannonry was playing a more significant role in major battles. Preparations for any military operations were therefore extremely complicated, with recognition of how important it was to have a constant stream of supplies, both for men and horses. Efforts were enormous, and so was the expenditure, which suggests that no monarch undertook to wage war lightly. Also it was becoming increasingly difficult to recruit men and pay their wages, resulting in much reliance on mercenaries from the Continent who saw an opportunity for looting.

Edward, therefore, had prepared as much as was necessary in order to suppress the Yorkshire uprising. Lord Herbert, as the new Earl of Pembroke, rallied his Welsh troops and set out across the country, until he met a rebel army at Edgecote, near Banbury. There,

Above left: A Bavarian anchorite begging alms from a German knight.

Above right: Polish knights representing medieval cavalry in the Hermitage Museum.

Note the attention to fashion, particularly the plumes of ostrich feathers attached to the helmets.

on 26 July 1469, he was heavily defeated and taken captive with his brother. They were beheaded at Northampton.

Earl Rivers, Elizabeth's stepfather, and his son Sir John Woodville were also captured and decapitated at Coventry, but Edward was captured at Olney by the Archbishop of York. First he was taken to Warwick Castle, then Middleham, yet was treated with respect.

Appreciating that the citizens and merchants of London were remaining loyal to Edward, Warwick could not command sufficient support to reinstate Henry as king and decided to delay his intent. As a consequence Edward was released and, unwilling to accept that the loyalty of both Clarence and Warwick was irredeemable, he issued a pardon to them shortly before Christmas. However, in March 1470 their opportunity arose for action, and they secretly organised an uprising in Lincolnshire. Edward, still convinced of their loyalty, was slow to react, but having been told of their guile he hastened with a force and defeated the insurgents at the Battle of Losecoat Field. He then summoned the duo to explain their lack of support, but they fled north hoping to raise an army of their own. Unable to do so, Warwick, his brother the archbishop and Clarence quickly embarked for Calais, where Warwick still held his governorship.

With the main conspirators all in France, Louis XI seized the opportunity to bring together Queen Margaret, Warwick and Clarence, in an attempt to reinstate Henry VI as King of England. Against all the odds he succeeded in reconciling the queen with her enemy Warwick, and persuaded them that a united action against Edward would succeed. With Louis's help they set sail and landed on the south coast early in October 1470.

Edward was again in Yorkshire quelling a second rebellion when he heard the news, and once more his trust in someone's loyalty was about to be dashed. Up to this time Warwick's brother Montague, whom Edward had rewarded with the Northumberland title and estates in 1464, had recently been persuaded to relinquish the honour in favour of Percy. Montague, having received Edward's message for help, arrived within a few miles of their rendezvous, then suddenly changed sides and marching forward instructed his

The Middle Ages

men, numbering some 6,000, to shout out rallying cries in support of King Henry. Edward was quickly warned, and, accompanied by Gloucester and his brother-in-law Earl Rivers, hurried to Lynn (King's Lynn). The tide of support had turned against him and, being in no position to return south, he had instead sought help from his brother-in-law, the Duke of Burgundy, who acquired safe passage for him to Holland. On arrival, Edward was escorted to the Hague on 11 October 1470.

* * *

By this period the country had grown tired of fighting, but Warwick's actions were acting as a catalyst for a further period of warfare.

There is little mention of the Fittons of Gawsworth during this succeeding period. Sir Thomas (knighted at Blore Heath), whose wife Ellen was the daughter of Sir Peter Legh III of Lyme, had received a pardon from Edward IV and seems to have quietly returned to estate matters. Until his death in 1494, when, having no offspring, his

The Jodrell (Jaudrell) brass set into the floor of the central aisle in Taxal Church, close to the Cheshire–Derbyshire border.

elderly brother Edward succeeded to the estate, no particular mention of their loyalties or military involvement has been of note.

The same must be said of the Jodrell family, although one would expect the sons of Roger Jodrell (who fought at Agincourt) to have been called upon for service with the archers, but on whose side of the battlefield is somewhat speculative.

It was a very confusing situation for the gentry and tenants in Macclesfield manor and forest, and also for the townsmen. Henry VI's son Edward had been created Earl of Chester in 1454, but Richard of York had managed to obtain Parliament's permission to gain the title for himself in 1460, together with that of Prince of Wales and Duke of Cornwall. He was, of course, killed shortly afterwards at the Battle of Wakefield.

As the two titles relating to Wales and Chester were not automatically acquired, but had to be recreated by the sovereign for his heir apparent, surprisingly there is no record of Edward IV gaining the latter title. However, circumstantial evidence suggests that by this time landowners and their tenants in the Macclesfield township, manor and forest were quietly remaining loyal to King Edward.

* * *

After Edward's arrival in the Hague, at what point he learnt that his son Edward had been born at the beginning of October, is unknown, but it must have been both a blessing and a considerable worry. At the time of his departure for Holland, Elizabeth was resident in the Tower with his daughters. As soon as news of Edward's flight was conveyed to her, she wisely and quietly moved into the Sanctuary of Westminster, and there gave birth. Meanwhile, Henry VI was released from captivity by Warwick and declared king once more.

Edward IV therefore had two strong reasons to return to England and reclaim the throne. Having fled with only the clothes they had stood up in, he and his few devotees would have to rely on help from the Duke of Burgundy. With great persuasion, Edward achieved his request and the duke provided him with a substantial fleet and money, allowing him, together with Gloucester and Earl Rivers (son of his

deceased father), to set sail on 2 March 1471. Despite adverse weather conditions, they finally arrived near Ravenspur on the 14th, having avoided landing further south where Warwick's influence held sway.

Feigning his return as an act to recover his Yorkshire estates, and supported in his pretence by Percy as Duke of Northumberland, Edward, marching via York, finally arrived at Sandal, the estate of his late father. Few joined his somewhat depleted army as they continued south, but none intervened. At Leicester their numbers increased by 3,000 and suddenly support was swelling, causing Warwick to seek refuge in Coventry as he was pursued by Edward and his troops. Refusing to be drawn into battle, there Warwick remained, forcing Edward to withdraw to Warwick, where he was accepted and proclaimed the rightful king. With 7,000 men he rode out towards Banbury with Gloucester, Earl Rivers and others, to be met along the road by his brother Clarence leading a company of soldiers.

Edward had prepared for this meeting in advance by sending a message with an intermediary in France. The latter, mentioned only as a lady known to both of them, advised Clarence of his misguided alliance with Warwick and Queen Margaret. As the brothers approached each other, Clarence came forward and the reconciliation took place.

Despite Clarence's efforts to appease Warwick and settle matters with Edward, Warwick was in no mood to comply and was joined by allies. Edward proceeded to London where, on 11 April 1471, he was received with great acclaim. Anticipating the citizens' reaction the Archbishop of York had already decided to plead forgiveness and surrendered both himself and Henry to Edward.

With a relieved Queen Elizabeth escorted from the Westminster Sanctuary and taken to Edward's mother's residence close to Blackfriars Priory in London (where Edward had been crowned), he spent Good Friday in the capital. On the 13th, as Warwick and his army approached London, he marched with his troops towards Barnet, taking Henry with him. They occupied the town whilst Warwick's main force was encamped half a mile away.

As darkness fell, knowing that Warwick's men were close to a hedge, Edward placed his men not quite opposite, causing Warwick's

artillery, with their ordnance brought from Barnet, to fire towards an empty area during the night. Amongst Edward's troops was Sir John Savage IV and Cheshire troops.

A dense mist formed as daylight gradually arrived and Edward's western flank began to give way to Warwick's superior numbers, causing several of Edward's troops to flee to London and spread the word that all was lost. Those fighting on the eastern flank had an almost equal chance of success, until Edward's banner with its 'sun in splendour' proved its worth. In the reduced visibility Warwick's men mistook the banner of their ally, the Earl of Oxford, which sported a star with its radiating rays, to be that belonging to Edward, and started firing in the wrong direction. The earl's men immediately rushed off the field shouting 'Traitor!'

While Oxford escaped to Scotland, Warwick and his other ally Marquis Montague were found dead on the field. Two days later, when the bodies were placed on view at St Paul's in London, Margaret and her son landed at Weymouth with their army. After ensuring that his sick and wounded soldiers were taken care of, Edward was in Abingdon on the 27th. He finally located his enemy's position and engaged them in battle at Tewkesbury on 4 May, gaining a complete victory.

Margaret was taken prisoner and her son killed either in battle or shortly afterwards. Edward agreed to spare the lives of the Duke of Somerset and a few of his men who had sought refuge in Tewkesbury Abbey, but apparently, and uncharacteristically, did not keep his word, and the fifteen were executed after their surrender. In this battle Sir John Savage IV and his Macclesfield troops again fought in support of Edward – probably alongside those of Legh of Lyme.

The intended northern revolt was subdued by the news of Warwick's defeat, but one in the south was growing more serious. Warwick's deputies in Calais instigated an invasion of 20,000 men, which grew as they advanced through Canterbury. Fortunately Lord Scales (Anthony Woodville, Edward's brother-in-law) took action and persuaded the mayor of Canterbury to defend Sandwich against further landings, which he managed to do by slipping away with 600 horsemen.

Edward quickly issued commissions and raised 30,000 men from different counties. Many would be from east Cheshire, called to join Sir John Savage, who, together with his soldiers, arrived to join the defence force in London on 21 May. By a strange quirk of fate it was the night on which Henry VI died, said later to have been murdered by Edward's youngest brother, Richard of Gloucester. Edward's combined force was sufficient to scatter and defeat the rebels from Calais, and their adherents from Kent and elsewhere, ensuring his complete victory. With his enemies either deceased or in secure confinement overseas, he was able to rule once more. The extra forces were stood down and returned home, no doubt hoping for a more peaceful future.

On 3 July Edward created his son Prince of Wales, and on the 17th Parliament confirmed the decision, adding the palatine of Chester and Flint together with the dukedom of Cornwall. As a precaution Parliament additionally voted to levy a tax in order to raise 13,000 archers as a defence force for the country, which was increased two years later with the intention of invading France. Increased expenditure meant persuading people to donate what they could, and it was extremely effective due to Edward's charm and appeal, particularly amongst the wealthier ladies, and the promised peace was once more put on hold.

After considerable preparations Edward sent his demand to King Louis for the surrender of France, and set sail for Calais with 15,000 men-at-arms, 15,000 mounted archers, and a large contingent of foot soldiers. It took three weeks to land such a vast army at that period with all its equipment, but it was late in the year for beginning a campaign, which Louis correctly predicted.

Edward was expecting the arrival of the Duke of Burgundy with his army, but he arrived only with his entourage, creating a debilitating effect on the English force. And when the duke quickly left to defend Luxemburg, the English troops began to consider that they were there solely to fight for Burgundy's gains. As they progressed further the constable of St Pol, a supposed ally of the Duke of Burgundy, began to fire on them from St Quentin, inspiring Louis to take the initiative and provide a seven-year treaty. He promised to pay Edward an

annuity of 75,000 crowns each year for the remainder of their lives, and a marriage between Edward's eldest daughter Elizabeth and the dauphin. Ratified by both kings at Picquigny on 29 August 1474, the English returned home without striking a blow. Many would be disappointed that, despite the fact they had received pay for their service, there was no possibility of rich returns from their captives or looting, for they gained little from the wars with Scotland or Ireland.

The Duke of Burgundy died in battle on 5 January 1477, which ultimately led to the death of the Duke of Clarence, drowned in a vat of malmsey. Clarence, a widower, had endeavoured to marry Burgundy's daughter, arousing Edward's suspicions, and after Edward's accusations against him before Parliament at the start of 1478, Clarence was held in the Tower, where the so-called 'unfortunate accident' took place. It was an act that haunted Edward until his death.

The French pension did continue for a few years, but the arranged marriage never took place; neither did the one that Edward arranged for his daughter Cecily to the heir and son of James III of Scotland. Edward fell ill and died on 9 April 1483; his successor was his young son, Edward V. Significantly, Sir John Savage IV was one of the selected pall-bearers of Edward's coffin as it was carried into Westminster Abbey.

* * *

Whilst growing up young Edward had been placed in the care of Earl Rivers and John Alcock, the newly created Bishop of Rochester (member of a family who resided in the Macclesfield township during the second half of the fourteenth century). On 2 January 1476 the child had been appointed justiciar of Cheshire with power to appoint other justiciars in Wales and the Marches. It was five years later when he had become king on the death of his father, at the age of only thirteen years. This was the start of a power struggle between the Woodvilles and Richard, Duke of Gloucester.

Richard was actually the eleventh child of Richard of York. By the time Edward IV was crowned, five of his brothers had died, leaving

The Middle Ages

three sons and three daughters. Edward accordingly created his brother George Duke of Clarence, and Richard Duke of Gloucester. As Richard grew up he had remained faithful to Edward, which ensured his election as a Knight of the Garter in 1466. When old enough he constantly supported Edward in all his battles and shared his exile in Holland. At Barnet and Tewkesbury he commanded the vanguard, displaying 'both skill and valour'; however, amongst other dubious deeds, he was suspected of killing Henry VI's son Edward.

On 12 June 1482 Richard was given command of the army against the Scots and took Berwick, then entered Edinburgh. He had taken with him Alexander Stewart, Duke of Albany, to place him on the Scottish throne as instructed by brother Edward. This was yet another opportunity for Macclesfield troops to take part, supported by the fact that Sir John Savage IV was elevated to a knight bannerette by Richard of Gloucester in recognition of his services, and Sir Piers Legh V of Lyme, who was known to be present, was granted an annuity of £10 when Richard became king.

Stewart was the second son of James II of Scotland, created Earl of March and Lord of Annondale by his father in 1455, shortly followed by his dukedom and a grant of the lordship of the Isle of Man. On his father's death in 1464, when his brother succeeded as James III, he was sent to his mother's home in Guilderland, a province of the Netherlands. Four years later, when sailing back to Scotland he was captured by Edward IV, presumably to force James III to keep his promise regarding Edward's daughter Cecily, but protestations from the Scottish government forced Edward to release the young man. After living in St Andrews, Alexander was welcomed in Berwick between 1465 and 1466, where he took an active part in Scottish affairs and administrations for ten years. During that time he became governor of Berwick, high admiral and lieutenant of Scotland. However, the reign of James III was proving difficult and Scottish nobles seized power, which created an atmosphere of revolution. Whereas in April 1474 Richard of Gloucester's intention to invade Scotland had not materialised, in 1482 Edward IV considered the time right. Exacting a promise from Alexander Stewart (to whom he had given the pseudonym John Balliol) that he would marry

Edward's daughter Cecily in return for the Scottish throne, Richard of Gloucester was given charge of the operation.

Unfortunately all did not go according to plan after their entry into Edinburgh. Alexander was taken into custody by the Scottish nobles and Edward was forced to return Berwick in order to obtain Richard's return. Although Alexander was initially acknowledged by the Scottish nobility after swearing allegiance to his brother, his scheming continued and in 1479 he was incarcerated in Edinburgh Castle from where he effected a daring escape with French help, which became legendary, and then managed to reach Paris.

Meanwhile, apart from many properties and appointments heaped on Richard by Edward IV was one that made him constable of England, but with the demise of both Clarence and the king Richard was left in an even more powerful position as the only surviving brother.

As protector he ruthlessly suppressed those whom he considered were plotting against him, which saw both Earl Rivers and others executed without trial. Buckingham, no doubt fearing for his own safety, gave an eloquent speech on 24 June 1483 in favour of Richard in London's Guildhall, at which time Edward IV's marriage to Elizabeth Woodville was declared illegal and their sons bastards, resulting in Richard's confirmation as the rightful king.

Before leaving for a visit to Windsor and elsewhere, Richard finally accepted the crown at Baynard's Castle, his mother's London residence, and began his reign during a visit to Westminster Hall on 26 June, followed by his coronation on 6 July. Amongst the pardons was that to Lord Stanley, who was released from confinement and granted the position of lord high constable, and Sir John Savage IV received another honour, becoming a Knight of the Body. He was considered a firm favourite of Richard III, who, as a warrior of great repute, was apparently impressed with Savage's skills in warfare and his loyalty.

Richard III

Feeling confident in his position, Richard contrived the reunion of Edward IV's two sons as residents in the Tower – the younger boy had been in the sanctuary with his mother. It was not long, however, before

The Middle Ages

Buckingham, amongst many, became disillusioned with the new regime. He already favoured a plot to support Henry, Earl of Richmond, to gain the throne, whose mother Catherine had married the 'insignificant' Welsh knight Sir Owen Tudor. Through his father, Henry was the legitimate heir descended from John of Gaunt, uncle of Richard II.

King Richard III, his wife and son set out on a northern tour, eventually reaching Leicester, Nottingham and finally York, where they stayed a few days in September 1483. In his absence plans had been made to rescue the boys from the Tower on the assumption that they were still there, and Buckingham took charge of the intended insurrection. News swiftly followed of their apparent murders, inspiring the duke to contact Richmond exiled in Brittany, advising him of a date for an invasion. It was later revealed that, during Richard's absence, the mysterious disappearance of the two boys had taken place under suspicious circumstances, allowing the new king to point out his non-involvement in the affair as he was elsewhere.

Richard, who had won the loyalty of many, was told of the intended usurpation by Buckingham and Richmond and quickly moved south, asking for help from Yorkshire, but it was to be stormy weather that defeated Buckingham. He was held up with his army in Wales due to severe flooding of the Severn, which swept away many bridges. Realising the danger he fled into Wales, only to be betrayed.

The gentry of Macclesfield would have quickly learnt of Buckingham's trial on 1 November at Salisbury, where he was judged a traitor, and of his beheading the next day, Sunday 2 November, outside in the marketplace. His vast estate with its considerable manors and lands, including his Macclesfield possessions with the former John of Macclesfield mini-castle and the Bohun family estates to the south, was confiscated by the Crown, and his widow, daughter of Earl Rivers, prudently married Jasper Tudor, Duke of Bedford, the following year, uncle of the Duke of Richmond.

The storm had also interfered with the arrival of Richmond and his army, allowing Richard to return triumphant to London at the end of November.

On 23 January 1484 with his title confirmed, Richard's son was declared heir-apparent. Edward IV's five daughters, cocooned in the

sanctuary, were promised good English marriages sworn on oath before Parliament, and somewhat anxiously returned out of their Westminster retreat. The business of Parliament continued and much was achieved allowing commissions for 'muster and array' of troops to combat any invasion. This would obviously affect the Macclesfield hundred, particularly with regard to Ireland, Scotland and Wales, suggesting that despite Buckingham's execution and the murders of the princes, the supposed loyalty of the area was to Richard III – or was it?

Whilst celebrating Twelfth Night on 6 January 1485 Richard learnt that the Earl of Richmond was planning a summer invasion. He forced Parliament to grant him a loan – another unpopular move – and when his wife died on 16 March rumours spread of his intended marriage to his niece Elizabeth. Richard was dismayed that his secret desire was known, and, whilst rapidly denying it, sent Elizabeth to a guardian who had the care of his nephew, Clarence's son, Edward, Earl of Warwick.

By June every county received orders to be on the alert at an hour's notice, so action could quickly be taken against Richmond's expected invasion. In August Richard arrived in Nottingham expecting a large army to be assembled, but his orders had only partially been obeyed. Lord Stanley, at his Lancashire residence near Preston, sent a message with his son, Lord Strange, that he was ill with 'sweating sickness'. The young man assured Richard that his father was loyal and would arrive with his soldiers, but when he tried to leave he was taken into captivity as a hostage. He continued emphatically to deny his father's disloyalty, but confessed that his uncle William had been in communication with the enemy.

Henry Tudor, Earl of Richmond, arrived at Milford Haven in August 1485 and easily reached Shrewsbury within a week, assisted by Welsh chieftains. Richard, alarmed at the earl's rapid progress, for he had delayed to celebrate the feast of the Assumption of Our Lady, allowing Richmond to reach Lichfield, rallied his army and immediately set out for Leicester, arriving on the 20th. The next day he led out what was said to have been the largest army seen on British soil.

The Battle of Bosworth

The two armies camped some 3 miles apart just south of the village of Twycross in Leicestershire, but without Lord Stanley, who arrived late with his Lancastrians and additional Cheshire troops. The majority from Macclesfield were apparently with Sir John Savage IV, who intended to join Richmond before battle commenced.

Richard saw Lord Stanley and his troops approach, and sent an order to join him at once. Stanley, who presumably did not know whether or not his son was still alive, made a bold decision and refused the invitation, at which point Richard ordered the beheading of his son. Fortunately the execution was delayed as preparations for battle were of the utmost priority.

Early the next morning of 22 August 1485, Richard positioned his army on Ambion Hill after leading them alongside a large marsh that divided the two armies, and immediately ordered the attack to begin.

The number of troops taking part in the encounter has been variously calculated over the years, providing estimates for Richard's army of between 8,000 to 12,000 men, with an agreed difference of between 2,000 to 4,000 less under Henry's command, but with an additional 4,000 to 6,000 under the command of the Stanleys. Taken at the ultimate it suggests a figure of some 24,000 men involved during the course of the battle.

Amongst Henry's army, apart from his Welsh forces and Continental mercenaries, his strongest support came from a large French presence and also a prominent Scottish contingent, and by none other than Alexander, Duke of Albany (confused by one writer with the French Duke of Aubigny). Alexander must have involved many of the Scots and also some of the French nobles, to whom he had no doubt promised concessions if made King of Scotland.

On learning of the death of Edward IV, Alexander, devastated and evidently incensed by the murder of Edward's two sons, transferred his allegiance from Richard III to Henry Tudor. He must also have judged that by supporting Henry, the latter would ultimately help him gain the Scottish throne.

William Stanley and his powerful force were lined up on Henry's side of the marsh, but quite separate from the main force, adopting

a pragmatic strategy after promising Henry their allegiance. Northumberland was also separated from Richard's main force, but his intention was more questionable as things turned out. Lord Thomas Stanley's men were weary and footsore, and the question of their allegiance in the unusual position in which they found themselves was confusing. Some lived in the unique palatinate of Cheshire and Flint, and accordingly had to reconcile themselves to whoever was Earl of Chester, whilst those from Lancashire had a strong affiliation to Lord Stanley.

Thomas Stanley, however, had made up his mind and seemed determined not to waste the lives of his men unnecessarily. By holding back, possibly waiting to see at what stage of the battle Northumberland would become involved, or waiting for a crucial stage in the battle when the combatants were growing tired fighting in the quagmire into which they would inevitably fall, he could engage his more refreshed men to greater advantage. Sir Piers Legh V was also present, apparently following Thomas Stanley's lead.

The Tudor cannonry initially played its role after the first volley of hundreds of arrows were shot almost simultaneously by the archers of both armies. Then followed close combat with swords, daggers, lances and poleaxes as the next preferred weapons. After almost two hours of intense fighting, when urged to come forward by Richard, Northumberland remained where he was, either impeded by the terrain or in the same mind as Lord Stanley. Richard furiously battled his way towards his foe, when he saw Henry Tudor in a vulnerable position. Urging his horse forward he raced over the hill, but the horse fell; he picked himself up, forced his way forward, and came to within striking distance of Henry. Totally unaware of what was happening around him, he did not see William Stanley rush into action with his men, and was instantly surrounded, fighting in vain for his life. Henry Tudor had finally gained his victory.

Richard III's dead naked body was carried on horseback to Leicester for display to prove him dead, then buried in a simple tomb within the church of the Greyfriars, later to be destroyed during the Reformation.

Whether or not myth or legend, Richard was said to have worn his circlet (i.e. a lightweight crown) at the start of the battle, and it is recoded that he and his wife on occasion had walked through the streets amongst the people wearing their crowns. In the aftermath of the battle it was claimed that William Stanley found the circlet caught on a hawthorn bush, and his brother, Lord Thomas Stanley, handed it to Henry Tudor, who was proclaimed king at the top of the nearby hill, which became known as 'Crown Hill'.

2

TUDOR TIMES

Henry VII
In many ways the Battle of Bosworth Field signified a turning point in the history of Macclesfield, allowing the Savage and Stanley families to gain considerable importance and control of its affairs.

With any new reign the established boroughs could petition for renewal of their town charters, incorporating privileges. Accordingly, Henry VII, confirmed by his coronation on 30 October 1485, received a plea from the remnant of Macclesfield burgesses, left to control its borough affairs after his accession to the throne. Their situation seemed untenable, for they wrote of their desperate plight due to their devastating losses at Bosworth. This had resulted in such a reduction of their number that their quota was below that required, i.e. 120, but wished for their charter's renewal.

Exactly what happened at this period can only be suggested by conjecture, for according to Corporation records the names of the mayors from 1479 to 1492 are missing, yet the business of the borough must have continued up to 1485 for the letter to have been written. (As the name of John Savage IV's son Lawrence is recorded as a possible mayor for 1492–93 it would seem that the Savage family had used their control to revitalise the township between 1485 and 1491, allowing borough proceedings to take place under their jurisdiction, with an eventual renewal of the charter.)

After Parliament's acknowledgement of Henry VII as sovereign, he soon rewarded Sir John Savage IV 'in consideration of his services

in our glorious and victorious battle [Bosworth Field]'. Sir John was granted the Macclesfield parkland for life and for his heirs. His son, John Jr, who was also a commander at Bosworth, was rewarded with several manors forfeited to the Crown in various parts of the country and became a Knight of the Garter. The family's dedication to Macclesfield, however, was to be their primary concern during the following few years, and several of Sir John IV's children, ten of whom were sons, would settle in the Macclesfield township, manor and forest. Of his five daughters, Ellen had already married Sir Piers Legh V of Lyme in 1467 and Catharine was the wife of Thomas Legh of Adlington, son of Robert Legh VI.

As Buckingham's son and heir was still a minor, he did have his original estates and positions eventually returned by Henry VII, but it does suggest that the majority of Macclesfield men taking part at Bosworth fought under the banner of Sir John Savage and his son. Both Sir Thomas and William Stanley, in holding their positions during nearly two hours of fierce fighting before committing their men to battle, would logically have suffered far less casualties than those of the Savage recruits, amongst whom must have been the bowmen from Macclesfield Forest complemented by their town burgesses.

* * *

The Stanleys were well rewarded, despite Lord Stanley's ambivalence during Richard III's reign. Sir Thomas Stanley, who had received his knighthood from Henry VI and been made Governor-General of Ireland for six years, subsequently enjoyed an important political career before dying in 1459. His eldest son Thomas, aged twenty-four years, succeeded as Baron Stanley. At Blore Heath in 1459 he had raised 2,000 men in support of Queen Margaret, but, located at a distance of only 6 miles, he had kept them out of the battle. His brother William fought on the side of the Yorkists, but Thomas was impeached as a traitor, yet the queen chose to overlook the affair. He did support Henry VI at Northampton, and in January 1461 was rewarded with the position of chief justice for Chester and Flint.

By 1471 Thomas was fighting on behalf of the Lancastrians and took part in Edward IV's French expedition, but privately curried

Military Macclesfield

favour with Louis XI of France. In that year he married the staunch Lancastrian widow Margaret née Beaufort, whose husband, Sir Henry Stafford, the youngest son of Sir Humphrey Stafford, 1st Duke of Buckingham, had predeceased his father.

Margaret was a powerful personality, twice widowed and a wealthy heiress, and most significantly the mother of Henry Tudor, Duke of Richmond, by her first consummated marriage. Her support for the Lancastrian cause and her strenuous efforts to bring about her son's acceptance as the last legitimate claimant to the throne on behalf of the House of Lancaster jeopardised Sir Thomas Stanley's position with Richard III. He therefore did much to restrain her until the time was right for appropriate action. Having proved his loyalty to Henry at Bosworth, and as a consequence was, by then, stepfather to the King of England, he was rewarded with the title 1st Earl of Derby on 27 October 1485. He also gained many forfeited estates around the Manchester area and, having already received the stewardship of Macclesfield Forest during the reign of Richard III, King Henry confirmed it as hereditary.

The Stanley Arms Inn today, close to Wildboarclough in Macclesfield Forest, is a reminder of Sir Thomas Stanley's stewardship of the forest and his elevation to 1st Earl of Derby on 27 October 1485.

The kinship between the Savages and Stanleys, which extended to the Leghs, had delivered substantial control, therefore, into capable hands, which would be of great benefit to the sovereign, for apart from the Savage control of the parkland and township, the Earl of Derby had considerable jurisdiction over a vast area of east Cheshire and south Lancashire.

* * *

The new king adopted the usual conciliatory procedure of offering pardons after his seizure of the throne. Northumberland, who had been held in captivity since Bosworth, pleaded his non-compliance to Richard III's command to join him at the height of the battle. He had been generously treated by Richard, who had restored his lands and appointments and had made him great chamberlain of England, forfeited by Buckingham due to his rebellion of 1483. He had also received the lordship of Holderness, held by the Stanleys for a considerable period. His supplication was accepted and his original estates were returned to him.

Not everyone in England had accepted Henry as king, despite his marriage to Elizabeth of York, eldest child of Edward IV, on 18 January 1486, and subsequent disturbances in Yorkshire forced Northumberland to mobilise 800 men. Henry had hoped that his marriage to Elizabeth would bring an end to the feuding between the rivals and supporters of both the Houses of Lancaster and York. Eventually it would, but meanwhile his hope of peace would be disturbed by impostors purporting to be surviving claimants from the House of York.

With the birth of his son Arthur on 20 September, nine months after his marriage, a new Prince of Wales and Earl of Chester came into being, although Henry had never held the titles himself. He placed the child in the care of his mother, with whom he had a special bond, although she had seen little of him as a child.

The Battle of Stoke Field
The following year the first impostor to appear was a Lambert Simnel, claiming to be the young Earl of Warwick, eldest son of the

deceased Duke of Clarence – the boys had apparently been born on the same day. Under the direction of an unscrupulous priest, Simnel was presented to the pope as the rightful claimant to the English throne, and the boy, groomed for his new role, began to believe in his own destiny and behaved with 'some extraordinary dignity and grace'. He achieved great success in Ireland where he was crowned King Edward VI. Assisted by the 8th Earl of Kildare and Germanic mercenaries, he invaded England by landing at Furness in Lancashire in June 1487, where he was soon joined by Yorkist supporters.

Henry VII, well informed of the event, wrote to His Holiness assuring him that the boy was of unknown illegitimacy. No one at that period knew of his paternal connection as the son of an Oxford joiner. After a council meeting in Sheen, a reassured Henry had the young Earl of Warwick removed from his confinement in the Tower and escorted through the streets of London, proving to the inhabitants that Simnel was an impostor.

The newly arrived invaders had by then made their way into Yorkshire, expecting great support, unaware that Simnel's deception was at an end. The Earl of Derby appears to have been in London at the time of Simnel's march south through Yorkist areas, until the latter eventually arrived outside Tadcaster with a force of some 8,000 men. There the troops were divided and, whilst one section easily defeated a small Lancastrian contingent of some 400 men, another part of the army diverted Northumberland's men, who had rallied on behalf of the king.

After three days of fighting in Sherwood Forest, Edward Woodville was forced back to Nottingham, but it allowed Derby's son, Lord Strange, to arrive with his considerable reinforcements, amongst whom would have been the longbowmen from the forests of Wirral and Macclesfield. With their presence Henry's numbers had swelled considerably and, with last-minute Welsh arrivals, they well exceeded those of the Yorkists. In any event, the Lancastrians had the better commanders, added to which Simnel was a very inexperienced individual when it came to warfare.

The usual battle formation was drawn up by Henry: the vanguard was led by the Earl of Oxford with archers on the flanks. The Yorkists remained concentrated in one crowded single formation on a hilltop. The attack began with the usual formidable longbowmen letting fly volley

after volley of arrows, which caused devastation amongst the sparsely armoured Irish troops. Although the Germanic mercenaries had the latest handguns and their initial charge into action almost overcame the Earl of Oxford's stout defenders, fierce hand-to-hand fighting for three hours, during which Henry held back his reserve soldiers, finally won the day. By the end of the battle one chronicler, Jean Molinet, wrote that thanks to the superb efforts of the archers the Yorkists resembled 'hedgehogs' full of quills. It was a final decisive victory for Henry VII, with the four Yorkist leaders found dead on the battlefield.

The Derby arms as they appear in the border of the 1610 map of Derbyshire.

Simnel and others who had survived were forgiven, and Henry's generosity was able to placate many of his former opponents. Later that year the queen was crowned 'with great splendour' on 25 November, and Thomas, Earl of Derby, played an important part in the proceedings, as he had done on the occasion of Henry VII's coronation.

Brittany

After settling matters in England, problems in France demanded attention once more. King Charles VIII, who had succeeded his father in 1483, had attacked Brittany and confined the duke in Nantes for a period. English sympathy was with the Bretons, and Sir Edward Woodville, uncle of the queen and governor of the Isle of Wight, sailed with volunteers to aid the duchy in the spring of 1488. Henry had been voted a subsidy in the event of a required invasion, but he preferred a more diplomatic and peaceful approach. He denounced the action as unauthorised and renewed the French truce for a further year. It was all in vain, for Lord Woodville and almost all of his men were slain in the Battle of St Aubin on 28 July 1488. The Duke of Brittany quickly made peace with France, but died less than three weeks later.

The duchy was inherited by Anne, the duke's daughter, and Henry sent a peacekeeping force to be opportunely in place whilst the truce lasted. In November, after a great council at Westminster, he sent embassies to France, Brittany and Burgundy, and at the same time included the Holy Roman Emperor Maximilian and the sovereigns of Spain and Portugal.

The New Year Parliament of 1489 provided a subsidy for an English defence force of 10,000 archers. The levy, unacceptable in Yorkshire, was in the course of collection by Northumberland when, on 28 April near Thirsk, having faced the rebels whilst leading forward his men, he was mowed down and killed.

Despite the occasional affrays the money was collected, allowing Henry to send troops into the Netherlands to assist Maximilian, who through marriage had acquired Burgundy and Flanders and was fiercely resisting French aggression. Charles VIII, however, continued to press for Henry's removal of his troops from Brittany, but in the midst of the turmoil Anne married Charles VIII.

With the considerable number of archers engaged in the defence of England or serving in the Netherlands, it is inconceivable that young males from Macclesfield, whose fathers had died during the battles of the last few years, would not have been included. It was an ideal opportunity for them to gain experience in their introduction to warfare.

What is overlooked time after time is the role of widows, and often daughters, in the aftermath of battles, and those whose husbands had returned maimed or injured. Particularly so, as in the instance of Macclesfield, where depleted male numbers occurred within a relatively small area, or one of a difficult administrative nature such as Macclesfield Forest. Families had to be fed, and the arduous tasks of farming, hunting or running businesses had to continue, encompassing many duties and responsibilities that the women had done (and done well) during their husbands' military absences. The Exchequer still required payment of forest rents and the annual payments of 12 pence each year from the occupied township burgage plots. The task of filling empty properties, whether within the forest, manor, parkland or township, would fall within the jurisdiction of the Savage family and the Earl of Derby.

The more fortunate widows had young or younger sons to assist them, but the tragedy was that, during the Wars of the Roses, the rapidity with which battles nationally took place meant that sons had hardly reached manhood before they were snatched away.

Though no longer visited by sovereigns hunting in the forest, the links remained between royal officials, their servants and the town, helping to strengthen once more the personnel network, active since the days of the Edward the Black Prince, connecting London, Cornwall, Wales, Chester and the Macclesfield area. Also playing their part were members of City of London guilds and others in the provinces who looked after their widows and orphans.

French Matters

Henry waited for one year before his planned French invasion took place, although his allies were not fully prepared. In October 1492 he laid siege to the well-fortified town of Boulogne. Amongst the casualties was Sir John Savage IV, who died from his wounds, which

supports the presence of Macclesfield troops. Finally Charles VIII offered peace, promising to pay Henry's expenses for defending Brittany and the two years' pension arrears of £5,000 per annum. The treaty, signed at Étaples on 8 November, resulted in the English army's homeward return to the anger of many, who, due to the enormous expense of providing men and equipment, had once again been deprived of booty with which to redeem the indebtedness of their estates.

Above: Effigy of Sir John Savage IV in the south wall of St Michael's nave, Macclesfield.

Left: Details of Sir John's sword and leg armour. There is also an SS collar around the neck revived by Henry VII from earlier centuries.

Some months later Sir Piers Legh V, having followed the Stanley lead at Bosworth by changing allegiance to Henry after the battle had commenced, was given the lucrative stewardship of Blackburnshire in Lancashire. Perhaps this was in compensation for his considerable financial outlay in sending men and their accoutrements to be part of the French campaign.

Another of Henry's problems was a certain Perkin Warbeck purporting to be Prince Richard, the surviving son of Edward IV, who had found refuge at the French court. Under the Étaples treaty Charles VIII was compelled to ask Warbeck to leave. The impostor moved to the Netherlands where Margaret, Duchess of Burgundy, accepted him as her nephew. For two years he was joined by disaffected Yorkists, and as Margaret had control of her estates under the terms of her marriage settlement, her husband Maximilian was unable to intervene despite Henry's constant requests.

Finally Maximilian and Margaret provided Warbeck's needs for an English invasion, although the former, in supporting his wife, was probably grateful to be rid of Warbeck's presence, for Henry's alternative had been to ban trade between England and Flanders. Henry had threatened to establish a mart for English cloth in Calais, to the fury of the Hanseatic League merchants and their Hanse counterparts in London. Spies had been able to report back to Henry of their observations in respect of Yorkist movements, which resulted in several arrests and four executions, one of which was that of William Stanley.

Preparing for invasion, Warbeck delayed until 1495. First came an attempted landing at Deal, resulting in the loyal country people taking action. Several men became prisoners, whilst the remainder were forced to set sail for Ireland, where they met with no success. Finally, claiming to be King Richard IV of England, Warbeck was welcomed by James IV of Scotland and there, during his few months stay, married 'a high born Scottish lady'. James, accompanied by his army and his newly acquainted 'King Richard', marched quickly across the border into England, but soon returned to Edinburgh when an anticipated Yorkist revival never took place.

During the following year – 1496 – King Ferdinand and Queen Isabella of Spain were anxious for Henry VII to join the Holy Alliance

in order to prevent France advancing into Italy. Henry finally relented and, as promised, they sent their most accomplished diplomat to Scotland to broker peace between James IV and England. Henry offered his daughter Margaret in marriage to James, but insisted on the reciprocal action of James sending Warbeck to him. This created an impasse and, having received Henry's dismissal in July 1497, the diplomat departed. This gave James the opportunity to cross the border again and lay siege to Norham Castle. Due to its vulnerable situation the place had been strongly garrisoned, and the English troops were well prepared.

The person with whom James had to contend was Thomas Howard, 1st Earl of Surrey and 2nd Duke of Norfolk.

* * *

Howard was an interesting character who had been loyal to Edward IV and fought beside him at Barnet. Soon afterwards he volunteered to support Charles, Duke of Burgundy, against Louis XI, but returned to England in 1473 before accompanying Edward to France at the head of six men-at-arms and 200 archers. He was knighted on 18 January 1478, and in 1483 became a Knight of the Garter. As a privy councillor and steward of the household he had sworn allegiance to the wearer of the crown, whoever that might be, and as a consequence felt compelled to acquiesce during the reign of Richard III by supporting the king at Bosworth, much to his disadvantage.

After Henry's victory Howard was committed to the Tower for three years and suffered forfeiture of his vast estates. However, he refused to take part in any rebellion against Henry VII, even when the door of his cell was left open by a disloyal jailer. Henry began to appreciate Howard's character and loyalty, and in January 1489 ordered his release. Although his title was restored, Henry withheld his former lands, but did return the lands pertaining to his wife's inheritance and those that had been granted to the Earl of Oxford. The rising in Yorkshire, during which Northumberland was killed, was quickly put down by Howard, who hanged the leader in York. His prompt action earned him the position of lieutenant general of

the north, and after quickly subduing yet another Yorkshire uprising he was considered to be the chief general in England. Those from Macclesfield who fought with the northern army would therefore come under his ultimate command.

* * *

By 1497, in charge of the Scottish–English border Thomas Howard was quick to act, and relieved the besieged Norham Castle. He followed James IV and his company back into Scotland, and challenged the king to battle. Weak in character, James refused to fight and then terrible weather intervened, during which Howard sensibly returned with his troops south into England.

Aware of Howard's initial action, Henry had sent an extra force to support when he was taken completely by surprise with the arrival of Cornish rebels on Blackheath protesting against the war levy. He quickly recalled his subsidiary force led by Lord Daubeney, which was totally successful in quelling the rebellion, resulting in the execution of the three ringleaders.

Warbeck, meanwhile, had quickly departed for Ireland, and having learnt of the Cornish unrest, landed there in September. This time he was able to rally 3,000 men and set out for Exeter. Hearing that troops had been sent to intercept them, he sought sanctuary in Beaulieu Abbey, whilst Henry was joyfully welcomed in Exeter where he gave his sword to the mayor in appreciation of his loyalty. Warbeck sent the king an appeal and, assured of his life, he surrendered. His wife was taken to St Michael's Mount and treated with utmost respect before being sent to join the queen. Unfortunately, after a failed attempt to escape, Henry had no option but to confine him to the Tower and impose fines on all who had supported him.

Finale

It was not long before another impostor, Ralph Wilford, surprisingly claimed to be the Earl of Warwick. Henry's patience in accepting yet another plea from an impostor was at an end, and the man was hanged at Tyburn in February 1499.

The intrepid Perkin Warbeck, learning of the affair from his jailers, contrived with them to send messages to the real Warwick. The uneducated and simple-minded boy was offered freedom, and through Warbeck's scheming was drawn into another of his plans doomed to failure. Henry, weary and exhausted after all he had endured with the subterfuge, saw Warbeck tried and hanged at Tyburn on 23 November. The poor unfortunate Warwick might have been pardoned had it not been for the interference of King Ferdinand; the boy had pleaded guilty, but after his trial he was beheaded on 28 November at Tower Hill.

Ferdinand had insisted on the latter action because of the betrothal of his daughter, Katherine of Aragon, to Henry VII's eldest son and heir, Arthur (named after King Arthur of the Round Table). The King of Spain was anxious that there should be a decisive end to any further rebellions before Katherine became queen of England in due course. The marriage took place between the fifteen year olds on 14 November 1501 before they departed for the English side of the Welsh border; there Arthur died on 2 April 1502 at Ludlow.

During the following year Henry's wife died in childbirth, leaving him stricken with grief, but one consolation was the marriage of his daughter Margaret to James IV on 8 August. Ferdinand and Isabella then took the opportunity to press for the return of Katherine's dower, for no children had been produced, but Henry refused. Probably in an effort to force the issue, he suggested that he should marry his widowed daughter-in-law, as Katharine herself was adamant that the marriage had not been consummated. Isabella was shocked and demanded Katharine's return to Spain, but Henry, ever the diplomat and seeking peace, obtained their agreement to an alternative marriage to his surviving son, Henry. The marriage settlement, as previously agreed, could therefore remain the same, with promise made for payment of the outstanding portion of the dower.

The following year the dispensation for the marriage was granted by Pope Julius II and sent to England by Ferdinand, but the further payment was not received. This forced Henry to insist that, on this second occasion, receipt of the additional dower must be made before the marriage could take place. Shortly before his death on 29 April 1509, despite the non-payment, Henry did tell his son that he could marry whoever he desired when he was king.

Tudor Times

The somewhat uneasy peace of the last decade had at least allowed Macclesfield to build up its resources once more and, thanks to Thomas, brother of Lawrence Savage, a grammar school had been established in 1504 next to the parochial chapel bordering the market square. It was built to accommodate the Savage family tombs on the ground-floor level, whilst the upper floor housed the schoolroom and the room of the first headmaster, who was a Roman Catholic priest. Extensive alterations to the main body of the church and Savage Chapel during the last two centuries have created one remarkable building. And with the removal of the original ceiling over the chapel area to increase its height, although the priest's room remains in situ above the stone spiral stairway, no trace of the schoolroom remains.

The Savage family gained much favour with Henry VII. Before his death Thomas Savage, who had entered the priesthood as a young man, had finally become Archbishop of York in 1501. His tomb is in York Minster.

Tomb of Archbishop Thomas Savage in York Minster, who died 3 September 1507. (Photo courtesy of Gordon Darlington)

Henry VIII

Born at Greenwich on 28 June 1491, by the time of his father's death Henry had been appointed lieutenant of Ireland (1494), created Duke of York (1495) and admitted into the Order of the Garter (1495). Following the death of his brother Arthur, he had also gained the title Prince of Wales on 15 February 1503, and the earldom of Chester.

Young Henry had grown into a tall, handsome and extremely well-educated man, fluent in French and Latin, athletic, could argue philosophy with any of the Church hierarchy, and had a great passion for music and astronomy.

Katherine and her sister had also been well educated, for their father wanted marriages worthy of his daughters and Spain. During her widowhood, and still in England, the best tutors taught both her and Henry, from whom they acquired a vast knowledge of canon and civil law. They also knew Desideratum Erasmus, the famous Dutch scholar, who had visited Oxford in 1498 before becoming Professor of Divinity and Greek at Cambridge.

Although Henry VIII was four years younger than his bride, he had grown to appreciate her profound intelligence and seemed extremely happy with his choice of wife. They were married at Greenwich on 11 June 1509, with their coronation taking place at Westminster on the 24th. As Henry was eighteen years old four days later, he could rule in his own right and avoid any unnecessary complications arising from a minority rule.

For two years there was peace, but then came several opportunities for Macclesfield archers and infantry men to be part of the renewed hostilities on the Continent, as Henry, although enamoured with jousting tournaments, feasting and dancing, became restless to prove England's might and regain some of the Continental possessions.

In 1511, at the request of Margaret of Savoy, regent of the Netherlands, 1,500 archers were sent to her aid. This was followed in May 1512 by an agreed force sent from Southampton to take part in an attack, orchestrated by King Ferdinand from the north of Spain, to recover Guienne for the English Crown from the French. Unfortunately no provision had been made for the English arrival and the troops began to mutiny, forcing their leader, Thomas Grey, Marquis of Dorset, to order their return, much to the fury of Henry.

Tudor Times

One year later, whilst Henry built up his naval force, he sent two detachments, totalling 14,000 men, to Calais. They were initially commanded by George Talbot, Earl of Shrewsbury, and Lord Herbert. Henry followed in June 1513, and after arriving in Calais he ratified agreements with the Emperor Maximilian then left, leading his army from the port. Augmented by 8,000 Germanic mercenaries, he entered French territory on 21 July.

Four years after Charles VIII's incursion into Italian territory during 1494, he had died, so it was his son and successor Louis XII who would have to deal with the young King of England. Amongst the English troops was Thomas Stanley, 2nd Earl of Derby and son of Lord George Strange. He had succeeded to the earldom following his grandfather's death in 1504.

At that time a treaty existed between France and Scotland to allay fears of an English invasion, for it stipulated that whichever country was invaded first, the other would reciprocate by invading England. With this in mind Henry had ensured that a greater part of his army was enlisted from the Midlands and south of the country, leaving the army of the north to deal with any Scottish reprisals. However, knowing the strength of the archers from the Wirral and Macclesfield forests, to suggest that Lord Derby was there without some of his elite soldiers does not seem feasible.

Also present was Edward Stafford, 3rd Duke of Buckingham, who, since Henry VIII's succession, had risen quickly through the ranks, finally attaining captain of the English army in France from June 1513 and in command of 500 men.

As regards the Leghs of Adlington Hall, Thomas Legh, son of Roger VI, was a little over sixty years of age and his only surviving son, George, was barely sixteen. There is no mention of their inclusion in the French campaign.

Sir Piers Legh V of Lyme, having become a widower in 1491, resigned his stewardship of Blackburnshire in 1511 and retreated to Lyme, from where he entered the priesthood. It was said that he had probably been encouraged to do so by his late brother-in-law Archbishop Thomas Savage.

The Fittons, so numerous at Bloreheath, yet pardoned by Henry VI on 29 April 1460, would surely have been involved in some way

in Henry's war preparations. Edward Fitton, who had inherited Gawsworth at sixty years of age on the death of his brother in 1494, had himself died in 1511. At the time of his death he was a forester of Macclesfield Forest and possessed several properties in the township and surrounding villages and manors. His son John inherited the estate, at which time he was at least forty. Perhaps due to his father's death he had been excused military service in France, but was held in reserve should James IV of Scotland undertake an invasion. However, that does not mean that he did not provide a few of his archers for the French campaign.

With regard to the Jodrell family, again there is no definite evidence that any were with the English army in France. When Nicholas Jodrell of Yeardsley, grandson of Roger Jodrell who fought at Agincourt, became head of the family about 1500, he had two brothers, John and Otiwell, and three grandsons, Roger, John and Otiwell, who seem to be of an age for active service. Because of the family's later involvement in military campaigns, it can only be assumed that they at least provided some of their best archers under Lord Stanley's command, even if they were not present themselves.

* * *

On 21 July 1513 Henry left Calais with what was said to be 'a magnificent army', but heavy rains intervened for twenty-four hours, and, with little protection provided by the tents overnight, Henry rode around the camp in the early hours of the morning encouraging those on duty. Four days later the army entered French territory then continued slowly. Rebuffing several pockets of resistance, they finally camped before the garrison of Thérousanne on 4 August, intending to meet up with the two divisions under the Earl of Shrewsbury and Lord Herbert. A week later, despite the awful weather, Maximilian and the king met briefly, during which the emperor agreed to serve under Henry, and Henry promised to pay the emperor's soldiers together with his own.

On Friday 13 August Maximilian and his entourage rode to Henry's camp, where the king, keen to impress, invited him into his

Roundel from a stained-glass window featuring two halberdiers, probably German, carrying their halberds and dressed in fashionable ceremonial military attire c. 1520. The halberd was longer than the poleaxe; it had a hook fashioned on the opposite side of the cutting edge of the blade with which to unseat a mounted soldier. (Private collection)

gold tent with great ceremony. That evening, having been warned by a scouting party that the French army intended sending supplies to the besieged town of Tournai, several commanders, including Edward Stafford and 8,000 men, marched out to meet them. The French, awaiting an opportunity to surreptitiously pass the English camp, saw them coming and abandoned the attempt.

At this juncture Henry's anticipated invasion by the Scots became a reality when a messenger arrived with an ultimatum from James IV. He demanded that Henry must vacate French territory, otherwise his invasion of northern England would begin. Knowing that James had been excommunicated by the pope because of his support for the French expansion into the northern Italian states, Henry stated the

religious reasons for not leaving French soil, which were dismissed by the recipient. Ignoring the threat Maximilian marched forward with Henry on 16 August to meet the enemy in what became known as the Battle of the Spurs.

The Battle of the Spurs

During the night of the 17th, carpenters constructed five bridges to enable troops to cross over the River Lys. By daybreak the light infantry were the first to cross, followed by Henry with the heavy artillery. He was shortly informed that a company of French horsemen had lain in wait behind the castle of Gyngate, but had been despatched by a group of English lancers, except for one who was captured. The man revealed that 15,000 French heavy cavalry were taking up positions on the other side of the Lys to prevent Henry's additional forces, commanded by Shrewsbury and Herbert, riding to his aid.

Henry first positioned his artillery, then gave instructions for his headquarters and other tents to be erected, leaving Lord Thomas Darcy to keep the treasury and other valuable possessions safe. Darcy had been appointed captain of Berwick in 1498, followed by treasurer and chamberlain from 1501, so he was ideally suited for his responsibility. Although Berwick was an English garrison town, its fortifications had needed repairing for some time, but Darcy left his son in control, having been assured by his Scottish contacts that James VI was unlikely to cross the border.

Henry next led forward the cavalry and foot soldiers, but at a distance of almost a mile the mercenaries, for some unknown reason, quickly moved to Henry's left flank, leaving those in the van exposed. The English scouting party returned shortly with news of some 12,000 Frenchmen moving in their direction and drawing near.

The ordnance, having set up a number of artillery weapons on a nearby hill, continued with Henry amongst his cavalry and mounted archers. Finally his commanders persuaded him to remain with his foot soldiers at the rear, whilst his Burgundian troops of 1,100 divided into two groups. The first of 700 rode to the top of a hill to join 100 mounted longbowmen. As the French had come into view, the bowmen quickly dismounted and ran under cover along a nearby hedge

close to the village of Bomy. They managed to bring down several French horses with their arrows, allowing fierce fighting between their lancers and French counterparts. Suddenly, throwing down maces, lances and swords, the French hurriedly remounted and galloped away at great speed, to the astonishment of Henry and his army.

Those on the hill, seeing their French vanguard fleeing, also abandoned the fight and were chased by the Burgundians. The French suffered a total rout, and after being pursued by English cavalry for 3 miles they managed to reach a river in a valley. As it was a gloriously sunny day the spurs of the fleeing troops produced a remarkable effect, for they glinted in the strong sunlight, hence the name adopted by the English for the battle.

The Earl of Shrewsbury, who was later joined by the king, had fought hard on the other side of the Lys. Lord Herbert's force suffered an artillery attack from the citizens of Tornai, but finally forced them back to the city gate where many were slain.

On the 22nd the garrison of Thérousanne surrendered, allowing Henry and Maximilian to walk in. After surveying the interior Henry ordered a complete demolition of the fortifications. By 12 September he had arrived in Lille to visit Margaret of Savoy and Prince Charles of Castile, and then travelled to the outskirts of Tornai when news of the battle against the Scots arrived.

Flodden Field

While in France Henry's judgment of Queen Katherine's abilities were such that he left her as regent of the realm, and she did not disappoint.

For some time conflicting reports of James IV's intentions had been received, but the hope was that the Treaty of Perpetual Peace, signed by James IV and Henry VII in 1502, which included the stipulation that Berwick would remain English, would be respected, although it was initially limited to seven years.

On 21 July 1513, as commanded by Henry, Thomas Howard, Earl of Surrey, as lieutenant general of the northern army, was sent north as a precaution and collected men and money en route.

By 4 August Katherine had received news of James's intention to wage war despite desperate pleadings from Queen Margaret, and she

immediately sent orders north to Sir Thomas to begin mustering his army. At seventy years of age he had not lost his ability to organise a sufficient and effective force with which to plan his strategy. He immediately ordered those in the northern counties to send as many men as possible and meet him at Alnwick. And having managed to rally an army of some 30,000, he instructed his commanders to form a column; then, marching to Berwick, he decided to attack James as soon as possible.

Amongst Sir Thomas's troops was Christopher Savage, brother of the late Archbishop Thomas, leading as many bowmen and artillery men as he could find from amongst the aldermen and burgesses of the Macclesfield township. This fact is very poignant and certainly indicates that the bowmen and others from the Macclesfield Forest were in France with Sir Thomas, 2nd Earl of Derby, and the Duke of Buckingham, for it is the only recorded time that a mayor of Macclesfield led his burgesses to war. However, although Derby was in France, his uncle, Sir Edward Stanley (fifth, and second surviving, son of the 1st Earl, knighted by Edward IV on 17 April 1483 and a pall-bearer at his funeral alongside John Savage Jnr) seems to have acted as his deputy. He had been sheriff of Lancashire in 1485 and directed to defend the county from a Scottish invasion, and later became a commissioner for Westmorland and Yorkshire. He was a royal favourite who had received several grants of land, and, in the absence of his nephew, was commanded by Sir Thomas Howard to raise troops for the battle ahead. It is therefore under his banner that the Macclesfield contingent must have been recruited.

Unfortunately there was a clash of personalities between Sir Thomas Howard and Sir Edward. The former was said to be envious of the position Stanley held amongst King Henry's favourites. Stanley, however, had gained a reputation for his valour and bravery in battle, and Howard would have had no choice but to send for his assistance.

* * *

Meanwhile King James's Scottish force had crossed the River Tweed at Coldstream and Lennel on 21 August, after capturing the border

castles of Norham and Etal. His army, which had outnumbered the English two to one, had already dwindled due to garrison duties and desertions but still outnumbered Surrey's men.

Leaving Berwick, Sir Thomas advanced with his men towards the River Till, but having set up his tent, appreciating that James was only a short distance away, decided immediately to cross the river. The accounts of what happened next, on 9 September, as later written by chroniclers and historians, are so varied in content that it is only necessary to relate details common to most in order to appreciate what the Macclesfield contingent must have been part of, and witnessed, on that memorable day.

On learning of the rapid crossing of the river, King James assumed that the English army would occupy a small hill that lay between the two armies. Hoping to confuse the enemy with billowing smoke, he had a series of large fires lit along a ridge of Flodden Hill. He was confident that the English army would quickly disperse when they saw his men and fine weaponry in a well-appointed position, and hurried with his men in full battledress to gain the hill.

Sir Thomas, presumably to taunt him, on appreciating what James had done, asked him to come down and fight. James rejected the request, but apparently did not appreciate that surreptitiously the English army, probably part aided by the smoke screen, was moving the heavy guns into position to combat any downward attack and also creeping along to encircle the Scottish army by keeping very close to the hill, thus avoiding the Scottish cannon fire.

Sir Thomas had initially divided his troops into two divisions, each with a commander in the van, and each with a left and right wing. Stanley, known for his valour and skill, was the assumed choice of commander to lead the van of the main division, but Howard placed him at the rear in charge of the left wing.

James had greatly miscalculated English resolve, and presumably, as the smoke began to clear, he realised what had happened and sent down his first division to begin the attack. Thomas Howard fought valiantly alongside his men, but the fighting was fierce and many would not have been involved in an actual battle before this encounter, so several panicked and fled. Ironically, by their action

they were the catalyst for providing an English victory, for James delightedly observed their departure and thinking that the whole army would turn tail and run, he charged downward and leapt from his horse. Seizing a weapon he thrust himself into the battling throng followed by his nobles.

It was later said that Edward Stanley and his men from Lancashire and Cheshire, having fiercely fought their way through for a couple of hours, managed to come forward and were amongst those who surrounded the elite of the Scottish army. A ferocious struggle ensued during which almost all of James's knights were slain, and he, foolishly ill-equipped with only one weapon, was killed either by Stanley or one of his men, but Sir Thomas never acknowledged this. It was left to Thomas Rudhall, Bishop of Durham, to advise King Henry later of Stanley's great effort and recommend that he be elevated to the peerage. Consequently Sir Edward Stanley was created a Knight of the Garter on 8 May 1514 and received the title Baron Monteagle.

Sir Thomas Howard had already received an acknowledgement of his great victory some three months earlier, on 1 February 1514, when he was created Duke of Norfolk with an annuity of £40 per annum and an addition to his coat of arms.

Despite the fact that he knighted over forty men on the battlefield, only one has a surname that could be associated with Macclesfield – Stapleton. However, the family was originally from Yorkshire, so it could have been a relative from that county.

The English casualties were reckoned as 5,000, which included Christopher Savage and several of his men, but the Scots were said to have lost twice the English total. The body of James IV was transported in a lead coffin to the Carthaginian monastery at Sheen on the outskirts of London, where it remained unburied for some time because of his excommunication.

* * *

In relation to Macclesfield there is a strange ending to this story of the battle, which has variations in the telling, so much so that it needed to be clarified once and for all.

Tudor Times

The only available photo of the Flodden flag taken, with great difficulty, by Laura Debeate of 'LIVE BORDERS', to whom I am extremely grateful.

At the end of the battle a figure was seen staggering along the road towards Selkirk carrying a flag or pennon. Being in a dishevelled and delirious state, the man threw himself and the flag to the ground in the marketplace.

The version that has entered into the folklore of the area is that his name was Fletcher and was of a local family, the only survivor from the eighty Selkirk men who had fought that day. The captured pennon was said to be that relating to Macclesfield and a large bronze statue of the man triumphantly carrying the flag was erected in the marketplace in 1913, where it remains today. Each year, on the anniversary of the battle, a ceremony takes place in Coldstream celebrating Fletcher as a hero.

However, some three years ago a letter was received by the Macclesfield Historical Society from a Selkirk Society, which stated that the man was called 'Snowball' and he had picked up a fallen Scottish flag and staggered along the road with it. As nothing further could be found the author was asked for help. The only additional information that could be supplied was that Snowball was a surname relating to medieval Macclesfield.

Fifteenth-century documents reveal that John and William Snowball lived in Le Dede Street, Macclesfield, and someone by the name of Fleecher (Fletcher – a man who made arrows) was also a resident of the town. This provides four possibilities for the anonymous man.

The next question, therefore, is whether or not the flag, or the remnants of it today on display in the darkest recess of the Halliwell's House Museum in Selkirk, is Scottish, English or relates in any way to Macclesfield. In examining the photograph kindly supplied, the following considerations have been taken into account when reaching a suggested conclusion.

If the Macclesfield contingent had quickly created their own flag it would certainly have borne the lion and the wheat sheaf insignia – it does not. Cheshire was in a unique position at that time being a county palatinate, and the lion represented the royal connection; the wheat sheaf represented the agricultural nature of the county. It was the device used by the county town of Chester and as a consequence was adopted by the Cheshire nobility in their use of arms, and also the borough of Macclesfield.

The Macclesfield manor and forest, which supplied the finest longbow men for the sovereign, would also be allowed to use the device under royal warrant.

The flag does not appear to be a military flag and was much embellished by eighteenth-century bows and a fringe, etc., when it came into possessions of the Selkirk Weavers Guild. However, a write up accompanying the photograph reveals that at one time two shuttles could be seen stretching across its length, together with an eagle and snake.

Military flags at that period were either square or of pennant or pennon form. The latter was usually of a considerable length with the tapering or tail end (known as the fly end) usually divided into two equal parts. What remains now is claimed to be from a pennant (pennon) after it was cropped. Admittedly it is now difficult to imagine the original shape, so one must believe that it was the greater part of a pennant, for it does not appear to have been square.

As seen today, the images suggest that it was part of a tapestry, possibly of silk embellished with devices in velvet, which could be reasonably light to carry. Macclesfield did not become involved with the production of silk fabric, i.e. weaving, until the nineteenth century. Before then it would have been imported; only narrow items such as ribbons and trimmings were produced on handlooms, or brought to the town from London.

The pink flower in the cartouche on the left-hand side is far too artistic for a flag; the Tudor roses are stylised and either red or white, not the beautiful shade of pink as seen.

There is clearly a figure to the right with its left arm bent and its hand grasping the two edges of a long blanket-like cloak, draped around the shoulders and reaching the floor.

What appears to be a hat on the figure's head does resemble a sort of plain helmet shape with a neb at the front. The blanket cloak is edged with a rope-like piping, which may have appeared to resemble a snake originally.

The latter could represent an ecclesiastical connection, as bishops did go to war, but the Bishop of Durham's insignia, who was present that day, in no way resembles the image. It was also necessary to check the coat of arms of Sir Thomas Howard, Earl of Surrey, in overall command; that of Edward Stanley, under whose banner the Macclesfield mayor and townsmen would certainly have fought; and the Savage coat of arms, as they were led by Christopher Savage. However, not one looks similar in any sort of way. The flag could have been brought from France with their troops, or with the mercenaries supporting the Scots.

The conclusion has to be that because of the textile indications it has been assumed that as Macclesfield men were taking part it must have been theirs, which often seems to happen without regard to the facts and only hearsay. The mention of Snowball must have come from somewhere, although the source was never stated, and if he was traumatised and fearing the worst he probably thought that by presenting the local people with one of their own Scottish flags, he would not be lynched and would receive a rapturous welcome, which provides yet another possibility.

* * *

Defence of the Realm

After returning to England Henry must have appreciated the advances made on the Continent in producing weaponry and armour, particularly in the power of guns and canon. He also became more and more obsessed with the defence of his realm and Calais, the latter so vital for English exports. Forts were built along the coasts. The Office of Ordnance in the Tower of London was where the manufacture of large cannon was controlled, with much brass imported at great expense from Sweden. Firearms were being developed, and the longbow, which for centuries had been an enormous success, was rapidly being replaced by pikes, poleaxes, daggers, swords and handguns. Henry at last appreciated that a well-equipped armoured army extolled efficiency and power, which could produce an overawing psychological effect when seen by the enemy, as it had done in the Battle of the Spurs.

What Henry would also have observed was that on the Continent armour was regarded as outer clothing and was therefore part

Above left and right: Sixteenth-century English military helmets. The one on the left, which has lost its visor, seems to be original, but that on the right is a Victorian reproduction. (Private collection)

of the fashion scene. Weapons and powder flasks were becoming decorated to match wall hangings and furniture, etc., with the same patterns as those appearing in the more aristocratic houses. Knights vied with each other for attraction by sporting plumes of ostrich feathers and sashes of coloured silks. One Spanish master of arms considered that armour should be light, secure and also flexible enough to allow freedom of movement. It took practice to move in suits when fighting under a hot sun, and to compensate for the alteration of weight when moving into action. Even the styles of helmets became more varied, and there is little doubt that whilst the English troops were by nature more soberly dressed, items of captured fashionable weaponry would be brought home and copied by artisans within their communities. Someone kitted out properly in armour portrayed his status, and it was a matter of pride that those following the banner of their commander were suitably attired in full uniform, although mercenaries usually appeared as something of a motley crowd.

* * *

Louis XI of France died on 1 January 1515 and was succeeded by Francis I, who renewed the charter with Henry VIII in April of that year. However, Francis undertook his first Italian campaign and won the Battle of Marignano in September. It was the same month that Wolsey became a cardinal following Henry's urgent request to the pope. Wolsey had been extremely helpful to Henry during his war with France and, having become Cardinal Wolsey, because of his acute business acumen and diplomacy, the king made him lord chancellor.

By March 1516 a strategy had been adopted to deal with Francis's overzealous desire to rule northern Italy. Swiss mercenaries had been engaged to combat French aggression, and they marched to Milan, where the French hastily shut the city gates against them. Maximilian, thwarted by Henry who had engaged the Swiss soldiers first, peevishly informed the English agents that until money was provided by Henry, although he wanted to curtail Francis's Italian ambitions, he would

withdraw, and made his way back to his southern German homeland. He threatened to agree terms with France unless 60,000 florins were received, which the senior English agent quickly gave him, much to Henry's chagrin. But needing to keep Maximilian friendly, Henry overlooked the action, ensuring that he would not be committing himself to further payments.

This was the year in which Henry's daughter Mary was born (18 February) and Charles of Castile, grandson of Maximilian, succeeded to the Spanish throne on the death of Ferdinand. Maximilian was angry when he learnt of his grandson's secret pact with Francis. As the intrigues continued Henry was well-equipped to understand what was happening and which actions were necessary to maintain control of matters.

During 1517 there were riots in London against foreign merchants, and throughout the summer months, sweating sickness spread, which seems to have had similar symptoms to Senegal fever, later prevalent in Britain during the months of July, August and September. The following year the pope conceived the idea of collecting contributions for a crusade against the Turks, and sent one of his cardinals to England for funds. Many families in Macclesfield must have wondered what the outcome would be, but there was no call to arms. Even a French embassy arrived offering peace for the return of Tornai and the betrothal of Princess Mary to the dauphin, resulting in two years of temporary peace for the European powers until Maximilian's death in January 1519.

Who would become the next Holy Roman Emperor became a contentious struggle between Charles of Castile and Francis I. Henry, however, secretly offered himself as a candidate, although not on the advice of Wolsey. Charles was elected, and although Francis learnt of Henry's cunning action, he chose to refrain from quarrelling.

Despite the cordiality between the two courts, Henry grew tired of the increasing familiarity shown towards him by some of his favourites after spending time at the French court, where they had become inculcated with French manners. His solution was simple: he dismissed them.

In November a certain Sir William Bulmer, who had left Henry's service for that of the Duke of Buckingham, came before the

king in the Star Chamber and was severely reprimanded. For some time Henry had grown suspicious of Buckingham's great wealth, favouritism, haughty manners and lavish entertainments. The duke, through his father, was a descendent of Edward III's son, Thomas of Woodstock, and his marriage linked him to the Percys – the Countess of Salisbury was mother-in-law to his son, and one of his daughters was married to Thomas Howard, Earl of Surrey. Buckingham hated Wolsey's familiarity with the king, which caused him to take retrograde actions at times, inciting Wolsey to issue a warning that he had better watch how he behaved in the king's presence. Meanwhile, Henry was preparing for the greatest British show ever to be staged on French soil.

The Field of the Cloth of Gold

A complicated situation arose as Henry tried to manipulate the situation between Francis and Charles, resulting in Wolsey arranging two summit meetings. First Charles arrived at Dover late in May 1520 as he was sailing from Spain to the Netherlands. Henry had ridden to the port to greet his guest, and the next day they rode to Canterbury to attend Mass. At Henry's command the Earl of Derby rode between them brandishing a sword. A banquet followed on the Monday before they returned to Dover for Charles's departure. Henry had hoped to prevent Charles from choosing a bride amongst the French nobility, and accept Princess Mary as his wife despite her French betrothal, but instead a promise was made for a further meeting in 1521.

As soon as Charles sailed out of sight Henry left for Calais, taking with him the queen and 5,000 attendants. His intention was to present the greatest impression of wealth and power, which was later referred to as the Field of the Cloth of Gold, and to succeed in some careful negotiating. Amongst his retinue were the Duke of Buckingham together with Sir Thomas Stanley and his wife, Lady Anne.

The meeting took place just over the border with Calais, near Ardres, and no expense was spared. An enormous temporary palace was erected using timber and canvas embellished with porches

and galleries. Tilting grounds were organised and a wealth of luxurious fabrics, such as velvets, satins and gold cloth all made with the finest silks, were sent over from England. The heralds were kitted out in the most splendid tunics with gold braid, and the finest wines (one suspects from Burgundy, as Lord Stanley had an import licence for Burgundy wine) and victuals would have been available.

Francis, in turn, not to be outdone, provided the best that France could offer, ensuring that all his retinue were lavishly kitted out, and created his own city of tents. The showpiece, however, was Henry's beautiful tent of gold, which was composed of three parts, with an elaborate tent-like structure at either end joined together by a long central pavilion.

The festivities lasted from 5 to 23 June 1520, but little was resolved due to the considerable time taken up with feasting, entertaining and jousting. By the time the emperor returned to England as promised, Henry gave him his full commitment to war.

Meanwhile, the Duke of Buckingham, who had been present at Henry's meeting with Francis, came under increased suspicion in the spring of 1521 and was ordered to London, where he was committed to the Tower on 16 April. It is possible that he had been too familiar with the French king on arriving at the Field of the Cloth of Gold, having spent time at his court, and had made it known that he had not been happy with Henry's French negotiations. Certainly there were reports made about him, and he was taken to trial and condemned, with his unfortunate father-in-law having to read the unanimous verdict of guilty. As the axe was turned towards him, it is said that Thomas Howard wept on having to read out the verdict and declare that the execution would take place on Tower Hill.

The axe fell on 17 May, leaving the nation in complete shock and the nobility with the realisation that no further disloyalties would be tolerated. How the news was received in Macclesfield township is conveniently not recorded, but it would shortly be known that the duke's estates throughout the country had been confiscated by the Crown. However, his only son, Henry, who had been present with his father in France, was allowed to obtain a grant of the estates in Staffordshire,

Portrait of Edward Stafford, 3rd Earl of Buckingham, beheaded 17 May 1521 by an envious king. (By permission of the Master and Fellows of Magdalene College, Cambridge)

Shropshire and Cheshire in September 1523. Also included were nine tenements that the duke had owned in the Macclesfield township, including his fortified residence on Milne Street.

Six days after Buckingham's execution the Earl of Derby died and was succeeded by Thomas, his grandson, as 2nd Earl. Within the week, therefore, Macclesfield had lost its two significant overlords.

Wars with France and Scotland

In 1522 Francis I and the emperor has gone to war once more, but Francis had tried to keep the peace with England by restraining the Scottish nobility from invading the north. However, they had demanded the return of their regent, James Stewart, the illegitimate son of James IV created Earl of Moray, who had been detained in France. Francis, not expecting any problems, bowed to their demand, but Henry objected. Francis retaliated by seizing hold of English goods at Bordeaux and refusing to pay the annual pension, which was due. Henry despatched the Earl of Surrey to Brittany, from where he sacked the town of Morlaix. This was followed by the arrival of an army, sent by Henry, to assist Surrey in causing havoc in Picardy.

By April 1523 Parliament forced through a property and income tax to create a four-year subsidy for war, at which point Surrey was replaced by the Duke of Sussex and sent north to prepare for a Scottish invasion.

The expected battles never materialised, and by 1525 the war subsidy had dwindled away. If and where any of the Macclesfield soldiers were serving is not known, yet it is more than likely that many were ready for action and received some sort of retaining pay.

In February 1525 Francis again invaded northern Italy, anxious to capture Milan, but was taken prisoner at Pavia. Henry grasped the opportunity to suggest to Emperor Charles that they should undertake a joint invasion into French territory, but Charles confessed that he had little money, and, unless Princess Mary was sent to Spain immediately with her dowry of 400,000 ducats, he could not prepare for action.

Henry was also desperate for money and therefore could do nothing, which Charles had anticipated, for he wanted to break the betrothal between himself and the princess. However, in March, on the pretext that Henry intended to land an army in France, commissioners were sent throughout the country to levy a tax of 3 shillings and 4 pence in the pound on higher incomes, with a lower rate on others. This caused terrible problems everywhere and, with riots breaking out in London, the demand was immediately withdrawn; those in the north heaved a sigh of relief.

Finally, on 13 July a forty-day truce was agreed with France, followed by an offer of a more permanent peace from Francis's mother acting as French regent. Charles was advised by Henry that he could not refuse the reasonable French offers, and accordingly a new Anglo-French alliance was signed on 30 August and proclaimed in London on 8 September. As Charles still held his prisoner, Francis was forced into leaving his two sons as hostages in Spain and conceding Milan, Naples and Burgundy in order to regain his throne.

Henry took a line of strict neutrality when the pope, together with several European powers, formed a league against the emperor, whom they considered was growing too powerful.

* * *

From this time on Henry's desire for a legitimate heir, and his realisation that an enormous amount of wealth was submitted to Rome each year in the form of tithes from the ecclesiastical establishments, is well-documented elsewhere.

With Wolsey deprived of his position as chancellor on 17 October 1529, one week later Henry chose Sir Thomas More to take his place.

Katherine of Aragon died on 8 January 1536, but Henry had already obtained an annulment of their marriage (although not by the pope). His marriage to Anne Bolyn was ended and he married Jane Seymour on 20 March, and the pope's authority in England was ended by Parliament. Fate had yet a further hand to play when his bastard son, titled Duke of Richmond, died on 23 July, and early in October a rebellion broke out in Lincolnshire against another offensive tax collection, which quickly spread north to Yorkshire. It became known as the Pilgrimage of Grace, forcing him to take action in order to appease everyone.

First Henry let it be known that he would go north to York, where the queen would be crowned, and where he intended to hold a Parliament at Whitsuntide to address the issues. The northerners were sceptical; then in January 1537, Sir Francis Bigod and John Hallam attempted to seize Hull and Scarborough, but failed. Thomas Howard, 2nd Duke of Norfolk, had died in 1524 , so it was his son Thomas, the 3rd Duke,

who was sent to quell the rebellions. With him was Edward, 3rd Earl of Derby, who played a prominent role in the campaign. Edward's father Thomas had died three years before the duke, and as second surviving son he had inherited the title and estates. In the event, Henry was forced to delay his departure due to concerns regarding Queen Jane's pregnancy.

Trouble next arose in Westmorland, but the purge was on with a spate of executions, which soon resolved the problem; fortunately Cheshire seems to have remained quiet.

By the time Henry married his fifth wife, Catherine Howard, on 28 July 1540, England had become more pro-Protestant without a single monastery remaining, and he had been excommunicated by the pope. Henry, however, felt uneasy with regard to a possible Roman Catholic uprising, so the executions continued. Early in 1541, ill with fever, which exacerbated the problems with his ulcerated leg, he learnt of a northern conspiracy. This resulted in hangings at Tyburn on 27 May, and the beheading of the Countess of Salisbury. Still not content with the situation, having at last decided to journey north as promised, he dispatched to their deaths all those who had been incarcerated in the Tower for some considerable time. He was also hopeful of meeting King James V of Scotland at York, and accordingly sent him an invitation.

After a three-month peregrination Henry and his large entourage finally arrived in the city, having been impeded en route by flooding. James V did not appear, inciting Henry's anger at his refusal to meet. Nor did his efforts to undertake the journey reap any rewards, quite the opposite when he discovered that the queen had been unfaithful. Catherine and her accomplices were tried in December, and the queen was beheaded on 13 February 1542. Despite her immature, childish behaviour, Henry's grief at her death was said to be greater than that felt for the loss of any of his other queens.

The only way in which Henry's personal affairs affected Macclesfield was in the continual redistribution of his wives' dower lands. The other important decision of 1541 had been the declaration of Ireland as a separate kingdom on 23 January, with Henry proclaimed King of Ireland in addition to England.

* * *

Problems with Scotland continued with the usual skirmishes along the Scottish border, but James V's refusal to meet had not been forgotten, and Henry took action once more, although he knew it would cause problems with France. Unsurprisingly, James Stewart was lieutenant general of a French force comprising 5,000 foot soldiers and 5,000 horse, loaned by Francis to be the personal bodyguard for the Scottish king. Confident of success, however, Henry sent the Duke of Norfolk to settle the matter once and for all, and with him was Edward, Earl of Derby.

On 21 October 1542 the duke crossed the Tweed and laid waste the land wherever he could, but then ran out of supplies and returned to Berwick. The following month the Scots were routed at Solway Moss and it was said that James V died in December utterly affected by his defeat, which left his young daughter Mary as claimant to the Scottish throne.

With James's death and important Scottish prisoners in captivity in London, Henry proposed to unite the two kingdoms by Mary's

Effigy in St Michael's Church of Sir John Savage V wearing armour of the period. He fought at Bosworth Field, but died Macclesfield 1527.

marriage to his son, Edward. He obtained a pledge from the prisoners that if he allowed them to return home they would support him in his proposal to create 'the Union'. They accepted and returned to Scotland in the company of the Earl of Angus and Sir George Douglas, who had lived in England many years as refugees from over the border due to their rebellious deeds. But the Scottish nobles were again feuding amongst themselves, despite treaties drawn up on 1 July 1543, which, due to French influence, were set aside. Henry had already concluded an alliance against France with the emperor in February 1543 and withdrawn his ambassadors, then, after marrying Katherine Parr on 12 July (his sixth and final wife), he sent a detachment of troops to aid Charles.

The following May he sent Edward Seymour, Earl of Hertford, to attack Edinburgh and the surrounding countryside with an English force supported by the fleet.

The Pillage of Edinburgh

On this occasion the facts confirm that a large contingent of Macclesfield men was included and that all served extremely well.

Edward Seymour, born c. 1506, had achieved many honours over the years and become a great favourite of Henry VIII. He was present with the king on many important diplomatic occasions, and as brother of Henry's former queen was uncle to Prince Edward, the future king. In March 1544 he had been appointed lieutenant general in the north.

Where the Macclesfield contingent joined the army is not known, but Hertford had arranged transportation by sea at the end of April, and those assembled in Berwick sailed from the garrison port. On 3 May they arrived in the Firth of Forth, and the next day 10,000 men landed at Leith and were able to seize Blackness Castle. Their landing had been observed, but the Scots refrained from attack.

By 5 May Sir William Eure (often erroneously translated as Evers) arrived with 4,000 mounted troops from Berwick. He had been governor of the latter garrison town in 1539, commander of the north in 1542, and on Henry's authority was titled Baron Eure from 22 February 1544. Originally ordered by Hertford to

supply 1,000 Yorkshire archers, he had apparently well-exceeded expectations. As the Macclesfield troops were more than likely mounted for their long journey to Berwick, because of Baron Eure's delay of two days, they were possibly amongst those riding with him.

As Seymour led his army to the gates of Edinburgh, the provost offered him the keys to the city if those citizens who wished to leave were allowed to do so. Seymour refused, demanding unconditional surrender as punishment for their 'deliberate falsehood'. The reply was defiant, and as a consequence Canongate was blown in the following day, accompanied by two days of pillaging. Seymour did not have time to attack nor besiege the castle, from where the Scottish artillery was able to cause some harassment for the English troops below, but instead returned to Leith with his army and cartloads of goods and valuable possessions.

Anchored in the harbour were two ships effectively belonging to the very young Queen Mary of Scotland. These were commandeered and, together with the English fleet, heavily laden with booty sailed south to Berwick.

Whilst still at Leith, Seymour knighted thirty-nine men on Sunday 11 May and a further eight at Butterden on Tuesday the 13th. Amongst those knighted were at least twelve from the Macclesfield hundred, including Piers and John Legh and also Edmund Savage, which was an impressive quarter of the total of forty-seven knights created out of the thousands who took part. At least one more was from Cheshire, representing the Cholmondeley family. Although only circumstantial, it does suggest that those from Macclesfield are likely to have been involved in former forays along the Scottish border.

After returning to England, on 9 July Sir Edward Seymour was appointed lieutenant of the kingdom under the command of the queen, who was acting as regent due to her husband's imminent departure for France.

An unexpected event was the death of the Scottish regent James Stewart on 12 June 1544, when his earldom of Moray reverted to the Scottish Crown.

Modernisation of the English Army

By this period, although efforts had been made on occasion to have a national semi-permanent army for defence, no effort had been made to create a national standing army. Still operative was the military obligation for men between the ages of sixteen and sixty to serve in defending the realm, but it was limited to forty days and only within the county where they were recruited. The sovereign therefore was still reliant on regional overlords in encouraging recruitment when a call to arms was given. No longer was subservience operational, and most of the ordinary soldiers took part for little pay but still with the hope of a share of the booty; some, of course, sought adventure or were genuinely keen to serve out of loyalty and honour.

The English soldier was regarded as 'strong and courageous', but Continental armies were more advanced in their use of weaponry and in their methods of attack. Henry VII had inherited a 200-strong palace guard of elite archers, but did reconstruct it with his Yeomen of the Guard. Henry VIII progressed further with his 'Gentlemen Pensioners', who were mounted with poleaxes. He also appreciated that the best armour and arms were being produced in northern Italy and the southern German states. He bought the great cannon, known as 'the twelve apostles', from the Malines foundries near Antwerp, and 100 others. This encouraged him to bring craftsmen from the Continent in order to assist in developing the English industry and English craftsmen.

An addition of 11,000 foreign troops, in particular from the Balkans, encouraged the development of heavy artillery, comparable to that of Henry's Continental rivals. Those from Macclesfield, serving in any of Henry's armies, must have returned to the township and forest with tales of awe when relating what the new weapons were capable of, and of the new skills which they were achieving. Soon many would be returning with pistols, although the old forest tradition of using bows and arrows would never really die out, and in later centuries would continue until the present day as a favourite sport.

The Scots relied on foot soldiers, but without expensive protection. Many were armed with half pikes, long spears and Lochaber axes,

whilst others were equipped with basket-hilted swords and round targes (shields), but all suffered against heavy artillery, which would obviously give advantage to the English troops operating along the Scottish border.

Return to France
On 14 July Henry once more returned to France via Dover and Calais, taking with him his newest impressive weapons and armour. This was yet a further opportunity for Macclesfield troops to take part once more in operations in France, as two armies had already been sent ahead to prepare for Henry's arrival.

Suit of armour similar in style to that worn by Henry VIII. (Private collection)

Ceremonial halberd, not to be confused with a poleaxe, which was in effect a pickaxe on a shaft the height of the bearer. As weaponry it was superseded by the mid-sixteenth century, but remains as a ceremonial piece. (Probably Victorian reproduction. Private collection)

The first, commanded by Norfolk as lieutenant general, laid siege to the town of Montreuil, but to no avail. He then left after learning of the king's arrival and joined Henry to the north of the seaside town of Boulogne. The second army, commanded by Charles Brandon, Duke of Suffolk, was already occupying part of the eastern perimeter of land outside the fortified town.

Brandon was another of Henry VIII's favourites, who had become prominent only in 1509 when he was appointed chamberlain of North Wales. He rose steadily through the ranks whilst receiving several grants of land, manors and stewardships. Having proved himself a great warrior he was appointed marshal of the army in 1513 and saw action in France. On 1 February 1514 he was created Duke of Suffolk, and was involved in the marriage arrangements of Henry's sister Mary to Louis XII. However, unsurprisingly the marriage never took place, and Suffolk took the opportunity to secretly woo and marry Mary in Paris – much to the fury of Henry. But despite the fact that his private life left much to be desired, with wives, annulled marriages, mistresses

and a daughter born to his first wife, Brandon miraculously managed to escape execution. His charm and personality once more saw him regain his position at court and return to be one of the favoured few.

Brandon was present at the Field of the Cloth of Gold, and in 1523 commanded the invading army. Those who served under him must have been aware of his scandalous lifestyle, and those returning to Macclesfield would have repeated their experiences and gossip on their return, when conversing in the homes and taverns of the township.

In 1542 Suffolk was warden of the marches along the Scottish border, and whilst in that position, and also earlier when chamberlain of North Wales, he would have been well aware of the skills and abilities of the longbowmen and archers from the Macclesfield hundred. As he sailed with his force at the end of June 1544 and marched to Boulogne, he would surely have included those from Macclesfield who had recently returned from the Scottish raid flush with victory and richer by their share of the spoils. En route he managed to gain a fortress called Old Man whilst he awaited Henry's arrival.

Once the armies were in position Henry deployed his heavy guns, which caused such a battering of the northern area that there was barely a building left standing, whilst Suffolk attacked and took Basse Boulogne, the lower quarter of the city. After a month of attacks

Cannon from the period of Henry VIII at Culzean Castle, Scotland.

two of the town's officials came out and asked Henry if he would accept the keys of the fortress from their chief captain, then allow free passage for all the inhabitants to leave with their possessions. This Henry granted, no doubt to the chagrin of many who would have wanted to plunder the homes of the wealthier citizens; instead Thomas Howard, Duke of Norfolk, rode into the ruined town in triumph, and returned to hand Henry the keys.

That day almost 4,500 people left, a quarter of whom were women and children, with the remainder mostly soldiers and a few artisans. As the chief captain finally rode out, he dismounted and came to speak to Henry, who took him by the hand. The man knelt, kissed the king's hand and, after remounting, rode away. At that point Thomas Howard rode once more into the ruined citadel, and, after inspecting the walls, Henry gave instructions for the defences to be strengthened, after which, learning that the emperor had withdrawn support, he concluded a separate peace treaty with France on 19 September.

Henry then halted operations for the winter and sailed for England on the 30th.

* * *

Anxious for money and left to face problems with France alone, Henry resorted to desperate measures in order to fill his empty treasury, even mortgaging his plate and estates apart from raising taxes, which for once was accepted without much hostility. Having built his finest ship of the fleet, the *Mary Rose*, he despaired to see her accidentally sink on 20 July 1545, dooming the whole company of 500 personnel on board to a watery grave, even before she had undertaken any duties. Almost instantly the French caused havoc on the Isle of Wight, and after months of retaliations France agreed to peace on 7 June 1546.

England was left in possession of Boulogne for a further eight years, and with a promise that the arrears of pension and war expenses would be paid.

Action in Scotland

As regards Scotland, during the previous month of May 1546 St Andrews Castle was overrun by conspirators supporting

England, which gave Henry's forces a strong command post north of the border. It was a useful strategic position from which the English presence would be extremely difficult to remove.

Henry's final impressive speech to Parliament on 24 December heralded his last appearance there, as though he knew that his life was drawing to a close. It was not soon enough, however, for Henry Howard, the Earl of Surrey, who had been tried as a traitor on 13 January 1547 for an accentuated lack of judgement. Two days later he was beheaded on Tower Hill.

Since 12 December 1546, his father, the Duke of Norfolk, had also been imprisoned in the Tower, for he had not spoken out against his son's foolishness. Henry died at midnight on 28 January at Westminster without having signed the bill of Norfolk's attainder, although it had been passed by both Houses of Parliament on 27 December. He was left in suspense not knowing what his fate would be.

Edward VI

Edward was barely nine years old when told of his father's death at Hatfield. Henry's will confirmed the boy's succession and named a council of eighteen to act during the minority, with twelve more in reserve should they be needed. Edward Seymour was lord protector who also adopted the office of lord chamberlain and earl marshal. Dudley, Earl of Warwick, was chamberlain, and Edward Seymour's brother became admiral of the fleet (he was later beheaded when he attempted to usurp his brother's position).

Edward was a studious boy, and amongst those who shared his education were Edward Seymour (heir of the protector); Henry, Lord Strange (the Earl of Derby's son); John Dudley (son of the Earl of Warwick); Henry, Lord Stafford (heir of the last Duke of Buckingham); and Lord Thomas Howard (son of the attainted Earl of Surrey) – a strange combination under the circumstances.

Thomas Howard Snr had literally been saved from execution overnight by Henry's death the previous evening. Fortunately he had managed to petition the king asking that his estates be settled on Prince Edward, which Henry had accepted. Having learnt of this, the council, not wishing to spill further blood unnecessarily, kept Howard imprisoned in the Tower for the remainder of Edward VI's short reign.

Somerset was treated indifferently by young Edward, but was sent to Scotland in 1547 to enforce by war, if necessary, the prince's betrothal to the young Queen Mary, but French assistance once more came to the rescue and Boulogne was retaken. By October, influenced by Lord Dudley, the council turned against Somerset, who quickly removed Edward to Windsor causing tensions throughout the country. Considering that it was only sixty-two years since Henry VII had ascended the throne, signalling the end of the Wars of the Roses, the stories of that terrible period would still be in the minds of the grandchildren of those who took part, and no one would want to live through that again.

Fortunately Somerset was pardoned on 16 February 1550.

It was soon learnt that Mary, Queen of Scots, was betrothed to Francis, the French dauphin, but it did not deter young King Edward from bringing up the subject of his claim when her mother passed through England on her way to Scotland; it was politely ignored. The alternative was an endeavour to link him with Princess Elizabeth, sister of the dauphin.

Somerset was finally beheaded 22 January 1552 due to Warwick's scheming as the newly created Duke of Northumberland.

At this time trouble was expected between Philip II's Spanish Empire and France, but despite French demands for support Edward was advised to observe strict neutrality, so there was no call to arms; in fact, he sent complimentary messages to both combatants in June 1552. He had just recovered from measles and smallpox, and although he seemed quite well again, his health remained a matter of some concern. By Christmas, however, a hacking cough heralded his final illness, yet he struggled on with engagements. During May 1553, Princess Mary, who by her father's will was next in succession to the throne, was never far away.

On 21 May Lord Guilford Dudley married Lady Jane Grey, and his father, Northumberland, persuaded Edward to nominate Lady Jane's heirs as his successors and not his sisters, which he did. Under the instructions in his will he warned England 'against entering in foreign wars or altering her religion' – Protestantism – and finally died peacefully on 6 July 1553.

During his short reign there was little opportunity for any of England's soldiers to perform active duties, and despite the occasional alarms, as news was relayed from the capital, families were able to tend to their estates and smallholdings, hunt in the forests and enjoy once more the festivities, fairs and entertainments, and the gossip in the numerous taverns, particularly in market towns such as Macclesfield, which depended so much on trade.

The town had benefited considerably from the re-establishment of the Macclesfield grammar school on 25 April 1552, which had been deprived of its income during the years 1536 to 1540 when Henry VIII had seized all church properties and transferred them to the state. A petition from some of the surviving governors to Edward VI had been successful, and it became known as the 'Free Grammar School of King Edward the Sixth in Macclesfield'; today it still survives as The King's School. It was built behind the chapel of Queen Eleanor at the top of Bunkers Hill, and would become the wealthiest school in Cheshire during the eighteenth century.

Not only did Macclesfield benefit from Edward VI's penchant for education, rather than that of warrior king as promoted by his father Henry VIII, but several grammar schools throughout England were also established during this Protestant phase, for the headmasters, who were usually the only teacher in the school at that period, were all ministers of the Church of England. The pupils were taught classics and music, but their number was usually quite small, perhaps only six to twelve, until expanding later with assistance from second masters.

* * *

Queen Mary I

For years, even before her father's death, there had been continued pressure to find a suitable husband for Princess Mary, but many were Protestant and, as an ardent Roman Catholic, she would instantly reject such choices. During young Edward's reign, despite her protestations, she was not allowed full religious freedom by the council and appealed for support to the Holy Roman Emperor, who

did intervene, but the council procrastinated. Finally there was an appeal to brother Edward; he conveniently ignored it.

On 18 November 1551, Charles V's ambassador informed the council of his intention to leave England, then war would be declared unless Princess Mary was appeased. With secret arrangements made to transport her to Antwerp, ships appeared off the east coast of England, but were intercepted and quickly sailed away. Her only hope was to convert Edward to the 'old faith', which she was convinced she could do, but she obviously never succeeded.

After Edward's death events moved on swiftly. As stated in her father's will Mary assumed her position as queen, but faced an angry crowd in Protestant Cambridge, from where she escaped disguised in the costume of a market woman and found refuge in Bury St Edmunds. An appeal to the council on 9 July resulted in their declaration of Lady Jane Dudley, née Grey, (cousin of Edward VI and daughter of Henry, Duke of Suffolk) as queen on the following day.

Soon, however, the situation began to turn in Mary's favour, with support provided by an armed force led by the earls of Sussex and Bath. John Dudley, by then Duke of Northumberland, soon learnt that he had a price on his head, and Mary was finally declared queen in London. Determined to reverse the tide against Protestantism, she accordingly advised Henry of France and the emperor, Charles V (her cousin), of her intention.

As queen, Mary worked hard on government matters and invited the Duke of Norfolk and the earls of Derby and Shrewsbury to join the council, for they were all ardent Roman Catholics, but her religious fervour caused problems within the council and riots in London. She was warned not to act too quickly, yet on 22 August Northumberland and several of his supporters were tried and condemned; his execution soon followed. A shrewd move saw her remit Edward VI's taxes, causing great rejoicing, and slowly but surely civil war was avoided, allowing a peaceful coronation to take place on 1 November in Westminster Abbey.

Initially Mary resisted ordering the execution of Lady Jane Dudley. Finally, however, on 9 February 1554 both she and her husband Guildford (fourth son of Northumberland) were beheaded on Tower Hill.

The problem of Mary's marriage was becoming an urgent issue and she appealed to Charles V, who declined her offer considering himself too old, but instead suggested his son Philip, who was a widower like himself. Philip had one son, Don Carlos, and although eleven years Mary's junior, he accepted the invitation. Knowing of his religious devotion to the Catholic Church, Mary was delighted, but she knew little of his character and although she received little encouragement for the match, even amongst her loyal supporters, there was sufficient for her to accept the betrothal.

Philip proved a very unpopular choice in the Spanish Netherlands, and also amongst Londoners in general; however, despite disapprovals he landed at Southampton on 2 July, and five days later the marriage took place in Winchester Cathedral. Mary had ensured that her pledges to England had been strictly adhered to in the marriage settlement. Only native Englishmen could hold office in the court and Parliament, although Philip could aid in the country's governance. Both husband and wife were to rule their respective kingdoms, and Mary's child would inherit the English throne, not Philip, should she die first. The child would also inherit Philip's benefits derived from his Dutch and Flemish provinces provided by the Duke of Burgundy. There were to be no wars with France in which England would be expected to take part.

Despite the safeguards provided, insurrections broke out in the Midlands and the South. The feelings of those in Macclesfield are not known, but taking into consideration that the Earl of Derby, the Leghs, and possibly the Fittons, were still loyal to the Roman Catholic faith, if any protestations were prevalent in the borough and its environs, they appear to have been quietly observed and did not result in any repercussions.

Soon Philip was demanding that council reports were to be sent to him in Latin or Spanish, and ordered coins to be struck for his Neapolitan kingdom bearing shields of himself and Mary, with his description as 'King of England'. The reaction amongst Londoners did him no favours.

By 11 November, with the opening of Parliament the reconstitution of Roman Catholicism began with Pope Julius III's granting 'of England's absolution for past offences', and he commissioned a medal to commemorate the event.

It was not long before Mary deduced she was pregnant, but the unfortunate queen was mistaken, due to a condition that had plagued her since her teens. Philip, growing restless, began to interfere in political affairs and promoted the idea of his coronation, without success.

Burnings at the stake were recommenced for fanatical heretics; tithes of rectories and glebe lands, claimed by the Crown since 1528, were to be given to the re-established Cardinal Pole to augment smaller livings and support preachers, and by 1555 papal power had been restored.

As Mary's health began to fail, so did her marriage, during which time she found herself at variance with Philip's demands, leading to an angry confrontation. At the end of August 1555 Philip left England and a queen in great distress, supposedly to visit other countries under his rule. He evidently returned in the spring of 1557, intent on drawing England into war with France once more, having been given the thrones of Spain and the Netherlands by the abdication of his father. In April, Thomas Stafford took the unfortunate step of declaring himself protector, which played into Philip's hands, for Stafford and his rebels were accused of being in the pay of the French.

Mary gave in to Philip's wishes, and war was declared on 7 June 1557. Ten days later William Herbert, Earl of Pembroke, left at the head of 8,000 men to join Philip's force in the Netherlands. A large percentage of the troops were presumably from Pembroke's Welsh estates, but with a strong possibility that a Cheshire contingent and even a number from Macclesfield were also included, especially if they had served in France previously and were aware of French tactics. They joined the Prince of Savoy and his men, which resulted in their victory at the Battle of St Quentin on 10 August.

During the autumn the Scots declared war in support of France, encouraging the French to make preparations for a winter march on Calais. Too late did Mary appeal for reinforcements to sail to France, for Calais had surrendered on 7 January 1558 to the Duke of Guise. Mary begged the council to take action, desperate for the recovery of England's 'most valuable possession', yet without resources, due to the remittance of taxes and monies squandered on Philip's extravagances, they could do nothing.

Mary's health deteriorated, and Philip, who had offered help to recover Calais, sent her a message telling her to recognise Elizabeth's succession. On 10 November a burning of heretics took place at Canterbury, bringing the total to 300 during her reign, a policy that she had initially not condoned but then had changed her mind, thus adding to her considerable unpopularity.

Philip, whilst appearing to have relinquished his desire for the English throne, had marriage with Elizabeth in mind in the event of his wife's death, for the two had grown close. Mary died on 17 November 1558, preceding Cardinal Pole by one day. Elizabeth was quickly declared queen within a few hours, but her refusal to accept Philip's subsequent offer of marriage saw him make peace with France and marry the French king's daughter, Isabella.

Queen Elizabeth I

Incredibly the beginning of Elizabeth's reign heralded a completely new situation as regards European history. There was only one duke left in England – Thomas Howard of Norfolk. All her old enemies and friends had died naturally or by execution during the days of Mary I's reign: Charles V was gone, shortly to be followed by Henry II of France and Pope Paul IV. Elizabeth, by declaring that she would 'die a virgin', had allowed fate inadvertently to place the younger Queen Mary (Stuart) of Scotland in the more positive position of heir to the English throne.

A Spanish envoy, when commenting on Elizabeth's situation and that of England, ended by remarking that she had 'no captains, no soldiers, and no reputation in the world'. Although he had previously admired Elizabeth, he had grossly misjudged this formidable woman, who with tenacity, good judgement and ingenious scheming would drag England out of her financial straits by ridding the country of its debased coinage, prevalent during the last three reigns. This was also achieved by reissuing a sound currency, strictly allowing no unnecessary expenditure, particularly on waging war, by carefully handling the situation with Scotland and the Continent of Europe, and last, but by no means least, on appreciating the necessity of trade and the need for England to be as self-sufficient as possible.

Fortunately for Elizabeth her father, Henry VIII, had used the revenue gained from the Dissolution of the Monasteries, not only to increase England's fortifications, but also to create a county scheme whereby the most prominent and loyal men were chosen for the position of lord lieutenant, each with a deputy. Uniquely, at first Cheshire did not fall within the scheme as a County Palatine.

Because of its northern defensive position within England, William the Conqueror, in ridding the country of King Cnut's Danish earldoms, had allowed the Earl of Chester to rule the county with the powers of an independent prince, owing allegiance only to his overlord, the king, and was therefore responsible for providing military assistance when the necessity arose. With the subsuming of the earldom into the entitlement of heir to the throne by Edward III, Henry VIII was in turn Earl of Chester, until transferring the title to his young son Edward, and therefore evidently considered it unnecessary to commission a lord-lieutenancy for the county.

The logistics of providing Cheshire troops had been delegated, as already stated, to the patriarchs of the prominent families with vested interests within the county, particularly those in and around the Macclesfield hundred.

With the prominent position of the earls of Derby, one would have expected Edward Stanley, son and heir of Thomas, 2nd Earl of Derby, to have been lord lieutenant of Lancashire, as their grand residence was at Knowsley near Manchester and Preston. Instead the choice was Robert Radclyffe, 1st Earl of Sussex.

Radclyffe, born near Manchester, was a prominent courtier, important military commander and diplomat on whom Henry had heaped many honours. His first wife was the daughter of Henry Stafford, Duke of Buckingham, and his second was the daughter of Thomas Stanley, 2nd Earl of Derby, so evidently the Macclesfield connections were there. He had been sent north from Essex to quell the riots in Westmorland, bordering Cumberland, the latter then part of Lancashire, and had well succeeded.

With regard to Edward Stanley, on the death of his grandfather, when he was only thirteen years old, he had become a ward of Henry VIII and was placed in the care of Cardinal Wolsey. Subsequently, he had

of course played a prominent role in suppressing the northern revolts, and as a privy councillor from 1551 was well versed in procedures of the royal court and in diplomatic affairs. In 1552 he became lord lieutenant of Lancashire as one of Queen Mary's devotees; but despite their religious differences he would prove loyal to Elizabeth, and on 18 November 1569 he would receive the lord-lieutenancy of Cheshire in addition to Lancashire, which strengthened ties between the two counties.

Meanwhile Elizabeth's coronation had taken place on 15 January 1559 when she was twenty-six years of age, and Mary, Queen of Scots was seventeen. By that time, however, Mary had been educated in France from the age of six, and had married the dauphin on 24 April 1558. Before the marriage she had signed deeds giving Henry II of France the Scottish revenues until the French expenses spent on Scotland's defence had been recouped, and also confirmed his country's claim to Scotland in the event of her death. After marriage, Mary and the dauphin had assumed the titles King and Queen of England, Scotland and Ireland, asserting that Elizabeth's illegitimacy was a legality in support of Mary's claim of holding precedence over Elizabeth as the great-granddaughter of Henry VII.

During the first year of her unopposed reign, although much of Elizabeth's time and energies were taken up with domestic matters and a cautious approach to restoring the Protestant faith, her reluctance to spend money on waging war was an ever-present necessity to her way of thinking, yet she would be forced into action in the not too distant future.

* * *

On 2 April 1559 France, England and Scotland signed a peace treaty, and almost three months later the dauphin became King of France, and Mary queen consort. The following day France and Spain concluded a second treaty; however, Elizabeth's intuition told her that treaties were likely to be broken, and not only did she continue her chosen path of Protestantism for England, but with the same caution took to strengthening links with the Protestant movement in both Scotland and France.

Beginning in July 1559 troops and money were sent to Scotland to assist those resisting the Roman Catholic faith, and in January 1560 an English fleet arrived in the Firth of Forth, but the admiral made no attempt to instigate an attack. In May, Sir William Cecil, chief secretary of the council, went to Scotland and was instrumental in the signing of a treaty in Edinburgh on 6 July. The stipulations were significant: Queen Mary was to desist from using the title and arms of the queen of England and the French were to withdraw from Scotland, leaving the Protestants to fight their own battles without the presence of foreign auxiliaries. Elizabeth was proving to Philip of Spain that she did not need his help, but unfortunately for Cecil he was losing favour with the queen and council, as it was felt that he had overreached himself.

At this juncture Elizabeth took to flattering a young handsome courtier, Robert Dudley, and Europe gossiped, but, in her calculating mind, having received several foreign marriage proposals, which were instantly rejected, she was more than likely deliberately choosing to create a guessing game in order to confuse her enemies as to her true intentions. Undaunted, she continued to press on with her reforms, but did support Dudley when vicious rumours arose regarding his wife's death.

In 1560, Mary's husband Francis II died, and, managing to evade the English fleet, she returned to Scotland in August 1561. Meanwhile Elizabeth's Continental expectations were bearing fruition as problems erupted in France between the French Roman Catholics and the Protestant Calvinists, suggesting civil war was imminent. In Spain persecutions were dividing the populace causing repercussions in the Netherlands, whilst England quietly began to prosper.

The leader of the French Calvinists soon appealed to Elizabeth for help, but she hesitated, presumably bearing in mind her demand to France to allow the Protestants of Scotland to fight their own battles. She was even promised (Le) Havre, Dieppe and the return of Calais, and finally sent a small force of some 3,000 men under the command of Sir Adrian Poynings on 4 October as a token gesture. The expedition was a complete disaster and the civil war came to an end with the dreadful Battle of Dreux on 19 December, after the Earl

Signs of England's growing prosperity under Elizabeth I are indicated by the enlargement of Adlington Hall by Thomas Legh (and also Gawsworth Hall). Adlington Great Hall, built 1450–1505, was completed with the Elizabethan black and white (originally brown and white) additions in 1581.

of Warwick had desperately fought to save Havre. The peace treaty was signed on 25 March 1563 and Havre was finally surrendered on 27 July.

Although there is no evidence suggesting any Macclesfield troops were engaged in France, the possibility certainly exists.

Throughout the next twenty years of Elizabeth's reign, coupled with Roman Catholic intrigues and plots involving her assassination, she resisted all attempts to become involved in all-out warfare. One thing she could not avoid, however, was the situation in Ireland.

Troubles in Ireland

As early as 1155, Henry II (1133–89), grandson of Henry I, who had inherited the throne from his uncle, King Stephen, on the death of the latter in October 1154 had considered conquering Ireland. The country, originally divided into five ancient kingdoms but eventually

reduced to four – i.e. from north to south: Ulster and Leinster on the east, Connaught and Munster on the west – was ruled by strong ancient families as individual kingdoms. Henry delayed when his mother Matilda objected, but an opportunity presented itself late in 1166 when the King of Leinster had been usurped and appealed to Henry for help. The king agreed to the request, offering his English knights the choice of serving the Irish king.

A group of knights from the Welsh Marches accepted and the leader, Richard de Clare, married the restored King of Leinster's daughter. After his father-in-law's death, de Clare created himself Earl of Leinster and set about ruling the province from Waterford to Dublin.

Henry was in his Norman province at the time and, sensing future problems, sailed immediately for Portsmouth. After completing all the necessary arrangements he arrived in Waterford on 17 October with 4,000 men, transported in a fleet of some 400 small ships from Milford Haven.

Henry's next action was to close all English and Norman ports to the Irish, and by Christmas 1171 he was in Dublin, having obtained submissions and hostages from all the Irish princes except the King of Connaught. Dublin, which had suffered three sieges in two years, was given to the burgesses of Bristol, allowing them to colonise the port. In allowing free trade, the wealthy English port soon saw Dublin develop into a commercially successful city. However, Henry's severe repressions and forced rule had paved the way to centuries of problems for the English Crown.

One interesting outcome, as far as Macclesfield was concerned, was the appearance of the Dounes (later spelt Downes) family in Macclesfield Forest.

During the ten-year reign of King John (1189–99), there is a record of Robert de Dounes of Sutton Dounes in the forest south of the township. It appears shortly after the time when John, as prince, was sent to Ireland in 1185 by his father on a conciliatory mission as 'Lord of Ireland'. The name Dounes, or Done, is recorded as a derivation of the Gaelic name 'O'Dubhain', and many Downes family members were living in Limerick and Tipperary in 1172, confirming that it was a well-established Irish name by that period.

Prince John's mission was a fiasco, for the English knights ridiculed the Irish chieftains who had been called to attend a meeting; the outcome was rebellion resulting in anarchy and bloodshed. The reason for Robert de Dounes's appearance in Macclesfield Forest may never be known, but it does suggest that archers from the area were already in Ireland and had attracted attention, possibly encouraging him to move to a safer environment.

Descendents of Robert eventually acquired the area of Taxal, and another Robert de Downes is listed as one of eight foresters responsible for Taxal and Downes in 1288, a position that would remain within the family until the death of a John Downes in 1621.

* * *

As already mentioned, Sir John Stanley had served with de Vere in Ireland during 1386 and remained as lord lieutenant for a period. This was followed by Richard II's campaigns of 1394–95 and 1399, the latter involving Sir John Stanley, and Roger Jodrell with Sir Lawrence Fitton of Gawsworth accompanied by their best archers from Macclesfield hundred.

In the early 1490s Henry VII had become dissatisfied with the Irish situation due to its strong ties with the Yorkist cause. Even within the Pale his royal authority had little effect, and he vowed to complete the subjugation of the Irish. The Pale was the part of Ireland that had been forced to acknowledge English rule and law after the 1172 campaign. From time to time its perimeter did vary, but in general it included all the eastern counties extending from the Irish Sea inland – between 40 to 50 miles.

Elizabeth's father, when he was Prince Henry, was sent as viceroy on 13 October 1494 together with Sir Edward Poynings (1450–1521) as lord deputy of Ireland. Poynings tried twice unsuccessfully to take Ulster, but was more successful in the south. His powerful campaigns and reorganisation of the Irish Parliament in Dublin alleviated the king's concerns and he was recalled in January 1496.

It fell to Henry, as King Henry VIII, to deal once more with another serious rebellion, this time instigated by the Fitzgerald clan, a branch

of which had settled in Ireland from Wales in the twelfth century. Their stronghold was Kildare in Leinster, to the west of Dublin and Wicklow. Their hereditary rule was as the earls of Kildare from almost the time of their arrival in the Emerald Isle, and they were staunch Roman Catholics.

It was Thomas, the 10th Earl, born 1513, who began the rebellion of 1534 after being appointed deputy governor of Ireland. The Fitzgerald rivals, the Ormonde family, started a rumour that Thomas's father had been executed in the Tower of London, which Thomas, in anger, seems to have believed. His reasoning appears to have been based on the fact that it was the year in which Henry had declared himself head of the Church of England, and had begun the process of converting the country to the Protestant faith, which meant Ireland would likewise be forced to follow. He rode into Dublin with 140 men all sporting silken fringes on their helmets, earning himself the soubriquet 'Silken Thomas'. Refusing to listen to reason, his Fitzgerald temper got the better of him, as he loudly renounced his allegiance to the English Crown and declared war on the Irish Parliament. The officials of the city fled in terror, with many of them seeking refuge in the castle.

The inhabitants of Dublin rallied to Fitzgerald's support and stormed the castle, dragging out the unfortunate occupants on whom they reaped revenge. This had the effect of spreading the rebellion quickly amongst the different clans in the province and causing a mini-civil war. The English navy set sail from Beaumaris and amongst the troops on board was Sir William Brereton from the hamlet of Handforth, only 8 miles from Macclesfield, who must surely have been accompanied by troops from the forest and township. His branch of the family would later support the Puritan cause in England.

* * *

As Elizabeth's reign began Thomas, 3rd Earl of Sussex, grandson of Robert Radcliffe the former lord lieutenant of Lancashire, was an important figure at court and was known for his diplomacy and military prowess. He had already served in Ireland at the end of Queen Mary's reign, and had captured the castle of Meelick and

repulsed the rebels who had been dealing with the Scots. In 1556 the earl, as lord deputy of Ireland, had been accompanied by Sir Henry Sidney, treasurer and member of the Irish council, who took part in many of Sussex's campaigns.

In 1558, after spending Christmas at court, Sussex again returned to Dublin. By September he had ridden through Leinster suppressing all rebellions, and then sailed from Dublin to attack the Hiberian Scots in Islay. Blown off course by a storm he anchored at Carrickfergus, and, after destroying several villages, returned to Dublin where he learnt of Queen Mary's death. Leaving the government under Sidney's control he sailed for England to attend the funeral and Elizabeth's coronation.

Early in January 1560 the Parliament was called to enable the Earl of Sussex, who had arrived in Dublin for a two-week visit, to ensure that the official procedures took place whereby Elizabeth was declared queen of Ireland. Whilst this did not necessarily affect the constant rivalries between the powerful Irish families, it was the order for Protestant services to be observed in all the churches and cathedrals that caused outrage.

In 1566 Edward Fitton of Gawsworth, great-grandson of Thomas who had fought at Blore Heath, was knighted by Sir Henry Sidney. The latter was responsible for the establishment of the provisional governments of Connaught and Munster, and three years later Sir Edward arrived in Ireland designated president of Connaught and Thomond (the present-day counties of Clare and Limerick and parts of County Tipperary). Under instruction from Sir Henry Sidney he took up office in July. Initially all seemed well with the province when his governance began, but, as reported by Sir Edward in 1570, after Christmas everything went awry and he found himself besieged in Galway by the Earl of Thomond and the Earl of Clariscarde's sons, resulting in Sidney sending troops to the rescue.

The Earl of Clariscarde insisted that he was loyal and supported the troops helping Fitton to escape. Seizing the opportunity, Fitton captured Shrule castle, but, while resisting an attack on his camp, he fell from his horse and was seriously wounded in the face. Sidney praised Fitton as a man of 'good counsel' and 'great worthiness'; however, Sidney's successor, Sir William Fitzwilliam thought differently.

Fitton, convinced that Clariscarde was secretly encouraging rebellion through the actions of his sons, had him thrown in Dublin Castle, much to the anger of Fitzwilliam. The deputy complained that no reason had been given by Fitton for his action, nor had it been reported to the council. Fitton could only say that it was an instinctive decision. After six months Clariscarde was released and, in order to prove his loyalty ordered the hanging of one of his sons, his nephew, his cousin's son and fifty others of his force who had taken up arms against English authority.

Fitton was never forgiven and was isolated once more – this time in Athlone. He could only hope for troops to assist him, but prayed that he might be relieved of his duties. The rebels finally burst into Athlone in the summer of 1572 and he was recalled, allowing the position of president to disappear quietly. On his return to England in October he was once more ensconced in Gawsworth Hall, near Macclesfield. However, he had not lost favour with the queen, and in December Elizabeth appointed him vice-treasurer and treasurer at wars. Fitzwilliam was accordingly advised.

In 1573 Walter Devereux, who had been created Earl of Essex the previous year, volunteered to colonise Ulster and bring it under English control as a private adventurer. Elizabeth privately lent him £10,000 using his properties in Essex and Buckinghamshire as collateral. He agreed to share the expense of raising 1,200 men for the task and the cost of fortifications. Volunteers were quickly recruited, and part of the force sailed from Liverpool on 19 July 1573. This was another opportunity for Macclesfield volunteers to join the intended invasion force; however, the whole idea was not condoned by Fitzwilliam. Things did not turn out as expected due to a storm scattering the fleet. Some ships reached Cork in the south and Essex was blown north, making a difficult landing in Carrickfergus.

Meanwhile, Fitton had returned to Ireland on 25 March as treasurer, but a quarrel between a friend of Fitzwilliam's nephew and one of Fitton's servants proved fatal. For some reason it was said that Fitton's servant had stabbed the man in the head, and shortly afterwards a servant of the nephew's friend ran his sword through Fitton's servant. A jury acquitted the former, but he was found guilty

by the queen's bench. Fitzwilliam overruled the judgement with a general pardon, which on its arrival was withheld by Fitton, who found himself imprisoned for contempt. Realising overnight the error of his action, Fitzwilliam ordered him released and admitted to the council, but Fitton appealed to Elizabeth, who chastised Fitzwilliam. After holding assizes in Connaught he accompanied the deputy to Kilkenny, then refused orders to proceed to Munster to prevent disturbances.

The deputy had already caused problems by refusing to aid Essex, whose provisions were rapidly decreasing. On the point of returning to England Essex begged the queen to help, and Fitzwilliam was ordered to give his assistance. It was even suggested that Essex should replace him, but the idea was put aside. In March 1574 a handful of men was sent from the Pale, but a lack of food and desertions forced Essex's planned attack on one of the rebel leaders to be abandoned and a truce was agreed by the end of the month. By May, with 200 sick men and many dead, amongst whom he had shared all their hardships, he desperately arrived in the Pale.

After successfully negotiating in Munster during June, Essex was sent once more to Ulster by Fitzwilliam, but in October committed a terrible crime for no other reason than *'pour encourager les autres'*. Having invited the supporting Irish chief MacPhelim to a sumptuous feast in Belfast with his family and servants, his soldiers rushed in, and after killing the servants MacPhelim and his family were escorted to Dublin and executed.

Fitzwilliam wanted the number of English soldiers in Ireland reduced to 2,000, forcing a petulant Essex to resign his position. Elizabeth decided otherwise, ordered the campaign to continue, and in March 1575 made Essex earl-marshal of Ireland. However, on 22 May she changed her mind and ordered him home. In his fury he carried out the most brutal campaign during the following four days, inhumanly slaughtering many, including an old woman and children hiding within a cave. This outrage was one of several that would be remembered in years to come by the Irish.

In May 1575, when the Earl of Kildare and his two sons were suspected of treason, Sir Edward Fitton escorted them to England,

Gawsworth Hall, inherited in 1579 by Sir Edward Fitton's son Edward, was reconstructed around the old manor house courtyard in 1591. The latter building was part used in the redevelopment plan.

but returned to Ireland for the last time in September with Sir Henry Sidney as Fitzwilliam's replacement. The final upset was in April 1578 when he withheld the fact that he had succeeded in increasing the revenue, a result that Elizabeth would have greatly applauded, for she was determined that Ireland would cause her no further expense and must be financially independent to sustain itself.

Whilst on expedition in Longford Fitton caught a fever prevalent in Ireland and died on 3 July 1579. The governor, Sir William Drury, in learning of his death, admitted that Fitton had not been without enemies, but to him the loss was great and he hoped that Fitton's successor would have the same 'temperance, judgment and ability' to serve Elizabeth's undertakings.

Sir Edward was buried in St Patrick's Cathedral next to his wife of thirty-four years, during which time they had produced nine sons and six daughters.

The Last of the Tudor Years

The older Elizabeth became the more stubborn she grew, causing her council and Parliament utter frustration at times. Her father's defence

system began to operate independently when required, supported by loyal individuals and the merchants of London.

Following the assassination of William of Orange in 1584 the Dutch states sent a delegation to England asking for help. Finally Elizabeth agreed to pay 4,000 troops to aid their cause, but until the debt was cleared she was to hold four Dutch coastal towns, including Flushing and Ostend. The troops, ill equipped and without a competent commander, arrived too late to save Antwerp, and, abandoned by their officers, without pay or provisions, the ragged remnant took months to return to England where many were seen begging in the streets.

Elizabeth privately began encouraging Francis Drake and others to harass Philip II's Spanish dominions and contemplated deserting the Netherlands. In April 1587 Drake sailed for Cadiz, a maritime province of Spain whose town of the same name was one of the country's chief commercial ports. Too late did she try to rescind her permission, and on the 19th the port was burnt, and the Spanish fleet, already prepared for an English attack with four of its ships laden with provisions, lost thirty-three vessels to Drake's thunderous attack. The four provision ships were seized and brought back to England. This strengthened Philip's determination to conquer Elizabeth's realm.

Due to his endeavours to project his absolute rule in the Netherlands, Philip had almost bankrupted Spain. His people were outrageously taxed, but this in no way impeded his determination to castigate Elizabeth by bringing about England's defeat. Soon enough he had a fleet ready for action, which set sail in July 1588, but he had greatly underestimated England's resources.

Despite having no standing army Elizabeth could rely on a militia fully trained and equipped that could be mustered in the different counties at any time. In 1564 she had agreed the establishment of the Company of Mines Royal, resulting in the arrival of miners from Augsburg in the Lake District. In August 1567 they had discovered copper, describing the mine, soon to be called Gold Scope, as 'the richest mine in England'; this allowed the company to be finally incorporated in 1568. It had been known for centuries that copper, when melted with a proportion of tin, had the ability to produce bronze. Over time it was appreciated that a recipe of one-tenth part

of tin to nine-tenths of copper produced the best alloy for weapons. This meant that Elizabeth no longer had to rely on imports of copper from Sweden, for which her father had paid dearly.

In addition to this, by 1570 at least fifty iron furnaces were in operation in Sussex and Kent, all capable of producing the finest quality iron ordnance in Europe.

Drake had already appreciated Philip's efforts to build up his fleet in order to invade England, but at first Elizabeth refused to believe that he would dare to do so. When the Spanish Armada was sighted off the Lizard in July, the English ships at Plymouth were said to be short of victuals and had insufficient powder and shot.

Leicester took command of forces on the Thames and 4,000 men were able to assemble at West Tilbury, but lacked adequate supplies of bread and beer. Yet by the first week in August the panic was over. It can be argued that Elizabeth's attitude of forcing self-sufficiency upon her people had actually paid off – based on her father's foresightedness.

The battle of the fleets had begun with five days of intense cannon fire. The Spaniards, however, wasted unnecessary powder and shot, forcing them to withdraw to an offshore position near Calais to await the arrival of reinforcements from the Spanish Netherlands.

Under cover of darkness Drake seized the opportunity to send in his fire ships, old hulks loaded with barrels of dynamite. Desperate to escape the Spaniards scrambled to weigh anchor, and those who could, scattered, with many sailing north. Although the English fleet was effectively blocking the Channel many drifted into the North Sea intent on reaching the Spanish Netherlands, and initially Drake feared that they would seek refuge somewhere in Denmark. The English ships gave chase but their efforts were not needed, for a ferocious storm swept many of the Spanish ships onto rocks.

Of the original fleet that left Cadiz, only fifty were said to have returned. A total of 120 ships were last seen struggling in the North Sea, twenty-five of which remarkably reached the Atlantic. Several attempts to reach the west coast of Ireland, however, were in vain as enormous waves dashed them to pieces on rocks. Those fortunate enough to reach shore anticipated a friendly reception, but were instantly cut down.

Although few English soldiers were actually killed, the spread of disease and inadequate victuals and care caused a considerable number of deaths. Elizabeth left it to others to pay the expenses, which again resulted in destitution for many.

Whilst it is logical to assume that those taking part were from the south of England, it is known with certainty that Peter Legh IX of Lyme was an Elizabethan soldier at that time. His father, designated Peter VIII, had died before his grandfather, so the younger Peter, aged twenty-six, inherited his grandfather's estates on the latter's death in 1589. He was therefore old enough to have served in the Spanish debacle – if not at sea then most likely in Ireland. However, he could have served at any time also in Scotland or the Netherlands, and where he went others from Macclesfield were likely to follow. On inheriting his estates he settled down to become 'a sophisticated courtier and patron of the arts', and also one of Cheshire's MPs.

Elizabeth continued her involvement in trade speculations during the 1590s, but the attempt to seize Philip's treasure ships was a failure, as was the attempt to assist Don Antonio claim his right to the Portuguese throne, which involved 160 ships and 23,000 men. Drake died in the West Indies on 28 January 1596 and it was left to the erratic and irascible Robert Devereux, 2nd Earl of Essex, to grasp his desire for glory in the second attack on Cadiz in June of that year.

On the 1st of the month four squadrons sailed from Plymouth under the command of Raleigh, much to the chagrin of Essex who was placed under Raleigh's command. On board one of the ships was Urian Legh of Adlington Hall, eldest son of Thomas Legh. Thomas, tenth in succession was only one-year old when his father died, and therefore a ward of the court. There is no indication of any active military service, except for the fact that he was High Sheriff of Cheshire in 1588, a position at last separated from that for Lancashire, which meant that he was responsible for the enlisting, rallying and training of Cheshire troops. His son, however, apparently eager to take up arms, had been serving elsewhere, possibly in the Netherlands with Essex, for he was thirty years of age by the time he was bound for Cadiz.

As the four squadrons sailed south from Plymouth, they were joined by a Dutch squadron, and arrived off Cadiz on the 20th. The English force comprised ninety-three ships and 13,000 men, and all were soon involved in a fierce battle resulting in total victory for the English and Dutch. At this point Essex, who had forced his ship forward at the onset, rallied 3,000 of his men, including Urian, and dashed ashore conquering all before him. On the 22nd his flag was hoisted in the marketplace of Cadiz, and Urian Legh was knighted for his military efforts. Two years later Urian was in Ireland serving under the 'Colonel-General' Bagenhall as 'Commander of the Horse Company'.

* * *

As regards France, the civil war was periodically continuing, and with the assassination of Henry III on 1 August 1589 the Valois dynasty was at an end. Elizabeth supported Henry of Navarre in opposition to Spain, but having become King Henry IV he sought help from Elizabeth, who provided money and a small army on two occasions, yet to little effect.

On 2 May 1598 France and Spain signed a peace treaty and Henry IV was received into the Church of Rome, resulting in the Edict of Nantes, which created a large migration of Protestant artificers, known as Huguenots, north to the Netherlands and also to England. In August of the same year Elizabeth signed a treaty with the Netherlands by which permission was given for the levying of forces within her kingdom for service abroad, but payment had to be made for such service.

During the same month Hugh O'Neill, Earl of Tyrone turned his attention to the important garrison of Blackwatertown, close to Armagh in Ireland. Sir Henry Bagenhall of Newry, marshal of the queen's army, hurried to its relief with 4,000 men, but was utterly defeated having been drawn into a trap. The death total included Bagenhall and 700 men, and if it is assumed that Sir Urian Legh was still serving in the horse company, then he must have been taken prisoner along with other survivors. Tyrone surprisingly soon allowed them their freedom, perhaps hoping, as happened, that some would defect to his army.

Affairs in Ireland had again reached a critical point due to O'Neill's actions. The whole of the four provinces were threatening all out rebellion, and it was decided to despatch as large an English army as possible. Essex was considered as commander, but his relations with Elizabeth had always been of an erratic nature. She hesitated, then finally agreed against her better judgment. The whole operation turned into a total disaster.

Initially feted in London on his return from Cadiz, Essex enjoyed his moment of populace adoration before assembling an army, and on 17 March 1599 began a slow march to Beaumaris in Wales. Having sailed to Dublin as the appointed lieutenant and Governor-General of Ireland he intended to advance into Ulster, but the Irish council objected. They pointed out that so large an army could not be sustained there. Instead, in May, he headed south with 3,000 foot soldiers and his friend Southampton, whom he had promoted to general of his horse with 300 mounted troops under his command as Bagenhall's replacement.

Along the way they were joined by the Earl of Ormonde with his 900 recruits, and must have created quite an impression, for the castles en route surrendered at their approach and Essex was able to convert them into English garrisons. Ignoring the council's intended planned campaign to engage only the Leinster rebels, he quickly marched into Munster.

This action proved to be Essex's Achilles' heel, for having selected a group of new recruits he alone led them to Arklow. Without training or previous experience they lacked the knowledge on how to respond under fire, allowing the rebels the upper hand. He reported to the queen on 25 June bewailing his difficulties, and how he considered that the subjugation of the Irish by military means would be expensive and time consuming. He suggested that it would be better to hunt down the Roman Catholic priests and bribe others to create a strong pro-English group amongst Irish leaders. Elizabeth was furious, especially when learning that part of the army under Sir Henry Harington had suffered a disastrous defeat near Wicklow through cowardice. Essex was court-marshalled in Dublin. Southampton and some of his officers were imprisoned, and a Lieutenant Walsh was ordered to be shot.

With the army reduced to little more than a quarter, after taking into account those left in the garrisons, this was an appalling indictment on Essex, for he had begun with 16,000 men at his disposal. Elizabeth sent him an angry letter, insisting that Southampton be removed. At first Essex stubbornly resisted, but finally relented, at which point Sir Urian Legh had presumably been given charge of the horse troop. Elizabeth then ordered Essex into Ulster.

The handling of the Tyrone affair subsisted of a meeting between the rebel leader and Essex, and culminated in a treaty being signed whereby the Earl of Tyrone agreed to try to bring two other rebel leaders to the negotiating table, but in this he failed. When Elizabeth discovered that Essex has acted on his own initiative without consultation with her or the council, she was infuriated. Placing the Earl of Ormonde in charge of the army, Essex and his small retinue of attendants hurriedly departed for London. Unannounced he burst into her bedchamber mid-morning. Taken by surprise at his unkempt state, and no doubt the wildness in his eyes, her reaction was one of civility in order to placate him. But as the day continued, having spoken to Cecil, her attitude changed, and Essex was summoned to a secret meeting with the council. They demanded an explanation as to why he had left his Irish post without permission, had acted in defiance of instructions, had sent the queen audacious letters and had presumptively burst into her bedchamber.

Whatever he responded, his attitude was one of expectancy for an order returning him to Ireland. In that he was to be abruptly disappointed, for he was placed in confinement under house arrest, and forbidden to see his newborn child; even his servants were not allowed to show him sympathy. As time passed only occasional visits by his wife were permitted, and his health began to deteriorate. In December Elizabeth did permit a team of surgeons to perform an examination. He wrote her appealing letters and even sent a New Year gift, which was promptly returned.

Meanwhile another of Elizabeth's favourites, Charles Blount, 8th Earl Mountjoy, was offered Essex's former Irish position, but then changed his mind. After Elizabeth had finally agreed to pay

him a large sum for initial expenses to support an army of some 13–14,000 men, he set sail for Ireland in February 1601. Amongst such a vast army there would have been many from Cheshire and Macclesfield who would have been well aware of the disgrace of Essex, but the latter, intent on ridding the council of his enemies, sent a message to Mountjoy.

Essex's idea was for contact to be made with James VI of Scotland inviting him to join Mountjoy's army and march on London creating rebellion. Momentarily Mountjoy acquiesced and contacted James, who refused. Realising his lapse of duty, he at once concentrated on the task in hand, for Tyrone, who was in almost total control of the country apart from Dublin, had assembled the largest rebel army ever gathered in Ireland, supported by 4,000 Spanish troops.

By March 1600 Essex had been moved from York House to Essex House still in confinement, but had gained a little more freedom. Having conspired with his friends, he went ahead with his plan for inciting the Londoners to rebel, but as he rode through the city he was seized and stood trial in Westminster Hall. There, on 19 February 1601, twenty-five peers and nine judges found him guilty of treason. Elizabeth reluctantly signed the death warrant but had it recalled, and then signed it a second time; he was beheaded in the precincts of the Tower on 25 February.

On learning of Essex's execution Mountjoy feared for his own life, as many of his friends had suffered the same fate, but Elizabeth chose to ignore the suggestion of his involvement in Essex's scheming. This time there was no room for failure, so he determinedly attacked and took Tyrone's stronghold Lough Foyle in July 1601; five months later his army won a great victory. At the same time Sir George Carew retook the south, and with the expulsion of the Spaniards Tyrone was forced to capitulate. Elizabeth intended to spare his life and return his former title and estates after swearing to the renewal of his former allegiance to the English throne, but she died on 24 March 1603 leaving Mountjoy to present the petition for pardon to her successor.

By this time Sir Urian Legh was in Adlington Hall once more, having succeeded to the family estates on the death of his father, Thomas in 1602.

3

THE STUARTS

James I

At the time of her death Elizabeth I had not nominated her successor, and any suggestion is absent in her will. The councillors, however, grouped around her deathbed and, knowing that she could no longer speak, reported that she had made a signal to confirm their choice of James VI of Scotland as James I of England.

On her return to Scotland, his mother Mary had at first managed to overcome much of the fierce Protestant opposition with her charm and grace. She was not politically minded but did relinquish Scottish ties with France, then set out on an imprudent course creating for herself a traumatic turn of events. Her marriage to Henry Stuart, Lord Darnley, on 29 July 1565 resulted in his murder one month after the birth of their son James on 19 June 1566. This was followed by the suspected love affair with the Italian Rizzio, who was also murdered. Her forced abdication allowed young James to be declared James VI of Scotland on 24 July 1567, after she had recklessly married Bothwell in February of that year.

Mary found herself under pressure to divorce, and was hounded from place to place whilst plots were afoot for her remarriage. Finally she crossed the border into Carlisle, but having been promised safe conduct found herself held in captivity for the remainder of her life, which terminated with the Babington Plot. Her subsequent trial for treason, culminated in her execution at Fotheringay in 1573. James, brought

up by Protestant guardians and tutors, was little affected by her fate, endeavouring instead to build a close relationship with Elizabeth, whilst bearing in mind his desire to inherit the English throne.

As a boy James VI of Scotland experienced a few eventful years in his Scottish realm. There two great powers, viz. the old Roman Catholic nobles, still operating under a feudal system, and the vast majority of the middle and lower classes guided by their Presbyterian principles, were archenemies. Fortunately James proved to be an excellent scholar, and his shrewdness in handling the political schism was far greater than expected. For a while at least, French connections faded and English reliance superseded.

Under the treaty, signed at Berwick on 2 July 1586, James was to receive a gratuity of £4,000 per annum from Elizabeth, and because of the alliance, together with his adherence to the Protestant faith, his mother Mary disinherited him and left her domains to Philip II of Spain.

From an early age, apart from his Protestant faith, James sought to foster peace wherever possible and in doing so his ambition coincided with that of Queen Elizabeth. When positive evidence was finally discovered of Mary's part in the Babington Plot to assassinate Elizabeth, on being advised of his mother's guilt, his somewhat ambiguous response was that he would not interfere. On hearing of the death sentence, however, he did send ambassadors to intercede with Elizabeth, but anxious to gain legitimately the English throne it seemed only a token response to placate his Scottish rebels.

With Elizabeth's death his ambition was fulfilled, and he set about choosing councillors who were eager to promote peace. By 1604 his orders for the cessation of hostilities with Spain were finally achieved.

James initially seemed anxious to promote religious toleration, which gave hope to the Roman Catholics of receiving better treatment than under Elizabeth's rule, but the actions of his English government were judged to be hostile. He was annoyed to discover that his wife, Anne of Denmark, was secretly practising her Roman Catholic religion and early in 1604 gave his royal assent to a bill for stricter control of priests and recusants. The resentment quickly built up, culminating in the Gunpowder Plot of 1605, inducing even stricter measures.

Next, James attempted to bring about full union between England and Scotland, and had already assumed the title King of Great Britain, without Parliament's consent. His continual attempts to reduce the power of the Scottish clergy, even forbidding the meeting of the general assembly, fostered rebellion. Against his express orders an assembly met in Aberdeen in July 1605, resulting in perpetual banishment for six of the nineteen ministers and confinement for a further eight. Realising he could not eliminate Presbyterianism he contented himself with appointing new ministers and extracting a guarantee that they would elect a moderator annually to oversee their meetings, rather than have a different one each time they met.

The attempt at political union was also a failure due to opposition from the English Parliament. In the Parliament called in 1606–07 James endeavoured to promote free trade and the naturalisation of Scots in England, and vice versa, but the House of Commons resisted. Instead James succeeded in obtaining legal judgment stipulating that Scots born after his accession to the English throne were to be natural subjects of the English Crown.

In his efforts for European peace he worked hard to bring about reconciliation between Spain and the Dutch Republic, and agreed to give military assistance to the latter if Spain decided to attack after peace had been agreed. Having signed to that effect on 16 June 1608, no peace settlement was forthcoming, so together with the French he persuaded both parties to submit to a long truce, signed finally in the spring of 1609.

At that time 4,000 English infantrymen were still serving in Holland, and he paid them to assist a Dutch force in taking the province of Juliers for the Protestant cause. Where these English volunteers were from is at present unknown.

On 6 November 1612 James's eldest son Henry, Prince of Wales and Earl of Chester, an ardent Protestant, died of typhoid fever. He was his sister Elizabeth's favourite brother, and despite asking for her, on hurrying to his deathbed she was denied entry, presumably because of the fear that she might become infected also. The following year she married Frederick V, the young Protestant Elector of the

German palatinate. The result was a Dutch treaty with Frederick on James's request, causing problems with Spain.

James's one success was the establishment of the Episcopalian church in Scotland, yet once more he caused controversy by promoting negotiations for his son James's marriage to the Spanish Infanta in order not to alienate the Roman Catholics.

In 1618 problems arose in Bohemia and James's son-in-law Frederick V was offered and accepted the Crown. James was asked to help if Spain interfered and attacked. He at first agreed then changed his mind. Meanwhile, Queen Anne died on 2 March 1619 and James also fell seriously ill, fearing for his life. He did recover and, with a further change of mind, decided to send an army with Sir Andrew Gray in command to defend the palatine in March 1620, but paid for by negotiating a loan from the King of Denmark. This was yet another intention that did not transpire, as he claimed that he wished to encourage peace instead. The reason was possibly due to the arrival of a Spanish delegation in the middle of the month to discuss further the marriage of his son Charles to the Infanta, daughter of Philip III. In the event he did allow voluntary contributions and men to be made available for the defence of the German palatinate.

In trying to please all factions, whilst at the same time exercising his royal power and control, unavailable to him in Scotland, James had sown the seeds for yet another devastating period of English history. Corruption became rife in his court and Parliament was constantly exasperated with his foreign policy, which wavered between Holland, the German states and Spain. At one stage the Spanish were convinced that Charles would convert to the Roman Catholic faith, and invited him to Madrid. By 1623, desperate for marriage and unknown to his father, he agreed to go with James's favourite, George Villiers, Marquis of Buckingham, who himself had considered conversion.

At first James was angry, but did agree to the idea, and out they sailed in May 1623. On arrival, when the Spanish religious intent became clear, added to which were further demands, Buckingham was adamant that the former was impossible. Matters deteriorated

over the next few weeks and he was accused of rudeness. To allow him more power James sent a message granting him a dukedom, but, with nothing resolved, the pair returned to England at the end of August.

So angry was Buckingham that he urged war with Spain, and he, together with his whole family, was baptised in the Church of England. He clashed with Parliament, which had no desire for war. Eventually, on 23 March 1624, both Parliament and Buckingham pressured the king in ordering the termination of Spanish negotiations. Buckingham's desire was a war for the recovery of the German palatinate, but the House of Commons preferred attacks by sea on Spain. Meanwhile, he was busy promoting a marriage between Charles and Henrietta Maria, youngest daughter of Louis XIII of France.

By January 1625, Buckingham's plan for 12,000 foot soldiers to be sent under the command of Count Mansfeld to assist Frederick V had been agreed with the king. The problem was the treasury's shortage of bullion, and as a consequence there was no financial support for the scheme, resulting in a dreadful failure. The army was unable to proceed further than the Dutch border. The troops began to starve, fall ill with disease and infections, whilst others died or dwindled away.

Ebullient as ever, Buckingham planned a whole catalogue of enterprises, to which Charles meekly gave his support contrary to his father's wishes. The intended French settlement was agreed, including the stipulation that whilst Henrietta and her entourage would be accepted as Roman Catholics in England, there would be no toleration for others. The French Cardinal Richelieu had other ideas, and at the last minute included religious liberty for all Roman Catholics in England. A weakened king, under pressure once more from Buckingham and Charles, acquiesced, and the settlement was signed on 10 November 1524. No Parliament was called to give approval, for it was known that they would reject Richelieu's demand.

James fell ill on 5 March 1625 and died on the 27th, but his burial in Westminster Abbey did not take place until 5 August.

Fitton tomb in Gawsworth Church completed in 1629, still supported by the alabaster figures of Dame Alice Fitton, who died 1627, and children. The effigy of her husband, who died in 1606 (former Lord President of Munster as his father before him), has long since disappeared.

Whilst there had been little opportunity for Macclesfield's military involvement during James I's reign of almost exactly twenty-two years, unless, of course, some volunteers had managed to serve in Holland, the same cannot be said of his successor's reign.

Charles I

Charles I, born in Scotland on 19 November 1600, was created Duke of Albany at his baptism in December of that year. He was brought to England in 1604, but caused great concern due to his physical weaknesses, especially his ankles, which seemed to be 'out of joint', and his slight speech impediment. His father suggested drastic cures for the boy, but was persuaded to allow nature to take its course, and with time Charles outgrew these 'defects'.

On 16 January 1605 he became Duke of York, and following his brother's death in 1614 was created heir apparent. Not until 3 November 1616 did he receive the titles of Prince of Wales and Earl of Chester. This was highly significant for both Chester and Macclesfield when the question of loyalty to the sovereign would become an issue.

On his accession Charles was totally under the control of Buckingham, and any efforts by Parliament to rid the king of his favourite were in vain. Buckingham's sole ambition was glory by waging war, with utter disregard from where the financing would come from.

On 1 May 1625, Charles and Henrietta Maria were married by proxy, then finally met as husband and wife in Canterbury on 13 June. The king soon embarked on various schemes to raise money for the war effort, even pawning the Crown Jewels. Informed of the fact that Louis XIII had refused to allow English soldiers to march through French territory in order to support Frederick V, he decided to ignore Richelieu's last-minute addition to the marriage settlement with regard to Roman Catholics and vehemently supported the Protestant cause. This not only included those in his own realm, but also those on the Continent. With his considerable efforts to stamp out Roman Catholicism, inevitably it led to war with France.

Initially, however, Buckingham's quarrel with Spain was allowed priority. Charles gave orders for a large fleet and army to be quickly assembled, with disastrous results. Many of the ships were merchantmen, and the majority of sailors were press ganged into service and the soldiers were levied. This resulted in an army of men inexperienced in warfare, many of whom were disgruntled individuals and lacking officers of good calibre.

Buckingham chose Sir Edward Cecil to head the strategy. Cecil had served during many campaigns in the Netherlands, had been knighted by Queen Elizabeth after gaining a considerable military reputation 'for valour and conduct', and had achieved high ranking in the army. As Charles reviewed his fleet in Plymouth, he raised Cecil to the peerage with the title Viscount Wimbledon. They sailed

out of Plymouth on 8 October with orders to attack anywhere on the Spanish coast. Accompanying Cecil were the Earl of Essex, Lord Cromwell and Sir John Burgh.

Cecil chose to land at St Mary's on Cadiz Bay, but saw Spanish ships anchored in the outer harbour of Cadiz. Realising that an immediate attack should prove a success, he fired a token round towards them and signalled for the others to follow. For some unknown reason, possibly jealously on the part of Essex as he was not in overall charge, the other vessels ignored his signal, and, realising the imminent danger, the Spaniards quickly cut their cables and retreated to the safety of their inner harbour. Suspecting that Cadiz itself was undefended, the other three commanders urged Cecil to take action, but apparently afraid of the lack of support, he hesitated. The rest of the expedition was a total disorganised failure, and on the 29th the fleet returned to Plymouth. Essex was quick to execute a formal charge of misconduct on Cecil, but much of the blame came to rest with Buckingham.

The king obviously believed Cecil's defence, for he received further important military positions before he died in 1638. However, Buckingham's interference was over – he had been assassinated in Plymouth in 1628, although not before he had led a final disastrous expedition. His intention was to relieve Rochelle in the Bay of Biscay and recover the English ships seized by the French in the Channel. Also he was determined to support the Huguenots of south-western France who were in danger of attack. Accompanied by men comprising the remnants of the Cadiz force, increased to 8,000 by inexperienced raw recruits, he landed at the Isle de Ré, offshore from Rochelle. His usual irrational scheming ensured yet another devastating failure and, sensing that his life was in danger from mutinous soldiers, the fleet returned to England. His fears proved correct, for whilst on a later visit to Plymouth he was stabbed by a discharged officer.

There is at present no positive evidence of anyone from Macclesfield taking part in these expeditions, but with the involvement of Essex in the Spanish escapade, again there is a possibility that a handful of youths, keen for adventure, could have volunteered, knowing the previous success of Urian Legh at Cadiz. One suspects, however, that the majority

of those press ganged into service, were from the south coast area, or had been levied in London and the surrounding region for the army.

* * *

After Buckingham's demise Charles's quarrels with Parliament rapidly escalated, particularly on the question of religion. Finally, in 1629, exasperated by his ministers, he dissolved Parliament and decided to rule alone.

By 1634, with the strength of the French navy increasing, he ordered payments of ship money to be collected, which was in effect a tax to enable England's seaports to build larger and better vessels for engagement with the enemy as necessary. A truce with Spain proved unsuccessful. Charles was also angered by the Dutch when he discovered that crews of their East India Company had been capturing and torturing English merchants and seamen in the Far East.

Ship money writs became necessary and were issued each year causing great resentment, especially when the collections spread inland. Added to this, in trying to placate Roman Catholics he took serious action against the puritanical element within the Church of England, resulting in executions. His lavish Scottish coronation in Scotland on 18 June 1633, and his attempts to force the rituals of the Church of England on the clergy who were fiercely Presbyterian, had lost him the support of the Scottish people. In an effort to subdue the ill feeling he decided to send a voluntary force from the northern counties, which, apart from being armed with weapons, was armed with copies of his proclamation meant to heal the differences between them – but no one was listening.

On 30 March 1639 Charles arrived in York and offered a reduction of 50% to all tenants who would take up arms against the Scottish rebels; it proved to be another ill-organised affair and short of funding. With the Scottish army mustered at Dunse (Duns) on 5 June, a little to the north of Berwick, the king finally had to abandon his campaign and instead sign a treaty at the latter town on 18 June. Meanwhile some Scottish nobles began negotiations with the French, which alarmed Charles, who managed to obtain a loan from the privy council. Still short of funds, on

The Stuarts

13 April 1640 he recalled Parliament after eleven years, but the members refused to grant money unless peace was concluded with the Scots. After the session known as the Short Parliament because of its rapid dismissal on 5 May, Charles continued alone with his plan for war and obtained money by other means, some of which were said to be 'dubious'. At this point in time he came under the influence of Thomas Wentworth, whom he had created Earl of Strafford.

* * *

Wentworth, born in 1593, was an extremely well-educated man, a student of Cambridge and a member of the Inner Temple. From 1614 he represented Yorkshire by gaining a seat in the Commons during the reign of James I. His policy was very much in favour of not supporting military action against Spain. He was not without enemies and at one juncture was unseated, but was reselected on 1 August 1625 – four days before the burial of King James. In November that year he became sheriff of Yorkshire.

Wentworth was a man of strong principles, and in defending the rights of the people through representation in Parliament, his policies had clashed with those of Buckingham and set him against the king. His powerful speeches began to take effect, resulting in his leadership of the House of Commons. On 22 July 1628 he was created baron Wentworth, and became viscount on 10 December; his appointment as president of the council of the north followed on Christmas Day.

It was no easy task for the viscount, who found himself trying to control the independent gentry of both Yorkshire and Lancashire, but by 1632 he had delegated much of his work to his deputy, leaving himself time to widen his authority. The result was his appointment as lord deputy of Ireland, although he did not arrive in Dublin until 23 July 1633. By then all the positions in the city were those occupied by immigrant Englishmen, or their descendents.

The Fitton family of Gawsworth had remained in Ireland – possibly accompanied by some of the soldiers from the Macclesfield area who had stayed as part of the small occupying reserve force.

After the burial of Sir Edward Fitton in St Patrick's Cathedral, Dublin, on 21 September 1579, his son and heir Edward had inherited the Gawsworth estate and hoped to replace his father as vice-treasurer in Dublin; however, it was not to be. After being knighted as a baronet he had returned from Ireland to his Cheshire estates. Learning that there was a proposal for Englishmen to colonise Munster, on 3 September 1587 he purchased just over 11,500 acres from the Earl of Desmond's forfeited estates in Waterford, Limerick and Tipperary. Having fruitlessly spent £1,500 without profit, he again returned to Cheshire complaining bitterly about his losses and asking for compensation in memory of his father's 'grace and favour'. He then settled permanently in Gawsworth Hall, where he died in 1619.

(It was his sister, Mary Fitton who, aged seventeen, was maid of honour to Elizabeth I from 1595. She caused a scandal in 1601 when, as mistress of young William Herbert, Earl of Pembroke, she bore him a son. The child died shortly afterwards, yet while the earl was sent to Fleet Prison, Mary escaped punishment. It was later rumoured that she had also given birth to two illegitimate daughters, but the only definite evidence seems to be that subsequently she was married twice.)

Edward's son, yet another Edward, 2nd Baronet, was High Sheriff of Cheshire in 1633, and would prove to be a staunch Royalist. The 2nd Baronet's great-uncle Alexander, the latter being the much younger brother of Sir Edward, was a captain in the army of Awrie in Limerick. He married an Irish lady and they remained in Limerick together with their three children.

When Wentworth arrived in Dublin he was faced with a formidable task. His integrity was utmost as he strove to make the Irish as wealthy as their English counterparts, to reform the Irish Protestant Church, and to create Englishmen out of Irishmen, thus ensuring their loyalty. First he managed to obtain from Charles an extension of one year for an additional grant with which to pay the soldiers of his small army, necessary for his protection, and to compel discipline in them. Despite his orders and desires, his good intentions to see them carried through were bound to cause trouble.

The Stuarts

Wentworth called his first Irish Parliament on 14 July 1634 and asked for their support in providing supplies, assuring them that in the next session their grievances would be addressed. However, during the second session in November, he firmly stated that he had no intention of allowing the Roman Catholics all the concessions which the king had promised. As many Protestant members had not attended, the Catholics held the majority and rebelled, which Wentworth later described as a mutiny. He also forced the substitution of the Calvinist articles for the Anglican ones, and continued by suppressing the Ulster settlers' puritanical practices – the latter settlers were mostly Scots.

Lord Mountnorris, who was vice-treasurer and an active council member, came under Wentworth's suspicion for malpractice. Finally, after several acts of vicious retaliation by Mountnorris, the king gave permission for the deputy to be court-martialled. On 12 December 1635 he appeared before a council of war and was condemned to death as a captain of the army. As Wentworth later tried to explain, his intention was only to frighten the man into resigning, and, having done so, he was set free.

In 1636 Wentworth returned to England, and in June of that year stated to the Westminster Council how much things had improved since his arrival in Dublin. The following February, Charles, who had begun to appreciate Wentworth's expertise, consulted him about declaring war on France and its supporters in order to assist the Austrians. But, as Wentworth pointed out, the king was not in a strong enough position for war, and shortly afterwards left for Ireland. There he made a considerable effort in securing Ormonde and Clare for a plantation. Unfortunately, however, he over estimated the number of English immigrants who were likely to settle in Connaught, and his schemes proved to be a failure.

During 1639 Charles was preparing for war with Scotland, and although Wentworth sent him £2,000 in support, he vehemently opposed the king's plan to attempt an invasion until he had time to levy and train an Irish army intended to assist the king's English force. Instead he insisted that it was better to blockade the Scottish ports until the full force was prepared. In the event neither took place, and Wentworth, who was then created Earl of Strafford on 12 January

1640, returned to take his seat in the House of Lords in time for the sitting of the Short Parliament. With its abrupt termination he arrived once more in Ireland on 18 March 1640.

Having already taken a firm stand, he initially persuaded the Irish Parliament to authorise a levy in order to raise a considerable Irish army. Word soon spread to England creating fear that the Irish would join the Scots. On 3 August the earl was appointed captain-general of both the Irish and English armies, but before the Irish army had time to join the action, Charles headed off to Scotland with his English troops. The Scots, however, judging that English sympathy was generally with them, crossed the Tweed on 20 August 1640. They defeated part of the king's army at Newburn eight days later, then proceeded to occupy Newcastle and Durham. Desperate for money,

Reproduction of a mid-seventeenth-century English breastplate, as worn in the Civil War. (Private collection)

Charles called a great council in York, which met on 24 September, but the council insisted on negotiations with the Scots, and Charles agreed to call what became known as the Long Parliament.

Once again it is difficult to judge whether or not men from Macclesfield played a part in the northern army's foray into Scotland, due to a lack of information. The Legh, Fitton and Jodrell families, together with the Earl of Derby (by this time a strong Protestant, although the Roman Catholic faith continued in the family through one of the sons) all remained loyal to Charles. Amongst them only Roger Jodrell, as a royal tenant in Macclesfield Forest, could have been swayed to send some of his men to join the Royalists in order to claim his rent reduction. By this period he also owned property and land in Twemlow parish, some 10 miles south-west of Macclesfield township, as agreed through his marriage settlement. Part of the land would later become the famous astronomical Jodrell Bank site.

Parliament was recalled on 3 November in London, and at first it proved to be a battle of wills between members and the king, but each time, under pressure, a weakened Charles reluctantly gave in – Parliament was proving the stronger. One of their first acts was to rid themselves of the interfering Earl of Strafford. Every possible indiscretion and more fallacious stories were presented – even the Irish Roman Catholics sent a party to add venom to the proceedings. On 25 November, with a charge brought against him, Strafford was imprisoned in the Tower. His trial opened on 22 March 1641. Already impeached, further accusations were presented in April and rumours began to spread that the king and queen had secretly asked for French help. The farcical trial continued, with Strafford reconciling himself to his fate.

The king was greatly distressed and on 2 May 1641, apart from it being the day when the marriage of his eldest daughter Mary to Prince William of Orange took place, the prince brought the king money in order to fight the Commons. An attempt was made by a captain with a military force of 100 men to enter the Tower of London in the king's name, with the hope of rescuing Wentworth. He was met with a refusal by the lieutenant, and likewise another attempt the following day on the pretext of recruitment for a force to be levied for Portugal. The latter action by the lieutenant of the Tower caused mayhem, with an angry crowd attacking the House of Lords shouting for justice for Wentworth.

The Commons presented Charles with the bill for Wentworth's execution, which he at first refused to sign. The new constable of the Tower informed the king that whether he signed it or not, he would ensure Wentworth was executed. Charles, appreciating the gravity of his own situation, finally signed the fateful document. Wentworth bravely went to his execution by beheading on Tower Hill two days later on 12 May, refusing to have his eyes bound. He left a distraught Charles, who, on 1 December 1641, granted Wentworth's only son, William, his father's forfeited honours by his attainder. The boy was fifteen years old.

* * *

By this time it had become obvious that the Commons was full of puritanical members whose every action was to strip Charles of as much royal power as possible. The rest of the country, however, was divided on the issue. The king erroneously thought that by appealing to the Presbyterians in Scotland he could save his English bishops. He set out for Edinburgh, where initially he received a rapturous welcome, but foolishly some unscrupulous members of his own party plotted to murder three opposing leaders when the king was refused help. The plot soon became known and he was suspected of being the main instigator of 'The Incident', as it was later termed. Added to this was the revelation that he had granted concessions to Roman Catholic Irish lords for ridding Ulster of its Scottish Presbyterian residents.

Over the next few months, Charles's oscillating policies of trying to placate everyone failed miserably. On 4 January 1642 he arrived in Parliament with an armed force to arrest the five members present, but did not succeed, and, as word of his action spread, the city turned against him. Six days later he left Whitehall to recruit as many as possible in a predicated arms struggle with Parliament, whose members were already busily recruiting for their own army in an effort to legitimise their position nationally.

John Pym, who had of late updated the Parliamentary finances, was leader of the war party, and having funds at his disposal he set about creating a temporary updated national Parliamentary army with the best weapons and equipment available.

On 22 August 1642, with the king in Nottingham, his standard was raised and the Civil War began. But without sufficient finances to follow Pym's achievements, Charles was already one step behind in the modernisation of his own force.

The Civil War

Never before had Macclesfield and its environs been invaded on home soil, not even in earlier centuries when Viking hordes carried out raids along the Mersey estuary and the north-west coast of England, but all that was about to change, for it was initially regarded as a stronghold of Royalist support.

The Stuarts had rarely been to Cheshire, although, of course, James I had arrived first in the county after revisiting Scotland. He was at Rocksavage in August 1617, and then spent the night hosted by Lady Mary Cholmondeley in the heart of Cheshire at Vale Royal. The following day he attended a reception in Chester given by the mayor, aldermen and burgesses, then returned to the Cholmondeley residence before heading south via Nantwich and Staffordshire.

After James's death, as king, his son Charles offered several knighthoods at his coronation, of which some were intended for

The Oseberg Viking longboat in Oslo, Norway (built AD 820), before the second reconstruction of 2006. Similar boats would have been seen in the River Mersey.

Cheshire gentry. However, many were rejected, the suggestion being the commitment to supply men and arms at the king's command.

Another aggravation was the ship money tax, and although in earlier centuries outports such as Chester had served the nation adequately, they had deteriorated over time, allowing the large cities such as Bristol, York, Whitehaven and eventually Liverpool (though the latter not until the mid-eighteenth century) to expand. However, the Tudor sovereigns, especially Elizabeth I, had seized upon the situation to collect import duties for the Crown, and the port of London was quickly developed to accommodate all foreign imports within large bonded warehouses. When the outports wanted to export to the Americas from the west coast, and Scandinavia, and other countries around the Baltic and North Sea on the east coast, goods were sent from London under guard to their appropriate bonded warehouses to be loaded on board ships as necessary, but always under the strict regulations laid down by commissioners of the customs and excise board.

Ship money hit some Chester residents hard, as they were assessed both in the city and county. Two such prominent citizens were Sir Thomas Aston of Aston Hall, just south of Runcorn in north-west Cheshire, and Sir William Brereton of Handforth – therefore not too far from Macclesfield. Both seemed willing to pay the double tax and, whilst it would be assumed that both supported the Royalist cause, in Sir Thomas's case this was true, but Sir William had other ideas.

Sir Thomas, educated at Brasenose College, Oxford, and then in law, had received his baronetcy from King Charles in 1628, and was high sheriff of Cheshire in 1638. He represented the county in the Short Parliament of 1640 and was a loyal supporter of the Church of England, even petitioning against the puritanical moves within the Established Church.

Sir William, who had also received a baronetcy from King Charles the year before Sir Thomas, was a true Parliamentarian of the puritanical party. His wife was one of the daughters of Sir George Booth of Dunham Massey, Cheshire, and both numbered amongst their friends Colonel Dukenfield, all of the same persuasion. The remainder of the Brereton family, however, remained staunch Royalists, unlike their cousin at Handforth.

William Brereton, also a religious man by nature, travelled extensively throughout most of Britain and Ireland, Holland and the Low Countries, and had studied in detail the different styles of worship, even keeping a diary of the conditions and events he encountered. He represented Cheshire in the Long Parliament and eventually took charge of the Parliamentarian forces in Cheshire and the neighbouring counties to the south as commander-in-chief. They would become known as the Roundheads because of their short hair and round-fitting helmets. Their opposing Royalists took on the soubriquet of Cavaliers, retaining their long flowing and often curly hairstyles; decked out in more fashionable attire, complete with colourful silk sashes and wide brimmed hats, many of whom provided vibrant portraits when compared with those of the austere-looking opposition.

Colonel Brereton headed north from London to Cheshire, where he arrived in command of a horse troop and regiment of cavalry.

* * *

King Charles meanwhile, having initially obtained money from the mayor, aldermen and burgesses of the City of London by using several of the royal manors and other property as collateral (which in the event would never be reclaimed, thus creating the first great opportunity for individuals to become landed gentry) left Whitehall for Nottingham on 10 January 1642. On leaving his capital Charles was advised by the mayor that he could not take the River Thames with him, a poignant reminder that it was the heart of British trade.

In the early stages of the Civil War Charles could have won the day, but fate conspired against him. During the summer months he was joined by William Cavendish, Earl of Newcastle, at York, who rapidly began to raise troops and as a consequence managed to take the port of Newcastle-upon-Tyne, after which he was given command of the four northern counties including Cheshire.

William, son of Sir Charles Cavendish, had been created viscount in November 1620 by James I and subsequently received his earldom

of Newcastle from Charles I on 7 March 1628. He carried out many royal duties and proved himself to be an excellent cavalry commander, particularly against the Scots. His military activities in Yorkshire were legendary, although at one period he did retire from court.

Charles, evidently bearing in mind the London mayor's words on leaving London, was determined to regain his capital, and, with a strategy conceived whereby he would hold Oxford and possibly Reading with his main army, the Earl of Newcastle was to march south with his northern force, mostly of Yorkshire men, and take the south bank of the Thames. In support Lord Ralph Hopton of Somerset, together with his force coming from the west, would seize the north bank of the Thames in order to halt the trade of the river between their 'pincer-like attack'.

Hopton had served on the Continent in the elector's army of the palatine, and after returning to England he became a lieutenant-colonel in the Mansfield expedition. As a Member of Parliament he supported the opposition party at first, but by the spring of 1642 he vehemently supported Charles I in the Commons. In March, having attacked one of Parliament's proposed manifestos, he was held in the Tower for ten days. This could have been the reason for his delayed response to assist in the Thames's embargo, and the whole idea of retaking London at that time had to be delayed.

With the port of Newcastle in Royalist hands the earl imported a supply of advanced weaponry, and also money, from both Denmark and Holland. Since the days of Henry VIII the Continental forces had considerably improved their armouries as they were constantly at war with each other, whereas Queen Elizabeth had, of course, avoided war as much as possible. However, her investments in the mining and smelting industries had provided a useful foundation for future generations.

The Roundheads were in the fortunate position of having the arsenal at the Tower of London at their disposal together with the armament foundries in the south-eastern counties, and Pym took full advantage of the government finances at his disposal, not only in ensuring that the weaponry was improved, but that the uniforms and boots for the Parliamentarian forces were of the highest quality.

* * *

On 20 September 1642, King Charles entered Shrewsbury. Three days later he was in Chester, where he raised as large a force as possible. After returning to Shrewsbury he headed south on 12 October in an attempt to reach London. William Brereton had already left Cheshire for the capital as soon as the king appeared in the county.

In the interim, the Earl of Newcastle was forced to return to Yorkshire in order to curtail the activities of Lord Ferdinando Fairfax, leader of the Yorkshire Parliamentarian army. The latter, sent to Holland as a young man by his father, Sir Thomas, in order to gain military experience, was to be a great disappointment to his parent, who considered him 'a mere coward' when it actually came to a fight. On 22 October 1642 Ferdinando did sign a treaty of neutrality with Lord Newcastle, which was quickly rescinded by Parliament.

At the same time the king and his army reached Warwickshire, where they encountered Essex at the head of his Parliamentarian force of some 15,000 men. Amongst Charles's soldiers, estimated to be slightly less than 15,000, was Edward Fitton of Gawsworth, great-grandson of Sir Edward, buried in Dublin Cathedral in 1579. Although only fifteen years old when he inherited his father's estates, by then he was a mature individual of thirty-nine years. On the king's arrival in Chester Sir Edward raised a force of 500 men amongst his tenants and family, including many from Ireland who supported the Royalist cause. Other Irish Roman Catholics, whose landlords had Cheshire estates, also chose to support King Charles, having grown discontented with their treatment from the Parliamentarian hierarchy with Presbyterian ideologies, whose presence in Ireland was to ensure the suppression of their form of religion.

The Battle of Edge Hill

On Sunday 23 October 1642 the king and Essex faced each other in open fields close to a ridge called Edge Hill in South Warwickshire. The outcome of the inevitable ensuing battle was considered by the two to be the ultimate answer in settling the question of which power

would rule the country: Parliament or the sovereign. Although few details are extant, indicators suggest that the battle took place during the afternoon and drew to a close around sunset.

Fighting was fierce and an estimate of lives lost or soldiers wounded suggests a total of between 3–4,000 men. Despite the king's chagrin at the outcome, which produced no outright victor, his men had halted the Parliamentarian progress and were in command of the route to London. This forced Essex into a northward retreat in order to reach the Puritan garrisons of Warwick and Coventry.

Charles and his remaining force, including Sir Edward Fitton's surviving men, continued as far as Brentford, having taken Banbury en route and making a short stay in Oxford. After learning that another Parliamentary force was not far ahead of them, on 13 November Charles terminated his campaign, declaring that with the winter advancing it was better to renew operations the following year. At this juncture presumably Sir Edward Fitton and his contingent returned to Cheshire to await further orders in due course.

Divided Loyalties

After the Battle of Edge Hill the country seemed suddenly to awake to the fact that this was no longer a political or religious disagreement with the odd skirmishes here and there, but one that had catapulted them into an arms struggle where declarations of loyalty were crucial to operations.

By this period James, 7th Earl of Derby and younger son of William the 6th Earl, had only succeeded to the title on the death of his brother Ferdinando on 29 September 1642. Titled Lord Strange throughout his father's lifetime, he had first spent several years abroad before representing Liverpool in Parliament. His father had held the lieutenancy of Cheshire from 1607, and from 1626 held it in collaboration with his son James. The latter, as Lord Strange, entered Parliament the following year and received the lieutenancy of North Wales shortly afterwards, but did not take part in the Long Parliament. He was also involved in the governance of the Isle of Man as hereditary sovereign lord.

Appreciating that the families of both Lancashire and Cheshire had been abruptly thrust into the crucible of opposing powers,

he had already declared loyalty to the king and raised an army of some 60,000 men from both counties. It is logical to assume that amongst that number were men recruited from Macclesfield Forest, as his father was hereditary steward of the area, a position which would shortly devolve on him. The plan was to rally in Warrington and raise the royal standard first for Lancashire, but King Charles countermanded the move and asked instead that he join him in Nottingham.

Strange obeyed the order and was commissioned to retrieve Manchester, a medium-sized well garrisoned town held by the Puritans in south-east Lancashire, from where raids could easily been carried out into the Royalist heartland of east Cheshire. Already the puritans had taken the town of Bolton and others in the east of the county, but those in the west supported the Stanley family and declared for the king.

As early as July 1642, Lord Strange had attended a banquet in Manchester with many whom he considered friends and associates, but was lucky to escape with his life. On returning north from Nottingham, in preparation for his siege of Manchester, he began by attacking many Lancashire towns that held arms and ammunition on behalf of the Puritans. On learning of his action a Parliamentary order was issued demanding that he return the seizures. Choosing to ignore the command he was declared a traitor and deprived of his lieutenancy on 16 September – two weeks before his father's death. Eight days later his siege of Manchester began, and by the 29th, as Earl of Derby, he successfully fortified Warrington. However, on 1 October a decision was taken to raise the Manchester siege as the soldiers were required elsewhere. This followed a week in which three attempted assaults had been made and rebuffed during days of atrocious torrential rain.

At the beginning of December, with the king having abandoned his campaign for the winter, the earl decided to continue his plan of increasing Royalist power within the region. On the 7th, Lord Fairfax received a commission from the Earl of Essex to establish his headquarters at Selby in the West Riding of Yorkshire, but it was not in Yorkshire that James Stanley had planned his next attack, but in Cheshire.

It is possible that the Cheshire suggestion came from Lord Robert Cholmondeley, eldest son of Sir Hugh the Younger, and

grandson of Sir Hugh, a renowned military commander who was knighted at Leith by Henry VIII in 1544 following the Scottish campaign. The latter had also fought alongside the then Earl of Derby during the Scottish invasion of England in 1557, for which he had equipped and paid a troop of 100 men. The family was well known in the Macclesfield area, having resided at Cholmondeley, 8 miles west of Nantwich, since shortly after their arrival in 1066 with William the Conqueror.

Lord Robert had been MP for the county in 1625 and was subsequently created Viscount Cholmondeley of Kells in Leinster, Ireland. The Derby and Cholmondeley families had evidently continued their close relationship based on their mutual loyalty to both sovereign and country, and as Lord Robert must have been aware of the growing Puritan sentiment in the area, he presumably kept Lord Derby informed of developments.

One particular personality who seemed to be causing concern was Colonel Edward Mainwaring of Kermincham Hall, only 2 miles east of Holmes Chapel. The Mainwaring family, like the Breretons, were mostly Royalists, but Edward Mainwaring, as in the instance of Colonel Brereton of Handforth, was an ardent Parliamentarian and both were increasing their powerful positions.

Edward Mainwaring's residence was only 5.5 miles north-west of Congleton, and this could have been the reason why three months earlier Edward Fitton at Gawsworth Hall, situated only 4 miles north of Congleton, was requested by the town's councillors not to quarter any of his troops in the township in order to avoid skirmishes. Instead they had sent him wine to the value of 3 shillings and 4 pence for his 500 troops, shortly before he and his men departed with King Charles for Shrewsbury.

Early in December Lord Cholmondeley and his recruits joined Lord Derby's company as they rode south for their preconceived attack on Edward Mainwaring' residence and estate, but the colonel had been forewarned of their approach, which necessitated their swift dispersal in order to avoid capture. Derby, with his 200 Lancastrians, hurried back to home territory avoiding the main routes leading north through Cheshire. Cholmondeley, in endeavouring to reach Nantwich

on 24 December, was not so lucky, as his men and horses fell prey to a company of Puritans. Their weaponry and horses were seized, yet their antagonists, who were possibly neighbours and former friends, generously allowed them to walk home without loss of life.

Whilst these actions were taking place in central Cheshire, there was no possibility of any reinforcements conveniently close enough to Macclesfield Forest to give assistance as the area came under attack.

No doubt being aware of the initial Derby and Cholmondeley progress south, Colonel Thomas Legh of Adlington Hall, who had established his Royalist headquarters on his estate, took action. Many joined his force, including men from Macclesfield Forest sent by Edmund Jodrell. Perhaps not realising that Lord Derby's plans had gone awry, as he marched through Macclesfield, no doubt to collect further recruits, Mainwaring attacked. The speed with which the latter had taken advantage of the situation must have been a complete surprise to Colonel Legh, and his company was overwhelmed. He managed to escape, dressed in soldier's uniform, but his drummer and some of his men were killed.

Mainwaring wasted no time in reaching Adlington Hall, where his soldiers were able to seize sufficient arms and ammunition for 120 men, after which he departed in order to attack Wrynehill Hall near Crewe, the residence of Sir Robert Egerton who was closely related to the Fittons. There also sufficient arms and supplies were collected for Mainwaring's company of 120. Confident that the Adlington stronghold was no longer a problem, he appears to have left only a small group of Puritans on duty, and Thomas Legh, having rallied a sufficient force, was able to regain his estate. Appreciating that Royalist Chester, where Savage family members were still resident, was about to come under attack, he quickly rode off to help in its defence, leaving his eldest son, Thomas the Younger, in charge of the newly fortified Royalist garrison.

Cheshire was in turmoil, and the mood in and around Macclesfield can only be judged from religious tendencies. Those within the borough would mostly support the Crown, being members of the Established Church, together with families such as the Fittons, Cholmondeleys and Leghs. Others, however, in outlying rural areas, were influenced by their local landed gentry, such as those

in north Cheshire who took a more dissenting stance in rejecting the sovereign as head of the Church of England and the form of the English prayer book; they were strong supporters of the Parliamentarians.

The centuries-old palatine, with its strong royal involvement, was fading as time passed. It had lost several privileges during the reign of Henry VIII and, as treasury needs dictated, one or two more had followed, but the traditions and loyalties were so inculcated within the lives of leading Cheshire families that to reject them was unthinkable.

However, to the north of Macclesfield a network of Puritan enclaves had rapidly developed, from the Booth family at Dunham Massey to Mainwaring in the Handforth area (both to the north-west), and from the town of Stockport in the north and to the powerful Colonel Dukenfield's estate to the east of Manchester near Ashton-under-Lyme, and therefore to the north east, which not only left the Jodrells susceptible to attack, but also the Leghs of Lyme.

The Lyme estate had been subjected to several changes during the lifetime of Sir Peter Legh IX (1563–1636), begun by his grandfather Sir Peter VII, whose eldest son, designated Peter VIII, had predeceased him. The grandson is known to have served time in the Elizabethan army, but on inheriting the estate in 1589 he retired to complete his grandfather's extensions. Sir Peter IX became a Cheshire MP and great patron of the arts. He had courted the friendship of Queen Elizabeth's favourite, the Earl of Essex, and in 1620 had invited him to hunt stag in the park. The herd of deer had become so famous by the Stuart period, that some were bought by Henry Cavendish to be introduced into his small deer park at Chatsworth in Derbyshire for breeding purposes.

The Lyme mastiffs were also considered a desirable gift for friends and diplomats. One was gratefully received by the Earl of Leicester, and another chosen to join a pack destined for Philip III of Spain by King James, as a diplomatic gesture at the cessation of the Anglo-Spanish war.

Following Sir Peter's death in 1636 fate again decreed that it was the grandson who would inherit the hall and estate. This Peter, aged fourteen years, had been snatched from his widowed mother as a baby due to a

Part of the 1714 map of Cheshire featuring Macclesfield (Maxfield) hundred (Stockport Library ref. 710A), with Manchester in the north and Sandbach in the south. Middlewich and Northwich are south-west, with Congleton central and east of the latter. Stockport (Stopford) is central and north of Macclesfield, with Handforth (Honford) close to the River Bollin, slightly left of centre and nearer Stockport than Macclesfield. Duckenfield is slightly to the south-east of Manchester, with Lyme and Adlington about halfway between the colonel's estate and Macclesfield. Macclesfield Forest is clearly visible in the south-east section of the map, stretching along the borders of Staffordshire and Derbyshire. Congleton is central and south, with Gawsworth slightly north-east and halfway towards Macclesfield. All were areas of great importance during the Civil War.

family dispute, and was brought up at Lyme by his severe grandfather from whom he appears to have inherited the same disputatious character. The Leghs were staunch Royalists and it is possibly because of this he became embroiled in a violent disagreement culminating in his fatal wounding, the result of a duel with the eldest son of Sir John Brown in 1642. This suggests that the latter could have been a Parliamentarian sympathiser and perhaps son of the Yorkshire-based Sir John Brown, a subsequent commander in the Parliamentarian army.

The estate quickly passed to young Peter's uncle Francis, who died childless during the following year. Next in line was the son of Francis's younger deceased brother Thomas. The boy, named Richard, was only eight years of age, and with his mother's death five years later (1648), the estate apparently served as a convenient non-combatant entity during Richard's long minority, capable of providing venison, vegetables and timber when need arose. Before his coming of age, however, much of Cheshire's landscape, and that of Macclesfield (both physically and metaphorically) would change dramatically.

* * *

The first blow to be struck was in January 1643 by Colonel Mainwaring on the 20th. He had occupied the Cheshire town of Nantwich during the previous month without using force. Aided by Manchester troops, who brought 'Three smale peeces of Ordnance' with them, which were strategically placed at the end of streets leading into the town, he set about fortifying the perimeter. Mainwaring then established his Parliamentary headquarters in the town before his attention was drawn elsewhere.

The Royalists who had taken men to defend the loyal city of Chester were Earl Rivers (John Viscount Savage) from Rock Savage on the Mersey Estuary near Runcorn; Thomas Savage of Chester; Lord Kilmorney from Shropshire; and Lord Cholmondeley, whose estate was close to Nantwich. They managed to negotiate a peace settlement with those in Nantwich during a meeting at Bunbury on 23 December 1642, which meant a cessation of hostilities within the county. This also occurred in Yorkshire and two or three other

The Stuarts

counties, but all were swiftly rejected by Parliament, whose belligerent members felt that they had the upper hand.

At this point Sir William Brereton arrived in Cheshire, having assisted in the defence of the capital. Perhaps his perceived fortuitous arrival in Nantwich had been a deliberate strategy to ensure that Cheshire was seized by the Puritans as quickly as possible, before Royalist sympathies took control.

Both Colonels Mainwaring and Brereton were well aware that their ardent opponents were those families who had held the privileged positions of Macclesfield foresters during earlier centuries, and accordingly the senior members of those families became the initial targets during the early stages of the conflict.

On 28 January 1643, Sir Thomas Aston and his infantry rode south to try to dislodge Mainwaring's headquarters at Nantwich, possibly unaware that Brereton had arrived with reinforcements. Aston and his troops fought hard in miserable weather, but were unfortunate that due to heavy rain an accidental explosion occurred with one of their cannon. The result was a humiliating defeat for Aston, who did succeed in escaping after a vicious struggle, and hurried with his surviving troops to Middlewich. This allowed Brereton to take command of the headquarters, making the town the centre of Parliamentary operations for Cheshire until further notice.

* * *

The first to feel the wind of change in the Macclesfield area was Edmund Jodrell of Yeardsley, who received a fine when it was discovered that he had sent men to Thomas Legh's aid. His response was a determined refusal to pay, but still the Parliamentary demands arrived. He finally submitted a sum of £20, which was evidently considered an insult, for he was seized and placed in Stockport jail from where he was removed to the one in Nantwich. This allowed a Parliamentarian force to plunder his Yeardsley estate and home in March 1643. They carried away items to the considerable value of at least £120, yet, still not content with the outcome, Edmund Jodrell was not released.

March was also the month of a concerted assault by Brereton on Middlewich in Mid Cheshire. Appreciating that the Earl of Derby was at a safe distance to the north, and Thomas Legh, ensconced in Chester, was unable to orchestrate an attack from the east, added to which Jodrell was in no position to rally any men from Macclesfield Forest, a possible reason for his removal from Stockport to Nantwich, which would also eliminate an attempted rescue should one be planned, Brereton acted quickly.

Little is known of Sir Edward Fitton's situation at that time, but at some point he was with the king's forces and found himself and his men under the command of the energetic and high-spirited Prince Rupert of Bavaria, whose mother was sister to King Charles. It had therefore fallen to the lot of Sir Thomas Aston, stationed at Middlewich and in command of the Royalist forces in Cheshire, to hold the town against attack.

On 13 March 1643 Brereton inflicted a severe defeat on Sir Thomas and his force, resulting in many of the Royalist troops taking refuge in the town's parish church, but to no avail. It was a humiliating situation with the loss of two cannon and arms for 500 men. Although the death toll was comparatively small, many Royalist prisoners were taken before the plunder began. Property and goods belonging to the burgesses were seized together with the valuable silver plate from the church, nor was the remainder of the population left unhindered.

Sir Thomas managed to escape and make his way to Chester, but was taken into custody by Royalist troops at the village of Pulford, just 4 miles south of the city. Accused of misconduct, he wrote an account in defence of his actions, which was accepted, and he was allowed to rejoin the king's force.

At some point during the summer of 1643 Brereton was defeated at Middlewich when the Royalists were reinforced by Irish troops, who regained control of the town. As Aston before him, he managed to escape, then evidently learnt that his adversary had reached Macclesfield. Having regrouped his troops, Brereton headed for east Cheshire, determined on victory. An extant record of what took place in Macclesfield when the attack began has yet to be found, but as Brereton's resounding victory is known, one can only imagine the terror of the remaining inhabitants. No doubt the boom of canonry

could be well and truly heard throughout the borough and in the surrounding plain and hills; exactly where the Macclesfield soldiers were serving, whether locally or at some distance, is difficult to assess. And how much hand-to-hand fighting or how many sustained wounds by those involved will probably never really be known.

Both Brereton and Aston were lucky to survive, allowing their vendetta to continue next in Staffordshire. There Brereton finally gained the upper hand when Aston, who is known to have been suffering from war wounds, was captured and imprisoned in Stafford jail after Brereton had taken the county town. The latter seemed unstoppable, for he captured Wolverhampton, then Whitchurch in Shropshire and several other Royalist strongholds en route, as he returned to Cheshire.

* * *

Meanwhile, after his nephew's arrival in England during July 1642, King Charles had created Prince Rupert general of the horse, which numbered 500. Rupert's appealing personality and inspiration soon took over, and on 23 September that year he gained a great victory over Essex's cavalry sent to defend Worcester. The part he played at Edgehill was a considerable success, although the overall outcome was stalemate. He drilled his men to charge through enemy fire with swords in hand, and only then to draw pistols and carbines when they were amongst the foe, a move which required a good deal of courage.

By this time Sir Edward Fitton and his infantry were certainly with the king's force, for he had taken part in the Banbury victory and that of Reading, although they were forced to evacuate Brentford after initially defeating two contingents of Puritan soldiers when Parliamentary reinforcements arrived, forcing them to retreat to Reading in the autumn of 1642.

Events moved on quickly, and Charles, having established his court and headquarters at Oxford, recalled Rupert on 16 April 1643, whose exploits throughout the Midlands and further south had won several victories for the Royalists, although interspersed with the occasional rebuff, but his reputation was established. At the king's command

Military Macclesfield

Monument of Sir Edward Fitton in Gawsworth Church, who died in Bristol in 1643, lying next to his second wife. Both are watched over by the alabaster figure of their only child, their daughter Margaret, who died aged seven.

an attempt to take Bristol had to be aborted, but on 18 July Prince Rupert set out once more and joined Cornish forces under Hopton for a concerted attack on the city held by the Puritan commander Nathaniel Fiennes. Amongst his company were Sir Edward Fitton and his recruits. Fiennes was forced to capitulate on 27 July, and two weeks later King Charles and Prince Rupert left to lay siege to Gloucester, leaving Sir Edward in charge of the garrison. His 'sudden death' during August was said to be from 'consumption', but it is likely that although he had the disease, the rapidity with which the death occurred, at only forty years of age, was due to an additional infection such as pneumonia, suggesting that he must have beevn completely exhausted for some time, but had shown great strength of character in carrying out his duties. He was obviously in royal favour, for his remains were initially buried in Oxford before they would finally be returned to Gawsworth in 1664.

* * *

During the early months of 1643 the Earl of Derby had been engaged in Lancashire. First he took Preston, then, having failed to occupy Bolton, went north to Lancaster. Although he seized the town, the castle proved impregnable, so he turned his attention once more to Bolton, but without success. During April Brereton took the opportunity to attack Warrington, which the earl managed to fend off before he himself suffered a defeat at Whalley near Pendle Hill in Lancashire by Captain Ashton. Unable to regain Warrington, he hurried to York, leaving the town's authorities little option but to surrender.

William Cavendish had had good success in Yorkshire, yet Derby's stay was of short duration for news of disturbances on the Isle of Man arrived; he reached the island on 15 June intent on restoring order. There he remained until November then attended the king's Parliament in Oxford before joining Prince Rupert in February 1644 in Cheshire. On 24 January the latter had been created Earl of Holderness and Duke of Cumberland. Having been given an independent command, Charles designated him captain-general of Cheshire, Lancashire, Worcestershire and Shropshire, together with the six counties in North Wales. The Royalist troops of the Macclesfield area therefore found themselves serving under the leadership of this particular dynamic personality.

Rupert established his headquarters at Shrewsbury and eventually had minor successes. After being recalled to Oxford on two occasions by the king, it was evident that the Royalist strategy had changed, and during 1644 efforts were concentrated in the Midlands and the north of the country, instead of London and the south. It was earlier in the year that Derby had sent Prince Rupert an appeal for help and subsequently joined him. In May they beat the Roundhead force of Colonels' Mainwaring and Dukenfield at Stockport.

It was unfortunately too late for the Leghs of Adlington Hall. With Sir Thomas in Chester, where he died in 1644, and his son Thomas, the lieutenant-colonel, taken prisoner at Stafford during 1643, Adlington Hall was quickly overrun by the Parliamentarians. There they established a garrison which would survive for some considerable time.

Sir William Brereton, meanwhile, seeing a fortuitous opportunity, signed a release for Edmund Jodrell, stating that within a few months he had finally paid his debt of £200. There seems little doubt that Sir William had personally contacted Jodrell, pointing out that with Adlington Hall a Puritan garrison and the Brereton and Dukenfield estates just a few miles to the north and north-west of his area of Macclesfield Forest, he would be wise to espouse the Puritan cause. Jodrell evidently agreed, though with what purpose in mind is hard to deduce. His reward was the position of sheriff of Cheshire. When the news reached Sir Thomas Legh in Chester before his death, he wrote to Jodrell implying that he had been noted as something of a traitor.

Rupert, accompanied by the Earl of Derby, with possibly a contingent of Macclesfield men who had remained loyal in their force, headed for Lathom House, near Preston. There, 'the gallant countess of Derby', under siege, had fearlessly resisted all attacks on their estate and headquarters during her husband's absence. Leaving the earl with his wife, Rupert pressed on.

Eventually the Royalists were gaining the upper hand in Cheshire, with the Puritans reduced to defending their garrisons at Warrington, Nantwich, a smaller one at Northwich and Adlington Hall. Sir Thomas Legh's wife Anne had long since left the hall and moved to Milne House near Prestbury village. Declaring that she had not held her husband's Royalist convictions, after his death she married a prominent Puritan commander and worked hard to recover their estate over several years for the family, despite the burden of several fines. Her husband represented Wigan and his son Alexander Rigby Jr had been taken prisoner by the cavaliers. Eventually their two sons, who were actually cousins, were exchanged.

Concern amongst the radicals in Parliament grew in respect of the northern situation and Thomas Fairfax was sent north accompanied by a formidable commander – Oliver Cromwell. Rupert, anxious to assist the Duke of Newcastle, hurried to Yorkshire, allowing Brereton to retake his former positions. On hearing of Rupert's approach the Puritans withdrew before him, but he kept up the pursuit, anxious for battle. With a Scottish army in Cheshire aiding

the Puritans there was no immediate help available, and those in Yorkshire were forced to face Rupert's troops at Marston Moor on 2 July 1644.

Rupert was full of confidence, but Newcastle was hesitant. Amongst their numbers was Derby and his force, suggesting that soldiers from Macclesfield would also be present. But it was to be Cromwell's day, and although Rupert's left wing was initially victorious, the right wing, under the prince's personal command succumbed to Cromwell's relentless onslaught. The battle in the centre was fierce, lasting for some time, but having overcome Rupert's right Cromwell chose to turn his troops left, overcoming the victors. Rupert narrowly escaped, despite losing 4,000 men, with a further 1,500 taken prisoner.

With the northern Royalist cause in ruins and his Lancastrian estate and headquarters in jeopardy, Derby, his wife and family managed to reach the Isle of Man later that month. There he built up the defences on the island against a mainland attack, and for the next few years was able to offer refuge to Royalist supporters in danger of persecution.

By October a second battle at Newbury was fought where Rupert was again defeated. The king, who had been engaged elsewhere, managed to return safely to Oxford, but he realised that his downfall was imminent after engaging in a plethora of unsuccessful intrigues during the following winter and summer. He was desperate for Irish troops, yet they would only be lent if he granted Ireland independence, and he only succeeded in obtaining a small support army of Irish and Scottish Highlanders who had won astonishing victories in the north of Scotland.

Whilst the opportunity had been taken to remodel the Puritan army, who were said to be 'filled with religious enthusiasm' and under strict discipline, Prince Rupert had alienated two or three of the Royalist nobility, which unfortunately caused friction amongst his commanders. The king had made him general of the Royalist army, and early in 1645 he imprudently divided his force, sending one of his disputants, Goring and his 3,000 horse back into the West Country, whilst he moved north.

At first the prince's campaign achieved success, and hearing of his approach the Puritans laying siege to Chester withdrew. But the hopes of those in the city were short lived, for Rupert hastily turned south on being told that Oxford was under attack. Overconfidence seems to have been his nemesis. The outcome was the Battle of Naseby in Northants on 14 June 1645, where the Royalists under the king and Prince Rupert were defeated by Thomas Fairfax and Oliver Cromwell. The report of the battle gave him credit for routing Fairfax's right wing of horse, but having given chase, on returning to the battlefield he discovered that the king's foot soldiers and the remainder of his horse were defeated. The foot soldiers were all taken prisoner, and his cavalry was chased to Leicester. Despite his endeavours he had been unable to encourage his men to make a second charge.

Charles headed for South Wales, and Rupert for Bristol. On 21 August 1645 Fairfax approached the latter, but after futile negotiations Rupert capitulated to the fury of the king. The prince finally left England on 5 July 1646, leaving behind a wake of recriminations citing his brutality and barbaric treatment of prisoners, but how much was Puritan propaganda is difficult to judge in many instances, for it has come to light that he had reacted to the brutalities being metered out to his own men.

Sir Thomas Aston suffered greatly. In endeavouring to escape from Stafford jail, and already afflicted with the effects of war wounds, he was viciously hit on the head by a soldier. The result was a serious infection and fever from which he died whilst still in the prison on 24 March 1645.

* * *

As events dragged on, and more and more outposts of Royalist resistance fell to the Puritans, a deluded king, on learning that the Scottish army had become disillusioned with the English Parliament, presented himself to them at Newark on 15 May 1646. From there they escorted him to Newcastle, but their Presbyterian counterparts in Scotland demanded a permanent establishment

The Stuarts

An English flint-lock pistol, ideal for cavalry use in the early sixteenth century, and issued to elite troops in the Cromwellian period. It was in favour as a sporting gun.

A powder horn of the same period.

of their religion. Negotiations lasted for months, during which Charles's Scottish allies were thwarted one by one. Finally, on 20 December, he decided to return to London and negotiate with the opposition.

The English Parliamentarians, however, confined him in Holmby House, Northants, until 4 June 1647, where he was well treated. But on that day he was taken at gunpoint by a very junior officer of the New Model Army to Newmarket. Having sent his proposals to Parliament, Charles was convinced all was well, and he had rightly judged that the army and Parliament would struggle for control, and the Presbyterians and Independents would begin to quarrel with each other. Thinking that he had the upper hand, as he was moved from place to place, he promised concessions to each and even to the Roman Catholics, till they in turn discovered his secret negotiations with each of the others.

During 1648 matters came to a head when the Scottish army promised to place him on the throne, assisted by English cavaliers, but Fairfax and Cromwell overcame their opponents, and on 1 December Charles was removed to Hurst Castle, then taken to Windsor on the 23rd.

Unfortunately the Commons had undergone a purge, leaving only those determined to rid themselves of the monarchy. Totally ignoring the lords and the king, they set up an illegal court, and on 19 January 1649 Charles was brought to St James's Palace. The next day he appeared in Westminster Hall, where he was condemned to death. Despite Charles's defiant stand, during which he declared the court illegal, which technically was true, the execution took place in front of Whitehall on 30 January 1649, to the consternation of the vast majority of those who witnessed the event and many more throughout the country.

Charles II

For the next eleven years, whilst Britain was in the grip of religious, political and military turmoil, so far as Royalist England was concerned, Charles II, the eldest son of Charles I, resident at The Hague at the time of his father's death, was king.

The Stuarts

The situation in Cheshire was excellently researched by R. A. Dore in his book *The Civil War in Cheshire* (1966), but the salient facts need reassessing in relation to Macclesfield, its hundred, manor and forest.

Former friends and neighbours of both persuasions seem to have settled down to their country pursuits, and both intermingled socially, even amongst the Cheshire hierarchy. Perhaps sensing that whilst calm reigned it was better to concentrate on matters in London, Brereton seems to have left well alone in his home county, especially after the capitulation of the Royalists in Chester. The citizens had fought off several attacks, but as the winter of 1644-45 approached the provisions supplied from North Wales dwindled. In command was Lord Byron from Lancashire, forefather of the famous poet, who finally had no choice but to surrender the city accompanied by a few officers on 3 February 1645. Welsh troops were allowed safe passage to Wales, together with any citizens who wished to obtain passes and accompany them. The Irish troops were unfortunately held as prisoners, and two or three small groups elsewhere in Cheshire, who were apprehended, were mercilessly slaughtered when their Irish accents were heard.

William Legge, whose medieval predecessors displayed their coats of arms in the stonework of Macclesfield's parochial chapel, was a personal friend of Prince Rupert and for a time had been governor of Chester. After the capitulation it was Colonel Dukenfield, the fanatical religious Independent, who took over the city as military governor, then engaged the fiery preacher, Samuel Eaton, to instil his form of worship into the soldiers in the garrison.

The first consideration has to be the remaining Royalist forester families, and as Sir William Brereton had been given the chief forestership of Macclesfield Forest and was seneschal (governor) responsible for the judicial and other various administrations of the Macclesfield hundred, there was little anyone could do but quietly conform.

After the death of Sir Edward Fitton in Bristol 1643, followed by his widow's second marriage and her death in June 1645, the estate had passed to his nephew William Fitton of Limerick in Ireland, and was evidently managed under the watchful eye of Brereton.

Military Macclesfield

Jodrell, who had been forced to provide soldiers for the New Model Army, was also obligated to provide loans for some of the commanders, amongst whom was Colonel Dukenfield. He also saw all his horses taken for the Roundheads' Yorkshire cavalry. Several other Royalists were plagued, like Jodrell before them, with a series of summonses payable to the courts of Macclesfield, Stockport, Nantwich, Northwich and Chester.

By this time the Presbyterians had successfully gained power in the Commons, and Cromwell, as one of the two Cambridgeshire members during the 1640s was well aware of Parliamentary procedure. He did endeavour to use his influence in obtaining just and fair treatment for the Royalists, but became aware of the worsening situation when the government took control of the army. His intervention almost cost him a prison sentence, when he was suddenly called to Oxford and then Naseby.

Under Fairfax and Cromwell the army was brought under control, and Cromwell then addressed the Commons, hoping to unite all the different parties of whatever religious persuasion, including those in the city. Whether or not he realised it, the effect was a suggestion of republicanism.

From 15 March 1649 Cromwell became lord lieutenant of Ireland and commander-in-chief, with a salary of £5,000 and £8,000 respectively, as confirmed by the council of state. The council also provided equipment and provisions for the army of 12,000. This was, of course, only six weeks after the execution of Charles I.

By this period a certain James Stopford had been living at Saltersford Hall in part of Macclesfield Forest for some time. The property, situated in a remote valley between Rainow and Goyt Forest, was constructed in the late Elizabethan period c. 1594. It appears to have come into the family when James married the daughter of a Henry Worrall, and would have been part of the marriage settlement. The family were no doubt merchants and farmers like many others.

The Stopford family name was said to have been derived from the medieval name of Stopport, today Stockport. In 1642 James

The Stuarts

Stopford (Stopport) was living at the hall when his son William was buried in Macclesfield. As a dissenting family they had remained on the fringes of the borough, but when the Civil War began James Stopford became a colonel in the Parliamentary army, and for his efforts seems to have first been rewarded with some burgage properties in the township.

The Earl of Derby not only held lands and property in Macclesfield Forest but also in Macclesfield town itself, at the northern end of the borough. He had several burgages, including the 'Castle' site adjoining Mill Street, and on what is now the Indoor Market site, i.e. Dog Lane and Barn Street; others included a cottage and additional buildings leased to a Thomas Stopford.

James, the colonel, had evidently proved himself to be a remarkable soldier and came into possession of burgages in the borough, which seem to have been some of those sequestrated by the government from the Earl of Derby when he was declared a traitor. At exactly what date this took place is difficult to deduce, as many property deeds from the Interregnum period have disappeared. However, he did accompany Cromwell to Ireland, where they landed at Dublin on 15 August 1649.

* * *

Cromwell

Charles II had been proclaimed king in Edinburgh as early as 5 February 1649, and representatives from the Scottish Parliament arrived in Holland during the following month, but had to wait for a year before being granted audience with the king. Meanwhile Lord Ormonde in Ireland also followed suit with the royal proclamation, together with the Scots of Ulster and the island of Guernsey. Other letters of English support began to arrive, encouraging Charles to revisit France, then sail to Guernsey in September 1649. However, on learning of the position of the Puritan fleet at Portsmouth, he returned to The Hague the following February. Earlier he had considered sailing to Ireland, but following Cromwell's actions it was by then out of the

Military Macclesfield

question. At last he listened to the Scottish delegates, and arrived in the Firth of Cromarty on 16 June 1650.

In the interim Cromwell's ruthless Irish campaign had seen 2,500 defenders slaughtered in Drogheda on 10 September 1649, and a further 2,000 some four weeks later at Wexford. The few who were spared were dispatched to Barbados for arduous work in the sugar plantations.

Cromwell was a complex character; as a military leader he obeyed the rules of war to the letter, but in his civilian role he obeyed civil law, which occasionally tended to seem paradoxical when Parliament conveniently chose the one best suited to their requirement. However, he thoroughly approved Parliament's policy of land forfeitures, and, reiterating the Tudor ideal, professed to achieve much with new English settlers in Ireland. Just as his second campaign on Irish inland fortresses began, he was recalled to attack the Scots under Fairfax's command. Fairfax, not wanting to invade Scotland, resigned his commission, but Cromwell, angered by Scottish support for Charles II, had no such qualms and took Fairfax's place as commander-in-chief of the English army on 24 June 1650.

James Stopford appears to have been one of the commanders left in Ireland, where he became an important landowner, but the family would retain their Macclesfield holdings for generations to come.

No doubt learning of the arrival of King Charles II in Scotland, Cromwell led his army north, where finally on 3 September 1650 the Battle of Dunbar was fought, and Edinburgh surrendered. Rumours spread through England and France that Charles had been killed, or at least was ill, but he had managed to escape, and was officially crowned at Scone on 1 January 1651. Ironically Cromwell, who by then had gained much control over southern Scotland, himself fell seriously ill. This allowed Charles to move his court to Stirling, and despite Cromwell's recovery and capture of Perth on 2 August 1652, Charles was able to march south into England, leaving Cromwell making excuses for his apparent blunder.

Whilst still on the Isle of Man, the Earl of Derby, ensconced in Castle Rushen, had been offered terms of surrender in July 1649,

which he had indignantly rejected. But in 1650 he received a request from King Charles to take command of Cheshire and Lancashire Royalist forces, as an insurrection was planned. Although unhappy with Charles's Scottish agreement to allow the Scots their Presbyterian religion, he did return to the mainland in order to join the king. He and his 250 foot soldiers and sixty horse landed in Lancashire, and after the royal encounter, as Charles marched south through Cheshire, gathering volunteers en route, Derby proceeded to Warrington, but was unsuccessful in gaining support and was finally defeated at Wigan.

The king pressed on to Shropshire, and if any from the Macclesfield area were able to join his army, this would have been an opportunity to prove their loyalty, but all would be in vain. With the gates of Shrewsbury closed against them, they arrived at Worcester on 28 August, having swelled to a force of about 13,000.

Cromwell, anxious to overcome his previous miscalculation, had hurried south and arrived on the outskirts of Worcester with a force said to be between 30-40,000 strong. The outcome was a foregone conclusion; although Charles fought hard throughout the night, he finally had to withdraw when his army was virtually annihilated. Amongst his escort was Lord Derby who helped find him safe accommodation, and for the next forty-one days he moved from place to place until arriving in Brighton. From there he finally landed in Normandy on 16 December 1651.

By that time Derby had been captured near Nantwich on his way north, and on 29 September appeared in Chester before a court marshal. At first he appealed as a prisoner of war according to military rules, but this was disregarded and instead he was found guilty of high treason. He pressed hard his appeal, surprisingly supported by Cromwell, but it proved futile. His request to his wife to surrender the Isle of Man was disregarded, and he was condemned to death. Although he managed to escape from Chester Castle, he was unfortunately caught by the River Dee and taken to Bolton; there he was beheaded on 15 October 1651.

Records of 1650 confirm that some of the Earl of Derby's retainers, employed in Macclesfield Forest, had been summarily executed,

whilst it was noted that three in Rainow had been listed as active against the Puritans and were continuing to behave maliciously. The minister of Wincle chapel had become disillusioned with the new regime and unwisely spoke out against it, nor were two petitions for help treated with any respect.

Margaret Platt of Rainow had lost two sons fighting with Sir Edward Fitton at Newbury, and made a plea for support to continue due to her appalling condition; this was denied. However, a Robert Wylde of Macclesfield, who had fought in Colonel Duckenfield's ranks, was also denied a grant of £3 per annum. Thomas Hinchcliffe of Kettleshulme, who actually fought in the regiment of the Puritan Colonel Henry Bradshaw at Worcester in 1651, had to suffer at least a dozen horrendous blows to his head, three to his back and right elbow, and the severing of an ear and his left arm, in order to qualify for his £4 per annum grant.

Cromwell, well rewarded by Parliament, received Hampton Court as his residence and lands valued at £4,000 per annum. Although later insisting that he had 'begged' for retirement after an attempt on his life in November 1651, he did become politically more active.

Desperate for money, Parliament again began Royalist sequestrations and heavy taxes, whilst the division between members and the army grew. The outcome was that Cromwell, offered the title of king, refused the honour, but instead was named Lord Protector of the Commonwealth on 16 December 1653. He inherited wars with Portugal and Holland, and a hostile France and Denmark, all of which he quickly overcame.

The Dutch had initially declared war on England after Charles II's rejection, but when Cromwell successfully negotiated a treaty with them on 5 April 1654, the English royals were excluded from the United Provinces, encouraging Sweden to follow suit by a treaty of 14 September. Denmark next agreed trading terms comparable to those of Holland, and Portugal extended English trading privileges.

A Parliamentary review was next undertaken, during which period ninety-nine members were excluded, and having become aware of

several Royalist plots, Cromwell acted quickly, supported by his excellent spy network. All were thwarted by many executions, and with the country reorganised into twelve divisions, each was placed under the governance of a major general in October 1655. In order to ensure that sufficient additional troops could be provided, a further tax of 10% of income was forced upon the already overburdened Royalists.

Cromwell, by then, was in complete control and insisted that his methods were the most efficient way of combating vice and settling religious issues. One of his final acts of 1655, as the military government tightened its grip, was to ban the use of the prayer book on 24 November and throw into prison any religious groups who objected to the government's form of approved preaching.

* * *

Macclesfield, devoid of any Royalist leader, was witnessing almost 600 years of loyalty to the sovereign apparently crushed. Its chapel of All Saints, forced to conform to a stricter and more simplified form of religion, saw its minister ejected and replaced by a Puritan cleric. An effort was made to mutilate the alabaster effigies on the Legh tombs, but luckily without much success, and a Geneva or 'Breeches' Bible, as it became known, was used by the preacher to replace the '2 great Bibles whereof one is of the last Translation', mentioned in an inventory of 1613; one of the latter seems to be the much admired 1611 translation of the King James Version.

The 'Breeches' Bible was the one produced in 1557 by Protestant exiles fleeing from France to Geneva under persecution from Mazarin. Its alternative title referred to Genesis chapter 3 verse 7 where instead of the previous translations referring to Adam and Eve's 'Aprons', the words read that they 'took fig leaves and made themselves 'Breeches'. A more liberal Presbyterian minister, Ralph Stringer, installed in 1643, proved to be popular with his series of monthly lectures, and chose to wear a Geneva gown instead of his surplice, which was considered 'popish'.

Despite Cromwell's apparent religious toleration to those outside the influence of Rome and the Church of England, its

selectiveness was highly prejudicial. Even the practice of the Jewish religion, officially banned in England for centuries, came under long discussion. Finally he refrained from proposing their right to worship, but when a synagogue was built in London, he conveniently chose to ignore it. The long battle for minds and religious ideals had begun, and Macclesfield, as an ancient borough, had been caught in the middle of it.

Up to this period it seems fair to say that all Britain's battles, both external and internal, were based on religious persuasions, which proliferated into the commercial, legal and social aspects of all societies. With the creation of a future standing army the divisions within these different groups would develop further, provoking the expansion of isolationist views of what was required to promote peace.

BIBLIOGRAPHY

Booth, P. H. W., *The Financial Administration of the Lordship and County of Chester 1272–1377* (Manchester University Press, 1981 – by permission of the Chetham Society)

Chetham Society New Series (2nd), Vol. 61 (1907), pp. 36–47

Chronicles of the Age of Chivalry (First Welcome Rain edition 2000 by arrangement with Salamander Books)

Chronicles of the Crusades (Bramley Books, 1996)

Chronicles of the Tudor Kings 1485–1553 (Bramley Books, 1996)

Dictionary of National Biography (Oxford University Press, 1993 edition) – for all principal characters.

Dore, R. N., 'The Civil Wars in Cheshire' in *History of Cheshire*, Vol 8. (1966)

Earwaker, J. P., *East Cheshire: Past and Present*, Vol. II – p. 479 et seq Savage Family; see also Jodrells, p. 538 et seq.

Fashion and Armour in Renaissance Europe (V&A publication, 2009)

Flodden Field, Chetham Society New Series (2nd), Vol. 61 (1907), pp. 13–17

Froissart Chronicles (Penguin Books, reprint 1978)

Hey, David, *Packmen, Carriers and Packhorse Roads* (Leicester University Press, 1980) – *see* 'Salt', pp. 152–156

Jackson, Gordon, *The History and Archaeology of Ports* (World Works Ltd, 1983)

Jodrell MSS, John Rylands – includes several items, e.g. No. 2 relating to William Jodrell's pass from Edward, the Black Prince

Kelsey, C. E., *A School History of Cheshire* (Oxford at the Clarendon Press, 1911) – for letter to Henry VII re charter see pp. 117–1180

Letters of the Queens of England 1100–1547 (Alan Sutton Publishing Ltd)

Rawcliffe, Carole, *The Staffords (Dukes of Buckingham) 1396–1521*, Cambridge Studies in Medieval Life and Thought, 3rd Series, Vol II (Cambridge University

Press) – The references are well documented including the collection of manuscripts in the Staffordshire Record Office relating to Macclesfield.

Record Society Vol. 19 (1889), pp. 28–31, 88, 154–155

Richards, Raymond, *The Manor of Gawsworth* (Scholar Press Ltd, reprinted 1974) – Fitton family

Stamp, A. E., *Register of Edward the Black Prince, PRO Part III AD 1351–1365* (printed copy in Chester Public Library).

The Anglo-Saxon Chronicles (Coombe Books, 1996)

The Chronicles of The Wars of the Roses (Bramley Books, 1996)

The Domesday Book England's Heritage Then and Now (Coombe Books, 1995)

The Oxford Illustrated History of the British Army 1994 (Oxford University Press, 1994)

The Plantagenet Chronicles (Tiger Books International PLC, 1995)

The Spanish Armada, Chetham Society New Series (2nd), Vol. 61 (1907), pp. 22–25

Individual Booklets

Hancox, Joy, *Adlington Hall: A House and its Family* – Legh family

Lyme Park (The National Trust, reprint 2007) – Legh family

ACKNOWLEDGEMENTS

As always my thanks go in particular to Eileen Talbot, a good friend and reliable proofreader, whose comments are always appreciated. They are also extended to the staff of Macclesfield Library and those in the Cheshire and Chester City Record Office, and the staff of the local studies section of Manchester Public Library, together with those of the John Rylands Library. Thanks are also due to those with private collections of weapons and armoury who have allowed photographs to be taken for the illustrations.

INDEX

Acre 15–16, 21
Adlington 37, 43, 47, 57–59, 62–63, 68–69, 71, 77, 86, 107, 121, 159, 169, 173, 197, 199, 205–06, 220
Agincourt 17, 65, 69, 72, 80, 94, 122
Archers 15–16, 19, 23–25, 27–33, 35, 37, 40–44, 46–47, 49, 51–53, 55–59, 63, 68–70, 72, 75, 79, 83, 87, 90, 94, 97, 104, 110–13, 116, 120–22, 124, 143–44, 147, 161
Aston, Thomas 190, 201–03, 208

Black Prince, The – see Prince Edward
Blore Heath, Battle of 84, 93, 107, 163
Bordeaux 40–41, 51–53, 138
Boulogne 33, 57, 113, 146–48, 150
Bosley 9, 75, 78, 85
Bosworth, Battle of 103–05, 106–09, 115–16, 141
Bowmen 16–17, 19, 24, 55, 59, 68, 72, 74, 84, 87, 107, 124, 126
Brandon, Charles – Duke of Suffolk 146–47
Brereton, William 162, 190–91, 193, 196, 201–03, 205–06, 211
Bristol 160, 190, 204, 208, 211
Brittany 19, 27, 48, 52, 55–56, 101, 112, 114, 138
Buckingham, Duke of 85, 108, 121, 126, 134–36, 149
Burgundy 48, 89, 93–94, 97–98, 112, 115–16, 136, 139

Calais 33–35, 46, 49, 56–57, 69, 74, 83–84, 88, 90, 92, 96–97, 115, 121–22, 132, 135, 145, 154–55, 158, 168
Castile 20–21, 26, 52, 54, 57, 125, 134
Cambridge 79, 120, 137, 152, 183
Cavaliers – see Royalists
Chandos, John 28, 30–31, 33, 37, 41, 43, 46, 49, 51–54
Charles I (1625–49) 179–189, 192, 210, 212
Charles II 210–13, 214
Chester 9–10, 12–17, 19–21, 23, 37–38, 40, 42, 50–51, 57–59, 62–63, 65–66, 68, 72, 76–77, 80, 84–86, 94, 97, 104, 107, 109, 113, 120, 130, 156, 176, 180, 189, 190, 193, 197, 200, 202, 205–06, 208, 211–12, 215, 219
Chester, Earl of 10, 16–17, 2137, 76, 94, 104, 109, 156, 176, 180
Cholmondeley family 143, 189, 195–97, 200
Conwy 62
Crécy 17, 27, 30, 32, 37, 57, 69
Cromwell 181, 206–208, 210, 212, 213–18
Crusade 15–19, 21, 134
Cyprus 15–18

Derby, Earls of – see also Stanley family 27, 35, 108–110, 112–13, 121, 126, 135, 137, 140–41, 152–53, 156, 187, 194–96, 202, 205–06, 213–14
Derbyshire 9, 25, 28, 38, 40, 68, 93, 111, 199
Downes family 45, 47, 65, 67, 160–61
Dublin 59, 160–65, 171, 173, 183–85, 193, 214
Dudley, Robert 158

Earl Rivers 92–95, 98, 100–01, 200
Edgecote, Battle of 91
Edge Hill, Battle of 193–94
Edinburgh 56, 87–88, 99–100, 115, 142–43, 158, 188, 213–14
Essex, Earl of 164, 169, 181, 195, 198
Edward, Prince (1330–76) – see also Black Prince, The 3, 28, 31–33, 39, 41–52, 57, 68, 80, 113
Edward I (1272–1307) 21–22, 24, 26, 50, 52, 61, 64
Edward II (1307–27) 22–23, 27, 38
Edward III (1327–57) 42, 46–49, 54–55, 61, 69, 72, 156
Edward IV (1461–83) 88, 93–94, 98–100, 103, 109, 115–16, 126
Edward V (1483–85) 98
Edward VI (1547–53) 110, 149–51, 152
Eleanor of Castile 20–22, 26, 151–52
Elizabeth I 155–59, 175, 180, 192

Index

Fairfax, Thomas 206, 208, 212, 214
Field of the Cloth of Gold 135-37, 147
Fitton (also Fitoun) family 47-49, 59, 63, 84, 122, 161, 163-66, 179, 183-84, 187, 193-94, 196, 203-04, 211, 216
Fitzgerald family 161-62
Flodden Field, Battle of 125-31
Flodden flag – see Selkirk
Foresters 14, 19, 21-22, 40, 49-50, 65, 80, 161, 201
France 23, 27-28, 32, 34, 37-40, 42-44, 46-49, 51, 53, 56, 58, 61, 67, 71-74, 76-77, 79, 89-92, 95, 97, 108, 112, 116, 121-22, 125-26, 131, 133-34, 136, 138-39, 141-43, 145-46, 148, 150, 152-55, 157-59, 170, 174, 178, 180-81, 185, 213-14, 216-17

Gascony 23, 27, 41, 44-48, 51, 55
Gawsworth 9, 47, 59, 68, 84, 93, 122, 159, 161, 163-64, 166, 179, 183-84, 193, 196, 199, 204
Grey, Lady Jane 150, 152
Gunpowder Plot 175

Henry II (1154-89) 155, 157, 159
Henry III (1216-72) 19-20, 76, 170
Henry IV (1399-1413) 62-63, 66, 75, 77, 170
Henry V (1413-22) 63-68, 71, 72, 77
Henry VI (1422-61) 64, 74, 76-78, 81, 84, 86-87, 90, 92, 94, 97, 107, 121
Henry VII (1485-1509) 106-112, 114-16, 119, 125, 144, 150, 157, 161
Henry VIII (1509-47) 120-24, 133, 142, 144-45, 147, 151, 156, 161, 192, 196, 198
Howard, Thomas – Earl of Surrey and 2nd Duke of Norfolk 116-17, 125-28, 131, 135-36, 138-39, 148-49

Isle of Man 63, 99, 194, 205, 207, 214-15
Ireland 15, 19, 58-59, 61, 63, 67, 78, 80-82, 84, 98, 102, 107, 110, 115, 117, 120, 140, 157, 159-66, 168-73, 183-86, 191, 193, 196, 207, 211-14, 223

James I of England (1603-25) 27, 74-75, 174-78, 183, 189, 191
Joan of Arc 74, 80

Jodrell family 38, 40-41, 44, 56, 58-59, 68, 71, 93-94, 122, 161, 187, 197-98, 201-02, 206, 212

Lancashire 63, 102, 104, 109-10, 115, 126, 128, 156-57, 162, 169, 183, 194-95, 205, 211, 215
Legh family 27, 37, 40-41, 43, 45, 47-48, 57, 59, 62-63, 65-69, 71-73, 77, 86-88, 93, 96, 99, 104, 107, 115, 121, 143, 159, 169-70, 172-73, 181, 187, 197-98, 202, 206, 217, 220
Longbow 24-25, 130, 132
Lord Fairfax – see Thomas Fairfax
Lord Herbert 90-91, 121-22
Lord Strange 102, 110, 149, 194-95
Losecoat Field, Battle of 92
Lyme 45, 49, 57, 59, 62, 65-66, 68, 71, 86, 93, 96, 99, 107, 121, 169, 198-200

Macclesfield Forest 12-15, 24, 27, 38, 40, 44-45, 50, 57-58, 63, 65, 80, 107-08, 113, 122, 126, 160-61, 187, 195, 197, 199, 202, 206, 211-13, 215
Macclesfield parkland 15, 44, 59, 68, 75-82, 85, 107, 109, 113
Macclesfield township or borough 7-14, 17, 23, 37-38, 40, 44, 46-47, 49, 57, 62-63, 67, 77-78, 80, 84, 88, 94, 98, 102, 107, 113, 119, 126, 128-31, 136-37, 140-41, 143, 147, 151, 156, 160-62, 164, 180, 187, 189, 196-202, 205, 211-13, 215, 217-18
Macclesfield, John of 63-65, 68, 75, 101
Marston Moor, Battle of 207
Mainwaring (also Maynwaring), Edward 196-98, 200-01, 205
Manchester 9, 41, 68, 108, 156, 195, 198-200, 219
Mary, Queen (1553-58) 143, 150, 151-55, 158
Mary, Queen of Scots 150, 157
Middlewich 9, 199, 201-02
Mortimer's Cross, Battle of 86

Nantwich 189, 196, 200-02, 206, 212, 215
Netherlands 99, 112-13, 115, 120, 135, 153-54, 158, 167-70, 180
Newcastle, Earl of 191-93

Normandy 10, 27–28, 37, 41–42, 51, 68
Normans 10–13
Northampton, Battle of 84–85, 92, 107
Northumberland, Duke of – see also Percy family 95, 150, 152

Oxford 13, 20, 79, 96, 110, 116, 120, 190, 192, 194, 203–05, 207–08, 212, 219–20

Pale, the (Ireland) 161, 165
Paris 28–29, 35, 48, 69, 71–72, 74, 77, 100, 146
Parliamentarians 190–94, 196, 198, 200–01, 205, 210, 212
Percy family 61–63, 92, 95, 135
Pilgrimage of Grace 139
Poitiers 17, 42–55, 56
Prince Edward – see also Black Prince, The 13, 28, 31–33, 39, 41–52, 57, 68, 76, 80, 113
Prince Rupert 202–05, 207–08, 211
Puritans 162, 194–98, 201, 203–04, 206–08, 213, 216–17
Pym, John 188, 192

Richard II (1377–99) 55, 57, 59, 63, 65, 72, 75, 78, 81, 101
Richard III (1483–85) 100–03, 108, 116
Roundheads – see Parliamentarians
Royalists 184, 187, 189–93, 195–97, 200–03, 205–08, 210–12, 215–17

Savage (also Sauvage) family 68, 71, 75, 77, 85, 87–89, 96–100, 103, 106–07, 109, 113–14, 119, 121, 126, 128, 131, 141, 143, 197, 200
Scotland 15, 26–27, 34, 56–58, 61, 67, 74–75, 87–88, 96, 98–99, 102–03, 115–17, 121–22, 138, 140–43, 147–48, 150, 155, 157–58, 168–69, 173–77, 179, 182, 185–89, 207–08, 214
Selkirk – see also Flodden flag 129–30
Seymour, Edward – Earl of Hertford 142–43, 149
Sherwood Forest 15, 110
Shrewsbury 10, 63, 77, 82, 102, 121–22, 124–25, 152, 193, 196, 205, 215
Shrewsbury, Earl of 121–22, 125

Sidney, Henry 163, 166
Spain 51–52, 112, 115, 118, 120, 135, 138–39, 154, 157–58, 167, 170, 175–78, 180, 182–83, 198
Spanish Armada 168
Spurs, Battle of the 124–25, 132
Stafford family 30, 77–78, 85, 87, 108, 121, 123, 137, 149, 154, 156
St Albans, Battle of 83, 86
Stanley family – see also Derby, earls of 22, 39, 63, 65, 77–78, 85, 100, 102–08, 115, 121, 126–28, 131, 135–36, 156, 161, 195
Stewart, James 27, 138, 141, 143
Stoke Field, Battle of 109–12
Stopford family 199, 212–14
Strafford, Earl of 183, 185, 187
Surrey, Earl of – see Thomas Howard

Tower (of London) 34, 62, 82, 94, 98, 100–01, 110, 116–17, 132, 136, 140, 149, 162, 173, 187–88, 192
Towton, Battle of 86
Troyes, Treaty of 71
Tudor family 73, 86, 90, 101–05, 106–26, 128, 131–36, 138–42, 144–59, 161–73
Turks 134

Wakefield, Battle of 86, 94
Wales 15, 21, 24, 40, 46, 49, 58, 62, 67, 80, 85–86, 90, 94, 98, 101–02, 113, 146, 162, 171, 194, 205, 208, 211
Wales, Prince of 28, 33, 37, 41, 76, 94, 97, 109, 120, 176, 180
Wallace, William 26
Warbeck, Perkin 115–18
Wars of the Roses 82–90, 90–105
William I, the Conqueror (1066–87) 8, 10, 12, 26, 28, 37, 68, 156, 196
Wentworth, Thomas – see also Earl of Strafford 183–85, 187–88

York 81, 95, 101, 116, 119, 139–40, 173, 182, 187, 190–91, 205
Yorkists 81, 84, 86–89, 107, 110–11, 115, 161
Yorkshire 9–10, 61–63, 83, 85, 90–92, 95, 101, 109–10, 112, 116–17, 126, 128, 139, 143, 183, 192–93, 195, 200, 205–07, 212

ALSO AVAILABLE FROM
AMBERLEY PUBLISHING

NO ORDINARY SURGEON
THE LIFE AND TIMES OF WILLIAM BINLEY DICKINSON

DOROTHY BENTLEY SMITH

9781445676401

AVAILABLE TO ORDER DIRECT 01453 847 800

WWW.AMBERLEY-BOOKS.COM

ALSO AVAILABLE FROM AMBERLEY PUBLISHING

DOROTHY BENTLEY SMITH

PAST TIMES OF MACCLESFIELD
VOLUME III

9781445658216

AVAILABLE TO ORDER DIRECT 01453 847 800

WWW.AMBERLEY-BOOKS.COM